Books by W. S. Di Piero

POEMS
The First Hour
The Only Dangerous Thing
Early Light
The Dog Star

TRANSLATIONS
Pensieri, by Giacomo Leopardi
This Strange Joy: Selected Poems of Sandro Penna
The Ellipse: Selected Poems of Leonardo Sinisgalli

ESSAYS
Memory and Enthusiasm: Essays, 1975–1985
Out of Eden: Essays on Modern Art

OUT OF EDEN

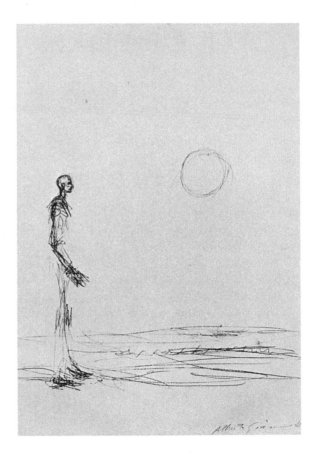

Frontispiece. Alberto Giacometti, *Standing Man and Sun,*
1963. Lithograph, 47 x 37 cm (18⁹/10 x 14²/5 inches).
Collection Fondation Pierre Gianadda,
Martigny, Switzerland.

OUT OF EDEN

Essays on Modern Art

W. S. Di Piero

University of California Press · Berkeley · Los Angeles · Oxford

The publishers wish to acknowledge with gratitude the
contribution provided from the Art Book Fund of the
Associates of the University of California Press, which is
supported by a major gift of the Ahmanson Foundation.

University of California Press
Berkeley and Los Angeles, California

University of California Press, Ltd.
Oxford, England

© 1991 by
The Regents of the University of California

LIBRARY OF CONGRESS

CATALOGING-IN-PUBLICATION DATA

Di Piero, W. S.
 Out of Eden : essays on modern art / W. S. Di Piero.
 p. cm.
 Includes bibliographical references and index.
 ISBN 0-520-07065-8 (cloth)
 1. Art, Modern—20th century—Themes, motives.
I. Title.
N6490.D44 1991
709'.04—dc20 90-48336

Printed in the United States of America
1 2 3 4 5 6 7 8 9

The paper used in this publication meets the minimum
requirements of American National Standard for Information
Sciences—Permanence of Paper for Printed Library Materials,
ANSI Z39.48-1984.

Cézanne discovered that it's impossible
to copy nature. You can't do it. But
one must try all the same. Try—like
Cézanne—to translate one's sensation.

———————

ALBERTO GIACOMETTI

Contents

Illustrations

Acknowledgments

I thank Scott Mahler for his good will and his commitment to this book at every stage of its preparation and Ira Livingston for his critical suggestions. I'm grateful to Hilton Kramer for publishing my first essay on art, "Morandi of Bologna," and several subsequent essays; he has been generous, open-minded, and patient. Wendy Lesser has been supportive, and her editorial judgment has helped me to refine some of the material in the book. Over the years, in letters and conversation, I've discussed most of the questions raised in these essays with Richard Pevear. Our friendship has given shape to what I say here.

The following essays appeared in *The New Criterion:* "Modern Instances: The Macchiaioli," "Morandi of Bologna," "Killing Moonlight: The Futurists," "Out of Eden: On Alberto Giacometti," "Notes on Photography," and "Matisse's Broken Circle." The following essays first appeared in *Threepenny Review:* "The Americans," "Miscellany II," and the sections in "Other Americans" devoted to Julian Schnabel and the Starns. "Miscellany I" and the section on Gregory Gillespie in "Other Americans" first appeared in *Epoch;* that on Jerome Witkin first appeared in *Arts.* "Francis Bacon and the Fortunes of Poetry" was first published in *Pequod.* "Not a Beautiful Picture: On Robert Frank" first appeared in *Tri-Quarterly,* a publication of Northwestern University.

Introduction

In the Pinacoteca Nazionale of Bologna hangs a picture by the
trecento painter Vitale da Bologna of St. George slaying the
dragon. The hero, pitching forward out of his saddle, is practically
astride the monster, his lance staking it to the ground. The image
has tremendous energy. The pictorial space is congested with
coiled forces: as St. George heaves forward, throwing all his weight
behind the lance, the horse's long neck strains up and backward,
recoiling from the dragon's rearing head. The torque of human
effort to kill the menace, to stay that chaos, is at once triumphant
and agonized. Vitale died at the age of thirty-eight and left only a
small number of finished works (among them the lovely, demure
Madonna dei Denti in Bologna's Museo Davia-Bargellini and a small,
thickly dramatic *Crucifixion* in the Johnson Collection in Phila-
delphia) and several badly damaged frescoes. But of his various
works it's that familiar motif of the hero that I love most. What
always draws me in is the formal enactment of struggle, the paint-
erly agon, the push-pull relation among man, horse, and monster
that suggests a necessary bond or interdependency. But I'm also
drawn in by the mythic action: the hero, in a way familiar to us
from its manifestations in other cultures, violently brings to rest
the earth disturber, the chaos bringer. St. George, in rescuing the
town from the dragon's terrible tribute of young men and women,
commits the primordial act of foundation, staking the monster so
that civilization may stabilize its structures, its precarious orders. I
do not mean to say that I "read" Vitale's painting as an illustration
of mythic action. It is not illustrational, it is a configuration of
formal feeling inseparable from sacred consciousness, in this in-
stance Christian consciousness, which both sponsors and infuses
the image.

The theme of this book is the transfiguration of realist painting

into modern kinds of representational image making practiced by certain artists. My theme, that is, is the nature of formal feeling and its expression by artists who have clearly contended with what Cézanne called the impossibility of copying nature and translating sensation into image. I've tried also, in a few of these essays, to investigate the modern desire to make images expressive of a consciousness that is more and more notable for the absence of a traditional sustaining feeling for transcendence or sense of the sacred. My awareness of the dimensions of this question has been informed and intensified by the writings of the historian of religions Mircea Eliade, who defines the sacred as "the revelation of the real, an encounter with that which saves us by giving meaning to our existence." I did not, however, begin writing these essays with my themes already worked out. They revealed themselves to me along the way.

I visited Vitale's picture many times during a year I spent in Bologna in 1985 and 1986, and it was then that I began writing the pieces in this book. I was writing in detail about the plastic arts for the first time, and my impulse was not to argue a thesis or devise a historical or theoretical model for the modern period. I was not seeking definitiveness. I began with the need to answer to images that had for a long time insinuated themselves into my life or that were making claims on me for the first time. I wanted to make adequate formal response in language to those presences. What began, therefore, in 1986 as an effort to explain to myself why certain of Giorgio Morandi's paintings were at once a formal magnificence and a curtailed curiosity—"Morandi of Bologna" was the first thing I wrote—over the next four years led to a series of confrontations with artists whose achievements, for one reason or another, demanded some response. I was instinctively drawn to artists and issues that corresponded in some way to the life of poetry and to questions about poetry that mattered very much to me. Eventually, I explicitly addressed the relation between painting and poetry in "Francis Bacon and the Fortunes of Poetry," the second to last of the essays to get written. My responses clung usually to the armature of available occasions, major exhibitions in recent years of works by Giacometti, Morandi, Matisse, and others.

The more I wrote back at these artists, the more caught up I was

by the apparent dissolution toward the end of the nineteenth century of the intimacy an artist might have felt with the wholeness of physical reality, such that the work of certain artists became more and more an adventure not to recover something lost but to make that new field—an alien, increasingly denaturalized, self-conscious, desacralized space which yet bore afterimages of the now-fled gods—an element in which art could be made, images forged. Giacometti is the covering presence of this book because he has been so in my life, and because his art (and spoken remarks) were so sensitive to the new condition. In 1921, he tried without success to finish a simple female bust. "Before that," he later remarked, "I believed I saw things very clearly, I had a sort of intimacy with the whole, with the universe. Then suddenly it became alien." Even more than Matisse, who, irreligious as he was, admitted his desire to make over hedonist colorism into sacred decoration, Giacometti acted out more purely and economically the core myth of estrangement from a community of representational idioms with which many artists before the modern period felt more or less at one. That is, presumably they felt so, and it's that presumption that matters as the foundation of so much modern practice. My first preoccupation, therefore, is with the transfigurative form languages developed by certain artists, though along the way I've skirmished with a possible renewed understanding of the practical religious imagination in art and in poetry, one that might absorb the facts and the formal contingencies of our historical period and be at the same time sufficient architecture for the hive of modern consciousness. An understanding, that is, of the way images both express and mediate our relation to transcendence, even or especially when that relation is an antagonistic or negating one. In this, too, I've depended on Eliade's description of religious experience as "an experience of existence in its totality, which reveals to a man his own mode of being in the world."

The only thing missing from these essays is everything. No Braque, Balthus, or Derain; very little about Picasso, Cubism, or Surrealism. For a book concerned in part with transcendence in modern art, there's little about Van Gogh and Brancusi, and nothing at all about Chagall. This is mainly the result of the occasional

nature of these pieces. I've tried to compensate for this narrow and selective view by including two sections where I've gathered and arranged material from my notebooks. My intention in including the Miscellany sections is to build on and talk around ideas raised in the essays and to speak to artists and works that the determining occasions of the essays excluded. I really could not pursue my themes, for instance, without saying something about the first generation of Abstract Expressionists, but my only way of doing it was to situate in Miscellany II some observations on Rothko, Pollock, and others. And because I regard my work here more as contentious autobiographical advocacy than as disinterested systematizing, I've included bits about artists outside the modern period whose work has determined the way I look at modern art. Tintoretto, for instance, is for me the grandest and also the most exasperating of Renaissance painters, and he is the master I see most often *at large* in modern representation. My hope, in any event, is that the Miscellany entries will not seem whimsical or too much like intellectual debris.

The first three essays make this seem a book about Italian art, though three-fourths of the way through it must begin to seem a book about American art. These are the casualties of circumstance. Although it was the last written, the essay on the Macchiaioli appears first because, for all the dragonish unfamiliarity of many of those Tuscan painters, their struggles engaged formal issues which painters continued to deal with for decades, such as their struggle with the desire to melt the definitions of illustration and anecdote so that picture making could become more intensely and exclusively a form-finding process than realist painting would allow. Photography takes up a lot of space in this book for several reasons: it has been decisive in displacing the traditional sense of an adequate copy of nature; it is generally taken to be a primary art language; it reports moral quality more blatantly (and prolifically) than any other art form; and several of the painters I discuss late in the book, even while responding to classical painterly precedents, use or inflect the photographic image in their paintings. Photography is also so young that it still has an aura of bruised innocence— it's still anxiously making precedents for itself.

Modern Instances:
The Macchiaioli

IN 1903, SEVERAL YEARS BE-
fore his decisive involvement with F. T. Marinetti and Futurism,
Umberto Boccioni made a painting called *Roman Landscape* that
shows a cow grazing in a dense field of grass and wildflowers. The
field is a storm of sparky greens, mustards, reds, yellows. The con-
ventional solidities and illusionist depth of realist painting are
transfigured into the sheared allover textures of Monet and Pis-
sarro. It's the kind of impressionist scene Clement Greenberg de-
scribed as "decentralized, with a surface knit together of a multi-
plicity of identical and similar elements, [which] repeats itself
without strong variation from one end of the canvas to the other."
But the cow, high in the right corner, is affixed to that wiry, moiling
surface like boilerplate, alien to the presentation of the scene. It's
as if Boccioni were pressing an Italian emblem onto French tech-
nique, to nationalize it perhaps, but also to rehearse what had been
a crucial moment in Italian art. That cow, with its even textures
and inflections of light, is a Macchiaioli cow. For decades, oxen
and cows had been a salient motif for a group of painters in
Tuscany called the Macchiaioli, and no Italian painter at the turn of
the century could pretend to ignore their existence, though in the
making of modernist art their influence would be not nearly so de-
cisive as that of Impressionism. By the end of the century, the tech-
nique called *la macchia,* first developed in the late 1850s, had long
been the most familiar manner in Italian realist painting, though by
1900 most painters were forsaking it in favor of French techniques.
Boccioni painted no other picture like this one, and his own lurch-
ing career is like a speeded-up narrative of the attempts of Italian
artists to make a new way for themselves after the consolidations of
Italian realism. Within a few years he would be painting brooding,
Magnasco-esque pictures of the industrial outskirts of Milan, and
soon thereafter constructing paintings that were practically illustra-
tions of the futurist aesthetic program. Futurism itself was in part
a jumpy, urban revolt against the pastoral pieties of much Mac-
chiaioli painting. In 1903, at any rate, that cow commemorated a
stream of European painting which, however slight its influence in

7

shaping the major idioms of twentieth-century art, produced some exceptional painters and helped to create the matrix out of which those idioms emerged.

Most discussions of the Macchiaioli—the best in English are Norma Broude's comprehensive *The Macchiaioli* and the essays included in *The Macchiaioli: Painters of Italian Life, 1850–1900,* both of which I've drawn on heavily for my discussion—commence with an analysis of the word *macchia* and the historical, aesthetic meanings it encodes. In common usage a *macchia* is a stain, a blotch, a smear. Technically, a *macchia* is also a quickly executed color sketch. *Macchiare* means to apply color through direct observation of a subject; Vasari used the term to describe works by Giorgione and the aged Titian, who both "drew" with color directly on the canvas. The *macchia* therefore conveys immediacy, spontaneity, on-the-spot transcription loosened from the definitions of preliminary drawing and studio deliberations. The essence of *macchia* effect is the flashing expression of sensation, boldly and simply, with color stains. It has its place in the line of stylistic continuity that runs from Tintoretto's sketchy spectral musculatures to Caravaggio's and Goya's voluptuous draftsmanship with the brush, down to the fibrillating colorism of late Impressionism and the instinctualism of Action Painting. For the original Macchiaioli, perfecting their technique during the movement's peak years in the early 1860s, the *macchia* was also a structural instrument, a critical method for probing in a new way the action of light on objects. Telemaco Signorini, writing in 1874, long after he had repudiated the *macchia,* described it as nothing more than an exaggerated, violent chiaroscuro, which for him and other young painters was initially exciting because it replaced the thinned-out, feeble chiaroscuro of academic painting with a robust, frontal, and emotionally responsive colorism.

Although they reacted against academic convention—many of them, like Signorini, got their formal training at Florence's Accademia di Belle Arti—the Macchiaioli adapted to their own purposes the preparatory sketching *alla mezza-macchia* that they had learned at school, using flattened, aggressive contrasts and bulky solidities of color. They worked up this exercise into a master style

especially suited to the plein-air painting they favored. As a technique, that is to say as a process of representing a felt vision of reality, the *macchia* could interrogate the coincidences or interpenetrations of light and matter in a more dynamic way than was available to them in the example of Barbizon painting, which they all admired. They wanted, in other words, a more nervous, instantaneous answer to the nature they sought to copy. Diego Martelli, Degas's friend and an eloquent apologist for Macchiaioli art, described their intentions in these terms: "To be charmed by a tonality that nature presents, to translate it with color so that in this translation are reflected all the effects of nature herself and all of the sensations that the soul of the artist has experienced."

The landscape they painted most often was the Maremma, the coastal plains and scrubland southwest of Florence, legendary as a refuge for outlaws. One word for that kind of wooded area is *macchia: fare alla macchia* means "to hide out in the woods." A Tuscan word for outlaw is *macchiajuolo.* So when a sardonic reviewer in 1862 referred to the new painters who exhibited at Italy's 1861 National Exposition as *macchiajuoli,* the term fused the new style to social mischief. The title inevitably took on a political suggestiveness, since by the late 1850s Italy had entered into the Risorgimento, the rebellions, wars of liberation, geographical redefinitions, and political realignments that in 1870 culminated in unification and freedom from Austrian occupation. The *macchia* emerged as a national, or nationalist, style. The coincidence of the new painting and political change was so intense—some of the painters fought in the wars of unification, and the Caffè Michelangiolo in Florence, their favorite haunt, was a famous gathering place for activists—that one historian of the movement, Dario Durbé, insists that political engagement "was a matter of primary, almost existential importance for the Macchiaioli." I'm not qualified to judge the truth of that assertion, but I can say that the Risorgimento sentiment flaring in some *macchia* painting, and not only in the actual battle scenes painted by Giovanni Fattori and others, was a natural volatility of style, of the *macchia* itself, a supple technique for expressing the doubt, exuberance, rage, discouragement, and sullenness the artists felt during that difficult time. The *macchia* was, after all,

fleeting, undeliberate, almost improvisational in effect: a momen-
tarily arrested changefulness. In its finest expressions it was tech-
nical skirmishing raised to an imperious style: it absorbed accidents
of light, it thrived on expressive impatience, it delighted in the
thrill of formal uncertainty that was in some way infused with the
anxious political atmosphere of the time.

The development of the *macchia* in the 1860s, the presence of
Martelli and others conversant with both Italian and French art,
the careers of painters like Federico Zandomeneghi and Giovanni
Boldini who began as Macchiaioli but changed their styles while
living in Paris, all suggest some lively connection between the *mac-
chia* and Impressionism. The Macchiaioli are still sometimes re-
ferred to as Italian Impressionists. They remained separate enter-
prises, however, while unknowingly sharing one or two ambitions.
Macchiaioli painting developed as a form of realism in a more scru-
pulous and less adventurous fashion than the impressionistic real-
ism of Manet and Degas, but at the same time it investigated color
and volume in ways that bind it to the troubled agitations of
nineteenth-century representation. The occasional coincidences
are startling. Monet said that Ruskin's *Elements of Drawing,* pub-
lished in 1857 (and studied by the young Seurat), contained most of
the theory of impressionist painting because of its emphasis on the
need to paint what the eye actually sees, the reality which, in Rus-
kin's words, "presents itself to your eyes only as an arrangement of
patches of different colors variously shaded." That in fact describes
the Macchiaioli's method of representing objects in *macchie* of
color. They were in their own way seeking to recover what Ruskin
called the innocence of the eye, painting out of "a sort of childlike
perception of these flat stains of color," which were the composi-
tional elements of the world. The *macchia* was a means of copying
those elements, though its emphasis was on technique, on the man-
ner of applying paint. The Macchiaioli were not concerned, as were
the Impressionists, with the dynamics of perception, subjectivity,
and the self-aware drama of optics. They were more caught up in
painting as a recovery, not a remaking or remastering, of the real,
and this persuasion puts them on the other side of the mirror that
stands as the passage to modern painting.

The *macchia* is important to our understanding of modern representation because of its preservation, in the finished work, of the look of the plein-air sketch. Sharp contrasts and highlighting, fat light, patchy swabbed brushwork, these are the effects the Macchiaioli heightened in the studio, giving the provisional and indeterminate a finished look. Although very obviously an act of copying, of getting down the appearance of nature in a particular way, the *macchia* stopped short of fusing itself to the whole scenic matrix of the subject, as the plein-air painting of Monet and Pissarro did. Giovanni Fattori, the most prolific and complex of the Macchiaioli and a superb *all'aperto* painter, considered himself neither a neo-Barbizon chronicler of landscape nor a radical singularizer for whom an optical impression sufficed as an emotionally true copy of nature. For him the *technique* of copying nature was above all an act of witness keyed to registers of feeling. With that assumption he could not pursue the project that Greenberg attributes to Impressionism, that of pushing "the faithful representation of nature so far that representational painting was turned inside out." But in pushing painting toward an irreducibility of technique, he and other Macchiaioli contributed to the pressures exerted on representation, unaware that the definitive sketchiness they practiced would become in the new century a master style.

The Macchiaioli did not consider their sketches on panel and cardboard finished works; they entered in exhibitions only canvases completed in their studios. But the sketches are today among their most compelling works because we experience them as genetic material in the evolution of modern representation, particularly as they confer on momentary vision the value of the permanent and realized. The most exquisite of Macchiaioli paintings is Fattori's *Rotonda di Palmieri* (1866) in the Galleria d'Arte Moderna in the Palazzo Pitti (Plate 1). (With the museums in Livorno and Montecatini, the Pitti has the best collection of Macchiaioli painting in Italy.) Fattori's little (4¾ x 13¾ in.) oil sketch on wood shows seven women in long skirts and shawls under an awning by the sea. The depth is collapsed into a stack of high contrast colors banded across the surface: a yellowish canopy with a serrated edge laid on a strip of white sky, and under that a sloping purplish pro-

montory, blue water, and muted sunlight skirting a roseate olive-green ground. The figures are deployed at vertical levels, as if on risers; the four faces visible are color blanks. The effect is geological: anonymous, fossilized human shapes fixed in mineral strata. The sketchiness, along with the severe color solidities, mysteriously intensifies the stillness of the scene.

Although they were trained primarily as plein-air painters, the Macchiaioli ranged far and wide for their subjects. Feeling the excitement and pressures of the new medium of photography—the Alinari family, Italy's first important photographers, opened a studio in Florence in 1854—they applied the *macchia* to the task of recording the diverse textures of contemporary Italian life. They had the old and the new right there before them. Florence was a commercial and political center (and from 1865 to 1871 the nation's capital), its suburbs were being developed and industrialized, its countryside hosted ancient peasant cultures and middle-class villas. The responses of the Macchiaioli, particularly of the three preeminent artists Signorini, Silvestro Lega, and Fattori, were so distinct that even to speak of them as a group seems a historical convenience. Though we identify them as a solidarity, as they indeed sometimes identified themselves, they differed one from another as much as did Monet, Pissarro, and Sisley. And around the mid-1860s each began to paint in ways that, while less boldly asserting the *macchia* as a signature technique, absorbed *macchia* effects into the more expansive, acquisitive ambitions of realism. Eventually, the stress lines where realism tried to recover the material world began to fracture under the pressure of modern facts and feelings.

In 1860 Signorini produced many renderings of scenes in La Spezia. In one sketch on cardboard, *Fountain at La Spezia,* the liquid charcoal shape of the fountain is centered inside a blocky gray archway; the other scenic elements are similarly massed, subaqueous darks pitched against lights. That same year he made an oil study called *A Sunny Day at La Spezia* in which the volumes of light and shadow are constructed in patchy strokes; here, too, there is a theatrical space created by an archway, beneath which are grouped

several unarticulated figures. The next year, Signorini exhibited in Turin the finished picture from that sketch, but now the title was *The Ghetto of Venice,* and the massive street scene roughed out in the sketch has been articulated as a squalid, cramped passageway in Venice's ancient Jewish quarter. There was certainly some opportunism in Signorini's modifications; the Risorgimento preached religious tolerance and encouraged the breakup of the old ghettos, and Venice in 1861 was still under Austrian control. But just as crucial was his willfulness in adjusting and pushing *macchia* technique—in the finished work the figures crowding the mean passageway emerge in harsh, almost cruel, chiaroscuro—to investigate resistant, provocative subject matter. The Macchiaioli often went on outings together and painted the same subjects. One famous pair of paintings, by Signorini and Cristiano Banti, is titled *Children in Sunlight* (ca. 1860–62). Both are executed in conventional *macchia* style, and yet Signorini's version is much more agitated in its rhythms than Banti's rather stolid rendering. Signorini's displays an almost neurotic alertness to chiaroscuro as a register of feeling, and the handling has a raciness that is thrilling. Other artists practiced the *macchia* with captivating and often moving effect. Giuseppe Abbati, Vito d'Ancona, Vincenzo Cabianca, and Odoardo Borrani (all first-generation Macchiaioli and contemporaries of Signorini) produced many paintings that are, to me at least, more interesting than a lot of Barbizon painting. Abbati's 7-x-10-inch oil on cardboard sketch *Cloister* (1861), in the Pitti, is a miniaturist masterpiece. Blocks of white and olive-black stone lie in the sun. The paint seems to possess the weight and density of the light-laden stone and to sweat of its own materiality. For all his dazzling technique, however, Abbati was, like those others, defined entirely by the *macchia*. Signorini wanted something more. In attempting to make himself into a realist able to accommodate new visual facts, he made impatience with the *macchia* a vital quality of his technique.

Because it was defined and circumscribed by its effects, pure *macchia* painting was not driven by the passion of the encounter between the inquiring imagination and the material presence of its

subject. In 1862 Signorini repudiated the *macchia* in the interest of achieving what he called a better realism. He did not mean that he aspired to include more patriotic or polemical content—he had already painted in 1859 the much praised Risorgimento scene *The Tuscan Artillerymen at Montechiaro Greeted by the French Wounded at Solferino*—but wanted rather to paint modern instances. He did not unlearn or suppress *macchia* technique in pursuing his new subjects of rural labor, marketplaces, city streets, and institutions; in fact, the *macchia*'s pasty indefiniteness enabled him to paint so that the subject often seems to be coming into existence there on the ever more flattened picture plane. The consciousness revealed to us is not exercising bold moods of light and shadow as much as contending somehow with its subjects. The creation of an effect, which was properly the end of most *macchia* painting, was overtaken by an apprehending realism that on a few occasions brought Signorini close to the transfigurative realism of Degas, Cézanne, and the young Matisse.

Passing through Florence in 1875, where he had relatives and where he had worked on his picture of the Bellelli family some years earlier, Degas saw in Signorini's studio *The Ward of Madwomen at San Bonifazio in Florence* and liked it so much that he carried news of it back to his friends in Paris. Apart from the strangely vaulted but compressed spaces in the picture and the broken arrangement of figures in their space, Degas must also have admired the way the dozen or so women in grubby gowns, most of them sitting on a long bench against the left-hand wall, are each an invincible solitude. This is a social group, of sorts, where no evident relation exists among its members except a shared general devastation. Degas's figure groups, such as *The Bellelli Family* or the later scenes in business offices and milliners' shops, all have that extraordinary self-containment, or separateness, of individual figures participating in some society. The isolation of the women in Signorini's picture, however, is both symptom and intensifier of derangement, each pose an articulation of disorder: one woman lies on the floor clutching a table leg; another sits twisting head in hand like mortar and pestle; one shakes a fist at a vision only she can see;

another stands queenly in the middle of the floor, staring at a wall. The drab light admitted by high windows seeps into the figures; the dingy illumination burnishing the walls is in high contrast to the sulfurous dark of the inmate figures. The familiar sunniness and color solidities of the *macchia* are converted in this picture to a grander purpose: the sunniness is scoured, abraded, and the solidities are combed to a finer, intenser plasticity. The chiaroscuro is not chiefly effect, it is the affective response to an instance of chaos incarnate.

In subsequent years Signorini explored a variety of contemporary subjects. The dissonant tonalities of urban life attracted him, and he met them with a technical audacity his Macchiaioli experience had instilled in him. In *Leith,* the best known of the works produced during a trip to England and Scotland in 1881, he contracts perspective in such a way that the people on the street—window-shoppers, a policeman, highlanders, a woman pushing a pram—are spread out beneath the blazon of a Rob Roy whiskey advertisement painted on a wall. Social relations are being lived out beneath that great sign, with its reference to the Scottish hero and Scott's (then recent) retelling of his story, as if the language of commerce were a new, watchful, volcanic deity. The sign's checkered red letters have a Day-Glo intensity, and I don't know any other painting of the time that filled so much canvas space with the kind of aggressive commercial message that several decades later would become both subject and method of much Pop Art. In 1894 Signorini returned to the subject of imprisonment with *The Prison at Portoferraio,* which Broude in her book rightly proposes as a companion piece to the asylum picture. More than anything else Signorini did, this picture approaches the florid depthlessness of early modernist painting. Although the subject and volatile handling of *Prison* set it apart from the cooler landscapes and small-town scenes he was painting around that time (works like *View from the Sanctuary at Riomaggiore* and *Street Gossip in Riomaggiore*), they are all of a piece with Signorini's mature enterprise: not to render a subject in a style but to make style the expressive means of finding the true emotional pitch of a subject.

In *Prison* two files of prisoners recede from the foreground toward the rear of a long barred corridor. Centered between them, pitched high on the lifted, almost upended, picture plane, are two officials in dark suits and, behind them, two guards dressed in blue-white uniforms and pith helmets. The prisoners' figures shrink away into patchy, indeterminate faces and physiognomies; their flesh seems to melt inside the sketchy rumpled clothes. Each one is distinct, however, even the most ill-defined one in the high, "deep" surface, and yet all remain irresolute in the slouching drawing and the streaked *macchia* striping of their outfits. The two guards are lanterns that shed only a small pool of light over the dark-clad officials. Signorini blocks out the scene in a way that might lead to sentimental irony or ideological scheme. But he does not allow content to determine style—the Macchiaioli were given to a sometimes gluey pathos—or style to reduce content to a mannered pattern. Signorini presents degradation, authority, the uniformities common to the different stations or degrees of freedom, and the appearance of community jangled by the essential solitude of personality with the same impassioned clarity that he brought to his asylum picture, because he is painting *through* documentary contents to find an emotional veracity. Broude accurately defines the prison and madhouse pictures, along with the stunning brothel interior *Morning Toilette* (1898), as Signorini's "extraordinarily powerful essays into the realm of social realism." But the pictures nearly slip the definition because the archival verisimilitude and content dominance crucial to social realism are rattled by the formal doubt, visible in all these pictures, about the capacity of a realist form language to copy nature. Moreover, just as important as the social content are the emotions stirred in the artist by the actual forms as he works them toward realization of a vision of affliction, estrangement, and despair. In *Morning Toilette,* the prostitutes' skirts are edged with candied oranges and reds, like theatrical backlighting or margins of firelight, and Signorini so severely compresses the space in which the women and their visitors are arranged that the fictive depth, as in a late work of Degas's like *Fallen Jockey* (1896–98), is only faintly gestural, and we feel depth suddenly as a frontal, complex immediacy, a mortal presence. Here

and in his best work, again like Degas, Signorini crushed anecdote from the scene to achieve a concentrate of formal feeling.

As a young artist, Silvestro Lega studied in Florence with Luigi Massini, the leading exponent of purist painting, which looked back with admiration to the German Nazarenes' "primitive" treatment of Christian subjects and to the indigenous art of the Florentine quattrocento, especially to the crisp drawing and pious moods of Fra Angelico and Giotto. Lega was a textbook instance of an artist skilled in treating biblical and classical themes who, in the charged political and artistic climate of the late 1850s, converted to *macchia* realism. Broude writes that the military events of 1859, when allied Piedmontese and French forces finally expelled the Austrians from Lombardy, provided Lega and other painters with "a new and patriotic incentive for turning to real life for both thematic and visual inspiration." As Signorini was beginning to apply the *macchia* to a realism of denser content, Lega himself was saying that "a work which is not done from nature . . . cannot be good." Lega's best work took as its subject the domestic arrangements of women, especially in the serene country villas of the commercial middle class whose economic and social stability was being affected by the general unrest during the Risorgimento. During the 1860s Lega was a frequent guest at the Batelli estate at Piagentina in the Tuscan countryside, a haven for several first-generation Macchiaioli, and it was here that he painted many of his best works. (He had already executed in 1860 a series of military scenes that secured him a place among the politically restive artists of the Caffè Michelangiolo.) In the ritualized household activities of life at Piagentina memorialized in Lega's paintings, we do not see the formal restlessness so evident in Signorini's work. If the erotic force of Signorini's art is felt in his compulsive, enthusiastic, kneading response to material reality, the eros in Lega's is worked out in the way matter is illuminated. Of all the Macchiaioli, he is light's voluptuary. When he paints a woman by a window, staring out a chink in drawn sea green shutters, he lights the scene so that the sunshine filling that chink washes down the entire front of her demure figure. It's an image of curiosity summoned by its object, real or imag-

ined. The figure is claimed by that light, while the darkened interior is her sanctuary.

A trio of women making music at a piano by an open window; a trio of visitors greeted by a friend outside a villa; a betrothed couple strolling through fields followed closely by a chaperon and two small children; women sewing, giving lessons, posing for painters; middle-class women, serving women, peasant women—these were Lega's subjects during the 1860s and early 1870s, and they have an obvious historical value in documenting social relations that photography had already begun to record. What makes Lega's Piagentina work so interesting is his use of the *macchia* in deploying color planes and figures that suggest, but do not polemically determine, social arrangements. In *The Betrothed Couple* (1869), he distributes the five figures across the broad picture plane, but they occupy their own emotionally charged pictorial zones. The couple, arm-in-arm on the left, turn their faces close together, in shadow, protecting their intimacy; farther right, the chaperon holds the hand of a young girl who, standing with downcast eyes in the chaperon's shadow, is already bound to the social matrix that produced the *fidanzata;* and farther right, another girl, younger, under the chaperon's vigilant eye, stoops to pick flowers, suspended there between nature and culture. My description makes the picture sound more schematic than it is, however, for the chiaroscuro inflecting these simple relations is handled with such delicacy and strength that Lega's picture, rather than diagram social formations, represents the mysterious privacies of attention that social exigencies of any kind make necessary.

His most famous painting is *The Pergola* (1868), in the Brera (Plate 2). A serving girl is bringing coffee in late afternoon—the original title was *Dopo Pranzo* (After Lunch)—to a group of women. It's a country setting, and half the canvas space is occupied with tall grass, arable fields, and cypresses, as if to establish the picture's plein-air pedigree. As in his other figure groups, the critical relations in *The Pergola* are worked out in the refinements of chiaroscuro. The three women of the villa household are clustered inside the recess of the pergola on the left side of the canvas. To the right, across the vertical divider made by one of the arbor poles,

the servant approaches. They are seated, in shade; she is walking, the lowering sun at her back. Their shadows are confused with the stunted shadows of the latticework; hers spears across the ground, running nearly the entire width of the picture. Again my description makes the painting sound overdetermined; it does have a pictorial scheme, but it's not used to exercise social criticism. Lega was not interested in analyzing the social hierarchy or petty bourgeois habits of his very generous hosts. Nor are his pictures, as some writers have said, idealizations of villa life, of gentry culture then on the wane, though the generally sedate treatment of the subject in *The Pergola* at first gives it the appearance of a precious harmonious moment preserved. A great realist like Courbet, whose work was still not well known in Italy—Italian painters were generally ignorant, it seems, of the 1855 Pavillon du Réalisme—handled paint so that it bore a sense of instability, the instability of the concrete world whose material fastness and monumentality the painter sought to represent. A painting's materiality was itself bound up in its aspiration to copy the look of matter. For nearly a century thereafter the *effort* to represent a simple fact of nature became more and more a primary subject. Giacometti once remarked: "Cézanne discovered that it's impossible to copy nature. You can't do it. But one must try all the same. Try—like Cézanne—to translate one's sensation."

Lega was no disruptive interrogator of material reality like Courbet, and he was no radical destabilizer of forms like Cézanne, but in *The Pergola* he avoids the predetermined (and therefore sentimentalized) emotion dictated by the social "paradigm" the scene depicts. The picture is charged with a fragile and rather remote melancholy that makes it not so much an image of social exclusions as one of self-containments and privacies. The melancholy itself is ritualized. The idleness of the young women looks very much like torpor; the child in the group looks as listless as they, just as much resigned to a life of waiting. The serving girl is not set in opposition to them, but she is zoned apart in a concentration or resolve not visible in the others, though even this attitude seems wearied by habit. She dominates the composition in a sly way: though her figure is drawn no more prominently, and her isolation is neither hero-

ized nor made pathetic, the way her shadow dominates the picture and underscores the group makes her identity more subtly assertive. She is finally the only one who seems to possess an articulated personality.

Lega was a confirmed republican whose deathbed portrait of the fiery reformer Giuseppe Mazzini is a passionate elegy to the radical force in Risorgimento politics. He was sympathetic to the peasant class, and his paintings of peasant women were, in contrast to the maudlin renderings of other Macchiaioli, fairly realistic and disciplined. The Batelli family, whose hospitality was so crucial to his work, were themselves in financial straits after the failure of their publishing business, and the austere interiors featured in a number of Lega's Piagentina paintings are testimony to their decline in fortunes. His own stylistic redefinition from neo-purist to *macchia* realist coincided with social and political redefinitions that he was in a position to witness. His distinction is that he did not reduce these redefinitions to a programmatic technique—the natural simplicities of *macchia* effects lent themselves to the simplistic reduction of content—but instead flexed the *macchia* in order to express the mixed tones of his own experience. And light, its temperature, velocity, and tenacity, was the bearer of that delicate mix. In *The Pergola* the blanched paving stones behind the arbor seem to soak up all the saving grace of the midday shade and transmute it into a sluggish graywhite penumbra in which all the women are held.

We can see Lega and Signorini more sharply, perhaps, in contrast to a painter like Zandomeneghi, who trained at Venice's Accademia di Belle Arti in the late 1850s, was closely associated with the Macchiaioli, then went on to settle in Paris in 1874 and exhibit at the Impressionist shows there in the late 1870s and early 1880s. In his 1873 *Beggars on the Steps of the Convent of the Aracoeli,* a sexton is ladling out soup to the poor. Mothers and children are scattered around the steps. Each figure is so meticulously posed— one lifts a plate to her mouth, another spoon-feeds a child, another scoops the last drops from a tilted cup—that the moral tension of the scene is dissipated in the overripe poignance of the details. The scene is purposive with a vengeance and is sentimental because it

allows no competing response to that of sheer pity—sentimentality in art is moral tyranny—and, in formal terms, seals off the event in the righteousness of anecdote. The bad social condition is not discovered in the formal inflections and interrogations of the artist, it is *deposited* there. In this instance, the *macchia* does not draw realism into its proper auroral wakefulness; it numbs all alertness to possibility in the interest of correctly plaintive sentiment. This sort of emotional claustrophobia was not uncommon among the lesser Macchiaioli, and by contrast Lega's use of the *macchia* opened anecdotal realist space to more complex, ambiguous, and unplanned feelings.

Of the hundreds of paintings of women the Macchiaioli produced, only a few were nudes, and these were mostly by Vito d'Ancona. An 1873 nude by him in the Museo d'Arte Moderna in Milan shows some of the residual excitement of the classic *macchia* in its phasing of shadow over the body and bed sheets, but the pose and handling of flesh tones are academic and derivative of Ingres. The Macchiaioli painted images of chagrined or coquettish modesty with sympathetic gusto, but elemental flesh—flesh as vulnerable, changeful, conscious but thoughtless materiality, host of desire, myth, dream—did not interest them as much as the body defined by custom and circumstance. They wanted to represent destiny by fixing human presence in circumstantial contexts, in the somber chamber interludes of villa life, the toil of field-workers or brush gatherers or charcoal burners, and the tumult of herders driving sheep or cattle to market. All this reflected in part the Risorgimento passion for national destiny, but it also spoke for the Macchiaioli's intent to document the organizations of contemporary life. And contemporary life, as I've said, included peasant cultures recognizable from the *Georgics*. One of Italian realism's great ambitions was to establish the ancient and modern as part of the same material continuum. The debasement of realism was the reduction of subject matter to the pathos of local color or to formal nicety. Cristiano Banti's paintings of peasant life, for instance, exemplify the many softened, tame reports produced by *macchia* realists in the late nineteenth century. Banti lights his scenes for brooding pastoral effect. His countrywomen are posed for their noble weari-

ness, not wretched fatigue. In Odoardo Borrani's 1880 painting *The Stonebreaker* all the exertion of hard labor has been refined out of the portrayal; the laborer looks like a large playful child smashing stones with a mallet. These later artists drew on the example of Courbet and Millet, but they lacked the gravity and violence of the French painters. And one seldom feels in *macchia* realism the material resistance of paint which in Courbet makes his own activity a complicit heroic action. The lesser Macchiaioli were content to represent reality as mood, not as material fatefulness or sensationalist encounter.

The Macchiaiolo who steadfastly refused the seductions of mood and local color was Giovanni Fattori. Around 1866, when he painted the *Rotonda di Palmieri,* he produced two related panels, *Woman Outdoors* and *Woman in Sunlight,* both featuring a woman with a parasol. The *macchia*'s sketchy simplicity of means is put to splendidly rough, half-definitive effect. The stressed, pulpy colors of *Woman Outdoors* mineralize the light. In *Woman in Sunlight* the color is so thinned out that it looks drizzly, scored through by the textures of the support. The handling of color volumes in these little pieces reveals an imagination that feels the obduracy and evanescence of material being as one story. The most prolific of the Macchiaioli, Fattori was also the most outspoken in declaring himself a realist. In 1903, after a career that covered an amazing variety of subjects—military episodes, portraits, seascapes and landscapes, interiors, life among herders, peasants, and the merchant middle class—he described realism as "the accurate study of contemporary society" with the intention "to reveal the evils with which [society] is afflicted . . . [and] to convey to posterity our customs and habits." His genius was a compound of the fleet light-registering impulses of the *macchia* and a socially responsive archival realism. Inevitably, especially in the large military paintings, his pictures so scrupulously preserved historical anecdote that they sometimes remained formally inert or mechanical. But in his best work, when that compound is realized, he created pictorial space not by copying and miniaturizing depth and volume but by laying these across the picture plane in a way that folded contents in strange, almost

irreal ways. Curiously, it's in the military scenes where this some-
times happens most powerfully. The soldiers whose backs are
turned toward us in *French Soldiers of '59* are anonymous pictorial
legends; moment to moment the figures shed their representational
force and are only beautiful blots of impacted paint. In the large,
busy canvas *The Wounded Prince Amadeo* (1870), outside the clus-
ter of worried attention shown by officers toward their wounded
leader, three foot soldiers lie dead, cordoned off by a row of trees
that mark the margin of life, a circle drawn around the dead nature
of those ignored fallen soldiers. Space in these pictures is a critical
bearer of feeling, contracted or distended right to the threshold of
modernist space, that theatrical setting for the self-aware manipula-
tions of perception and sensation. I don't mean to suggest that Fat-
tori precipitated the crisis in representation formulated by Cézanne
and Giacometti, but his art, in service to realist scruples, contrib-
uted unmistakably to the dissolution of conventional realist volume
and space. At the same time, he did not go so far as the Impression-
ists and turn representation inside out. I think Fattori's assertions
late in life were so bitterly put because he sensed he was at the end
of something. In 1891 he attacked what he felt to be the sterility of
divisionist painting. In 1902, still living in genteel poverty despite
his great local fame, Fattori gave lessons in life drawing in Flor-
ence, where one of his most gifted students was Modigliani, who a
few years later took off for Paris.

Of all the military paintings, *Man Caught in a Stirrup* (1880–82)
is the most disturbing and technically robust. A lifeless soldier
is being dragged face down behind his spooked horse. Fattori
buckles the depth of the scene so radically that the horse, galloping
up a road away from us, seems pitched beyond and above the sol-
dier. First we see the soldier; his spread arms pull our attention to
the long clawed tracks his hands have cut in the dirt; then we take
in the horse, a dark ganglion of force. Because of the severely con-
tracted space, the beast seems to be plunging into the canvas, as if
sucked back into the vortex of the imaginary perspective point.
The elements Fattori marshals to create this gruesome pictorial
torque—the runaway violence, the useless restraining gesture of
the dead cavalryman, the road that has the felt allegorical presence

of the ground of existence—all are *displayed* across the canvas with a mysteriously poised, almost decorative, suspension.

Fattori enjoyed the turbulence of life among cowboys and herdsmen in the Maremma, and he loved to paint the cast of light on animals, especially the pleats and creases of shadow on white oxen. The markets and cattle drives challenged him to dissipate centers of action and try new organizations of spatial relations. His *Market at San Godenzo* (1882) spreads riders, horses, oxen, country wives, and traders over a wooded hillside (or *macchia*). There's no core drama. The pictorial energy is distributed across numerous uneventful groupings and episodes that characterize a familiar cultural scene. It's good documentation, as Fattori believed realist painting should be, without the sentimental determinism of local color. In other instances, the documentarian impulse gets so confounded with his desire to push paint around on a surface that we can see the bounds of representation being tested. In the late *Peasant Houses* (1890–1900) the tumbledown stone structures are built of wobbly *macchie* of color; there's firewood heaped under a shed; sketched into the lower right corner is a woman whose pinched shoulders memorialize a life of repetitive labor. As in other pieces in which the act of labor is fused to his own formal ambitions, Fattori's feelings here are blended into the act of witness he thinks he is performing. Sometime in the 1870s he did a picture of a stonebreaker. If Courbet's famous lost painting represents not so much people working as the activity of work itself, Fattori's renders the shape of toil as the *travailles* of light on matter—the stonebreaker himself looks like the product of work, color patches cobbled together. In another piece from that period, *Fishermen Mending Nets* (ca. 1872), the men sitting at their work are unrecognizable, backs turned toward us. In the high right corner, shelved on the upended plane of the quay, a small unrigged ship sits on a blue band of sea. The only elements stirring in this static, almost decorative, arrangement are the grayish nets spread under the menders. They stream and crest with a memory of the sea, as if only the stolid menders' work were weight enough to hold them down.

In moving toward my own understanding and evaluation of Macchiaioli art, my guide star from another constellation has been

Degas. Their differences notwithstanding—the Macchiaioli, for instance, never drifted far from their plein-airist origins, whereas Degas was the supreme urban artist, fascinated not only by commercial life but also by culture institutions like opera, ballet, and theater—they and he felt compelled to get down the facts of their time and place, and they experimented with color volumes to represent material reality. Degas was the greatest of them because he brought to a higher, more daring resolution the possibilities of color, investigated more completely the sensations stirred by concrete images, concrete facts, and was passionate enough to question and dismantle his own resolutions. In *Fallen Jockey,* the spectral and material, the purely formalist and the realistic, come together in an image that is extremely unsettling because the drama of fused, collapsing plastic forms lived out by the artist on that surface is one with the picture's simple representation of accident and mortality. While the Macchiaioli were good draftsmen and often superb colorists, with only a few exceptions they did not kick loose the scaffolding of conventionally affecting social representation. And none of them, not even Fattori, had the almost deranged willfulness of imagination that could result in things like Degas's late pastel and charcoal bathers or his *essence* sketches of ballerinas, which are *about* the effort to coax form from oblivion, to show the protogenetic form life of blankness. In Degas's work there is often a cruelty, or at least a chilled, calculated disinterest, inseparable from moral curiosity, from image-making desire. This quality, like the coldness and "arrogant purpose" Greenberg attributed to Matisse, is surely one determining characteristic of modernist representation. Matisse certainly, but also Picasso and Giacometti, and even less turbulent artists like Balthus and Morandi, all possessed a devouring regard for subject matter and formal willfulness that none of the Macchiaioli could sustain for very long. As realists, the Macchiaioli did not so much consume their subjects as they shepherded and preserved them. Their formal response was not, as a rule, contentious and disputative and interrogatory. It was grounded in receptivity, accommodation, protectiveness, not in auroral vulnerability and appetite. If we can speak of Degas's love for his subjects, it was of a kind that challenged him to transfigure them, to give

them over entirely into the exile of image life. This extremity of love, hardly distinguishable from rage, the Macchiaioli did not possess with any such intensity.

The limitations and importance of *macchia* realism, set against the achievements of Degas (or, for that matter, Cézanne, whose career developed contemporaneously with Signorini's and Fattori's) are apparent in some of Fattori's portraits. His *Portrait of My Stepdaughter* (1899: the same year Degas did the pastel *Nude Woman Combing Her Hair* in the Metropolitan and Cézanne painted the Museum of Modern Art's *Boy in a Red Waistcoat*) shows a deft handling of color. The tonal range is austere: black hair, eyes, earrings, velvet choker, bracelet, and rings draw our attention top to bottom, interrupting the fluid ivory fields of the woman's dress and flesh. A small red globe on a Japanese fan in her hand is the one titillation amid all that pristine candor. In her expression Fattori preserves a blend of youthful dreaminess and patient regard for the act of portraiture. She is coyly aware of her role and evidently uninterested in it. Fattori seems intent on characterizing the familial and professional relation. A few years later Cézanne would tell visitors that in portraiture the hardest but most important thing to paint was the *distance* between himself and the sitter. His words reveal a significant difference between late Italian realism and modernist representation. Fattori gives those quivering fields of fabric and skin a startling presence, so that we feel not only the little drama of circumstance but also the force of incarnation. He does not challenge the imaging of incarnation as Degas and Cézanne were already doing. That same year, 1889, he painted a charming portrait of his wife in which the suggestion of beguiled incredulity about the act of portraiture is almost wickedly expressed in the woman's toothy half-grin. Fattori releases into the picture a quality of relation that preceded and will presumably continue beyond it. The determinant forces in both pictures are anecdotal affections, not the compulsions of "research." For all their fine execution and insinuating feelings, they do not bear any trace of the transfigurative enthusiasm that was already becoming an actual part of the new representationalism. Cézanne, and soon Picasso and

Matisse, were to look for a different god in nature, a god revealed in images of disincarnation.

There was an enormous quantity of Macchiaioli painting produced from 1855 to 1900. If you look at enough of the work, you begin to feel in much of it a conventionalized diffidence. At its most banal it announces the self-satisfied suggestiveness and atrophied curiosity which are the signs of provincial art. After viewing several rooms in the Pitti stuffed with similarly achieved effects— the scenes of peasant life, especially the softened renderings of peasant women, are particularly cloying—most of us will have seen enough. Signorini, Lega, and Fattori are important first of all because they painted more than a few exceptional pictures. But they also, more than other Macchiaioli, urged realist painting beyond the provincial circumspections of the *macchia*. And incidentally, their work helps us to see more clearly the career of modern Italian painting, not only the speedy self-exaltations of Futurism, which turned violently against the cultivated modesties and "nice" Italy of much Macchiaioli painting, but also the monastic rigor and obsessive modesties of Giorgio Morandi.

Morandi of Bologna

W̲HEN AN ACQUAINTANCE OF
mine who had been raised in the Italian countryside first came to
live in Bologna, the city seemed to him a dreary labyrinth. He ar-
rived in the abbreviated days of winter when the Apennine chill
and Po Valley fog press a steel lid on the town for weeks. The
streets throughout the historical center are lined with porticoes,
and to my friend the citizens coursing up and down the gloomy
arcades were mysterious bolts of shadow scrambling for constant
shelter. William Dean Howells detested Bologna for that reason:
the *portici* make the sidewalks "a continuous cellarway; your view
of the street is constantly interrupted by the heavy brick pillars that
support the arches." The entire city, he says in *Italian Journeys,* is
"dull, blind, and comfortless." Howells, like many visitors to Italy,
was too intent on the picturesque, the ample and immediately self-
disclosing view of things, to see the natural history of a town,
which is always a more private, withheld matter. If you are content
with the short view, with the chopped and interrupted picturesque,
the porticoes of Bologna can be elegantly spectral. The pillars and
arches are each palazzo's structural signature. And you can track
the seasons by the shifting blinds and ladders of light fanning out
on the pavement like primitive time-telling devices, though the gal-
leried view often bends out of sight in the near distance. Off the
broader, fashionable main avenues, the dimensions change; the
passageways become narrow square chutes, the pavement rolls and
swells, the pillars are squat, the ceilings stooped, and the shops are
mineral recesses with dusty illumination.

The shops on Via Fondazza, a narrow street connecting two main
thoroughfares, are considerably smaller than the average American
garage. There is a cobbler whose display space accommodates one
small table with one shoe on it; there is a one-chair barbershop,
and in the window of a shop that sells water heaters brass elbow
joints are spread like jewels. The houses are painted in familiar
Bolognese reds, oranges, and yellows—powdery textures so finely
distinct that they imitate the alarming minor changes of tint in
dreams. Via Fondazza is where Giorgio Morandi had his famous

dusty studio for most of his working life. The bunched columns and chopped towers of his still lifes, their "low ceiling," and the fibrous granular textures of his palette may not be directly modeled on Bologna's characteristics, but anyone who spends enough time there will recognize and perhaps better understand Morandi's form language, seeing in it the larval shadows of this unique cityscape. The Bolognesi are justly famous for their cordiality and outgoingness, but the look of their city is recondite, rounded back on itself, reticent, self-returning.

There are many legends and misconceptions about Morandi, the chief one being that he was a studio hermit who, working for several decades in a historical vacuum, teaching etching at a local university, imitated his own forms endlessly but brilliantly. The large show mounted recently by Bologna's Galleria d'Arte Moderna, Morandi and His Time,* was meant to destroy these assumptions and to position Morandi in the historical matrix of his time. His international reputation is certainly secure, but the historical criteria of that reputation remained to be convincingly articulated. The praise that greeted the retrospective at the Guggenheim in 1981 was, in too large a part, the exuberance of belated discovery rather than analytical reappraisal. Such reappraisal was the declared purpose of the Bologna show. The argument set forth in the arrangement of works (219 on display, 116 by Morandi) and developed in the catalogue is that Morandi's career is neither a regional isolated phenomenon nor an eccentric twentieth-century "case." He was instead, the show argues, implicated at every stage of his development in the redefinition of formal values in painting that was taking place in Western Europe. To chronicle and document Morandi's passage through the currents of his time, the show includes work by others selected to illustrate and endorse the argument. The problem with this strategy is that some of those selections turn out to be live grenades that practically explode the argument they are meant to prove.

The show is arranged in sections, each a historical or stylistic designation. The early stages—each room has its designated theme:

* November 9, 1985–February 10, 1986.

"Predecessors," "Formative Years: The International Context," "The Beginnings"—establish the formal matrix of what would become Morandi's most frequent subject, the still life. There are two Cézanne still lifes, *Still Life with Ginger Jar, Sugar Bowl, and Apples* (1890–94) and *The Blue Vase* (1886–87), which announce the early modernist formal values by which Morandi's practice might be better understood. Morandi took Cézanne as his first modern master, though he did not see much of the actual work until 1915, when he went to the Second Secession Exposition in Rome where some of Cézanne's watercolors were being shown. (He had already seen some canvases by Renoir and Monet in 1910 and 1911; for the rest, most of his familiarity with early modern French painting seems to have come from books.) The manner of presentation in the Cézanne paintings is, as usual, that of an object offering. The table, or platform, tilts toward us; the forms of fruit, dish, and vase are ritual presentations, self-disclosures. The objects are not in repose; they press themselves forward, ingenuously disposed, at once defiant and inviting. Juxtaposed to the two Cézannes is a still life by Braque dated 1916 (Morandi was then twenty-six). Even with its edited, reshuffled figures—pipe, glass, table cover—the canvas remains a field of offering, and the cubist self-consciousness of rearranged reality offers itself as part of the presentation. Likewise, in Cézanne's still lifes the canvas is a field that discloses the actual *activity* of the form-making imagination, not only the products of it. In neither artist is there any hint of monumentality (except, in Braque's case, to mock it, perhaps) or of the contrived statuesque.

The early Morandi oils on display, from 1905 to 1913, show the influence of Monet's thick, analytical brushwork, the color pushed to dissolve the definitions of the subject—flowers, landscape, snowstorm. The youthful exuberance in these paintings argues against the confinements of the frame, but this enthusiasm will be replaced later on by rigor once the full influence of the predecessors has been absorbed. Along with Morandi's early works are two still lifes by his contemporary Giacomo Vespignani, which have the same violent energy pushing against the frame that Morandi's early landscapes possess. Vespignani is also the subject of a portrait by Osvaldo Licini that appears close by one of Morandi's own early

female portraits. (Of the more than 1,350 paintings he did in his lifetime, only 9 are portraits, and of these, 7 are self-portraits.) The pinched, mechanical, heavily painted surface of the Morandi looks unintentionally primitive and embarrassed next to the Licini portrait, in which the forms are carved from paint, coaxed into a figure that seems tentative and romantically dissolute next to the overdetermined classicism of Morandi's portrait. Seen in the context of Cézanne's energetic maturity, Braque's witty experiments, and the nervous vitalism of his more conspicuous Italian contemporaries, Morandi's early explorations seem almost shy and becalmed. There is a deflective wariness in his work that at first glance seems like mere formal reserve.

The poster for the show reproduces a still life from 1918. It is both an unlikely and purposive choice, since that was the period of Morandi's brief involvement with *la metafisica* and his connection with *Valori plastici,* the so-called "return to order" magazine. Giorgio de Chirico was, of course, along with his brother Alberto Savinio, the exemplary metaphysical painter, treating ordinary reality under a visionary aspect. Everyday objects took on a spectral aloofness, angular and shadowy, full of promise or menace and vaguely haunted by mythic presences. These are the qualities that caused French critics to describe de Chirico's style as metaphysical before he left Paris for Italy in 1915. A few years later the magazine *Valori plastici* was founded in Rome by Mario Broglio, who would become Morandi's first champion and major collector. To translate its title "Plastic Values" does not convey the fairly reactionary quality, the "return to order" rigor, of the magazine's presentations; maybe "Formal Values" is the closest we can come to its emphasis on a modernist assertion of classical norms. It was international in character and became the first forum for ideas put forth by Savinio, Carlo Carrà (who stressed "an orientation toward tradition," though earlier he had been a Futurist), Filippo de Pisis, and de Chirico. Its second issue was devoted to Cubism. It did not publish the Futurists. Although Morandi declined to write for the magazine, his work was generously reproduced in its pages, and Broglio sponsored exhibitions of his work. Generally, *Valori plastici* stressed the importance of looking back to the Italian tradition

for instruction and inspiration. What most concerned de Chirico and Savinio was what they called the "spectral aspect" of the subject. Savinio coined the term *spectrality* to describe the purpose of metaphysical painting: spectrality was "the true, substantial, and spiritual essence of every appearance. To reproduce this essence in its complete genuineness is the greatest aim of art." Morandi's pursuit of the haunted object, and of still life as meditative occasion, was grounded in the arguments made in Broglio's magazine.

The poster image, at any rate, immediately establishes the cross-reference to de Chirico while also suggesting the formal rigor that remained with Morandi throughout his career. The image's colors are sand, buff, and dark brown; the standing objects are a bottle, a box, and a milliner's dummy, disposed in an attitude of military alertness. Morandi's famous organization of standing objects is already apparent but shaped by the historical definitions of his time. Another painting in this mode shows a big box with foldaway vertical planes that echo the box sides, forms gravely mocking forms. Up to this point, the show's argument is persuasive, but we can also read these earlier paintings as indications not of what Morandi was absorbing but of what he was choosing to exclude. The pictorial influence of *la metafisica*—its hard shadows, depopulated spaces, interrupted dream narratives—passes quickly, as if Morandi were merely trying out a manner. For in less than two years he begins painting the studio objects that would occupy him for the rest of his life, and the famous Morandi dust begins to settle on the view the canvas discloses. The hermeticism of subject that *la metafisica* favored soon gives way to a hermetic exploration of formal values. Even his early work, however, suggests that, for Morandi, the making of forms was a stay against some darkness, that all around the exposed platform were shadows held in check, barely, lest they consume and dissolve the articulation of objects that momentarily hold the light. I don't mean to suggest that some kind of Manichean melodrama is being worked out in Morandi's paintings. It is not a theological contest but a formal one in which the mind struggles to cope with, and *measure,* the forms it produces. Were it not for this contest, Morandi's work would be imperturbably monumental (as in fact it sometimes becomes). The monumentality

is in part a hedgehog reflex, self-protective and self-declarative. After the brief encounter with *la metafisica* and *Valori plastici* Morandi commences the crucial and definitive formal adjustments: the ceiling in the paintings gets lower; the field of objects is purged of suggestive whimsy; the arrangement of objects ceases to imply proliferation or abundance; the frame becomes a hermetic seal. He becomes the painter described by the brittle intellectual Steiner in Fellini's *La dolce vita,* the Morandi whose art "leaves nothing to chance."

He begins to push into the major style rather early, in 1920. In a still life of that year four equidistant objects—lime, cylinder, tubby narrow-neck bottle, small, tipped-over bowl—are spread across the platform colored a recognizable Bolognese reddish brown (Plate 3). The platform's rear edge, the horizon, is almost suffocatingly foreshortened. None of the objects, not even the bowl with its open white mouth, is presented as ritualized offering. The space between the objects is tenuous, something risked. Ash seems to have settled on the entire scene. The painting is both annunciatory and concealing. The subsequent years of Morandi's long career—he died in 1964—dramatized the closing and calibrated measures of those spaces, an increased huddled protectiveness, a diminishing faith in space as a field of disclosure but an abundant curiosity about the tense, rigorous modulations of restraint. From 1920 on, much of his imagination would be devoted to the infinite redefinitions in tint and texture of the scrim that often veils the scene he paints, the "second screen" of his art.

In the 1920s and 1930s Morandi began the long methodical testing of boundaries and trying out of his vocabulary of forms, conducted in the famous processional style. Nearly everything in the many still lifes produced in these years is upright. The background darkens. The tense, sober composition suggests enthusiasm forcefully held in check. The drama of color and brushstroke is deliberate, reserved, paid out in small sums. Even when the familiar bottles and lamps are pink, hazy blue, or sky green, the formal discipline infuses a weightedness into those buoyant colors. And there is now that constant Morandi scrim. A filter or mute has been locked on

the light source, so that every work is a kind of double canvas: first the field of objects on their platform, and then the screen that chafes or powders or scorches the light before it arrives to illuminate the field. Looking at the two dozen paintings from this period included in the show, I became more aware not only of the increasing density of color and variety of form in Morandi's art, but also, more important, that these have been *allowed* into the painting. The drama of still life presentation thus becomes in large part the assertion of denial, or exclusiveness, encoded into the normally expansive attention of formal curiosity. The paint is still thick, even a little raw, and its energy strains against a subtle diffidence that would thin out or repress that energy. In one of his many flower paintings, a 1924 *Flowers,* orange blooms rise tall out of a blue-gray vase against a violent yellow background. The shapes are rather tentative, as if Morandi has not quite decided just how vital they ought to appear. That tentativeness and the general reserve characteristic of his mature style are exaggerated by contrast with another Licini piece, a still life from 1926, in which a plate of what looks like spinach is a skein of frenzied yellow-black ribbons of paint, and an orange is drawn so tensely that it seems about to explode. Set alongside Morandi's measured deliberations, Licini's vitalism seems a hysteria of forms.

The great painting of those years is a 1935 still life with cans, funnels, and coffeepots spread on a wide platform (Plate 4). The objects are almost devoured by their background, a rose-tinted creamy mud that rhymes closely with the objects' colors. Even the platform, tilted slightly forward, seems fused to the background. The figure outlines in this alluvial landscape (or studioscape) measure and mark the frontier that prevents form from resolving into the oblivion of its ground. It is a terrifyingly beautiful painting in which Morandi's struggles with imaginative form are played out with impassioned, almost self-destructive, energy. Exhibited in the same gallery, however, are four pictures from 1935 to 1941, all with the same oil lamp and bottles, obviously the curators' attempt to demonstrate the variety of Morandi's formal vocabulary even when using identical objects in practically identical arrangements. But in the presence of that other work, these four are prefigurations of the

rather mannered stateliness that by the mid-forties would become a
familiar signature of Morandi's work. Too constant a return to fa-
miliar models familiarly expressed can soak up an artist's curiosity
about the very forms that presumably ought to vex him into new
assertions, new variations. This, for me, was the profound inhibi-
tion in a good deal of Morandi's work, and it becomes more evi-
dent as the style becomes more masterful. In that 1935 "mud paint-
ing," Morandi was more obviously caught up in a problem that
throughout his career would make good trouble and be a counter-
force to "masterly" executions. The frontier or membrane that de-
fines each object in that painting against its primogenetic ground is
clearly under stress. The stability of forms (which is to say, reality
differentiated) is a condition *won,* arrived at after trouble; it is not a
predetermined value or formal assumption. And the claims exerted
by the ground, the original mass out of which the forms have been
worked and stilled, are yet powerful enough to suck those forms
back into the molten, undifferentiated state that stifles and contests
emergence of any sort. For decades Morandi painted the same fig-
ures, and he held perhaps too strictly to the studio conventions he
had developed in those secluded years on Via Fondazza, but the
real *matter* of his career was the struggle with differentiation and
emergence.

By the early fifties Morandi's palette had lightened, but the ceiling
is even lower (without, however, pressurizing the interior space),
and it becomes more difficult than before to read a history of sen-
sibility in the paintings as we can in those of figurative artists like
Francis Bacon and Zoran Music, both of whom have very special-
ized form vocabularies but whose work, to use one of Bacon's fa-
vorite phrases, comes more immediately off their nervous systems.
With the brighter, hazier tones of the late forties and early fifties
also come a deeper reticence and hiddenness, as if Morandi were
becoming a prisoner of his own highly developed studio values.
Such a judgment gets easily confused with the legend of Via Fon-
dazza: the silent, solitary recluse, who pursued his own way, un-
distracted by trends and "isms." The Bologna show's catalogue,
like the one for the Guggenheim show, corrects a lot of this and
documents Morandi's frequent contact with local colleagues, his

attendance at shows of his own and others' work, and his acquain-
tances among Bologna's literary personalities. Some legends,
though, are grounded in fact: for a long time he did sell all his
paintings for the same price, so they were bought up quickly, on
the cheap, and consequently (so they say) every other household in
Bologna has a Morandi on its walls.

The larger question, and really the only one that finally matters, is
that of the hermetic quality of his art. Morandi's real solitude lay in
his strait, intense dedication to perfecting a narrow range of forms
in constant variations of arrangement, tone, and texture. Early in
his career, after the experiments with *la metafisica,* he limited and
sealed off the view—whether still life or landscape—and concen-
trated on the elected forms. He effectively cut down to nearly mar-
ginal dimensions the fields of forms within which his curiosity
could passionately engage itself. An artist like Zoran Music, whose
big retrospective in Venice contemporaneous with the Morandi
show was more revealing and suggestive in its arguments, also
worked countless variations of his Dalmatian scenes. Within these,
however, are various subjects and manifold forms: landscapes,
horses, peasants, gypsies, pastures, ferryboats. And he has other
subjects that allow obsessive, serial treatment: the Venice paint-
ings; the extermination camp series, *Non siamo gli ultimi;* the ex-
traordinary atelier paintings in which the artist is portrayed as a
minuscule figure before an enormous empty canvas, staring at his
model across an oceanic stone-gray waste. One sees Music's vo-
cabulary developing, expanding, pounding at its own limits, his cu-
riosity exercising itself in such a formalized way that the very ex-
ploration becomes a kind of subliminal subject. Morandi chose a
much less inclusive (though, some would argue, more exacting)
course and over the years was able to perfect that modest, remote,
always vaguely self-replicating majesty of forms. What makes Mo-
randi a difficult and troubling artist is that decisiveness. In the
work of the fifties, the ordinary pleasures of an artist practicing all
his powers are there in abundance. Morandi was a colorist of ex-
traordinary nuance: the phasing of the scrim, the refined densities
of tint, the subtly graduated pressures exerted by ceiling and plat-

form—all are achieved with remarkable precision. But if one inten-
sifier of pleasure is difficulty, that is, the uneasy and vexed delight
we feel before some of Cézanne's late watercolors with their empty
white patches, or Bacon's smeared figures, where the life of forms
is challenged just when it is most confidently resolved—that is not
one of the primary pleasures Morandi offers, though that tension is
not entirely absent.

His rapturously self-enclosing career is most aggressively dis-
played in a group of smallish canvases constellated on one wall—
still lifes and one landscape, all dating from the fifties—which
compose an imagination's universe of forms. It is, however, a plan-
etarium view. The paintings are so coherent that they harmonize
too availably one with another; their conversation is subdued and
well mannered. Within this voluptuously sober vision, however, is
that troubling element I mentioned earlier (visible only close up
and hardly at all in reproductions since it is so much in the life of
the paint) that suggests an earnest dissonance: the figures—all
those familiar cans, vases, and turreted pots—oscillate, their metal
skins quivering slightly, rubbery, almost liquified. The limits of so-
lidity are being tested. In previous decades, the drawing in Mo-
randi's canvases was generally more definitive, a stronger, less sup-
ple harness on the energy of forms. In the paintings of the fifties,
the containment of matter's chaos in those figures is more fragile
and uncertain. And the figures themselves are not planted on the
platform as in the earlier work; they balance, afloat on the nearly
molten stuff of the table, in a state of imminent dissolution.

This is not to say that Morandi returned to the drama of the
mud painting, but rather that within the cloister of his studio the
very mastery of the familiar generated an uneasiness and discon-
tent. The real interest of the late work lies in that provocative,
tensed delay in pushing familiar forms back to their undifferen-
tiated beginnings. Morandi's art was never as self-interrogating as
that of some of the artists I've mentioned or who are included in
the show. There is one Giacometti on display, an undated still life:
slate ground, slate foreground, brushstrokes like scar tissue, a
bunch of yellow radiants spearing from a vase already half-engulfed
by the whirling movement of the tabletop. One of the curators sug-

gested to me that Giacometti had learned lessons in still life composition from Morandi. I should say instead that Giacometti, the greater artist, was more skillful and tenacious in expressing, in the execution of his subject matter, the energy of the act of rendering. There is in all of Giacometti's post-surrealist work the active presence of an intelligence passionately engaged in formal explorations. Positioned as it is among Morandi's straining, polite images of the late period, Giacometti's one picture is a rude but memorable guest who might, in a moment of inattentiveness, spit on the rug.

And yet out of his elected scheme, out of that system of resistance and enforced calm, came one of the masterpieces of Morandi's last years, a still life of 1963. The small $11\frac{3}{4}$ x $13\frac{3}{4}$ in. canvas shows white vases on a snowy, spectral graygreen ground. Behind the vases looms a vermilion mass, more garish and light-infested than in the 1935 mud painting. The image is not, as I have heard suggested, a death song. An allegorical reading can only reduce the power of the image. What makes the painting sublime, in the terms I've been trying to put forth here, is that the figures, the containers of substance and restrainers of matter's chaos, are disappearing into their ground, into that now redder and bloodier alluvial muck that Morandi had tested so many years before. In that late painting he is turning the life of form back toward dissolution, conducting his own finest imaginings toward oblivion. No dust has settled on the image. No scrim protects it. There are only the open, enthusiastic, liquid textures of the figured paint. It is as if Morandi were reviewing and summing up the history of his form language while turning the act of self-review into a renewed contest with chaos.

Killing Moonlight:
The Futurists

Ondots OF THE MOST UNSET-
tling images in the enormous exhibition of futurist art recently in
Venice* is Giacomo Balla's *The Madwoman* (1905). The woman
stands full length, framed by a doorway, her hair mussed and
gnarled. The yellow springtime light shatters on the broad field be-
hind her. Her body is a coil of wrecked nerves, her long form one
stretched contortion, from her flyaway curls to the tensed flex of
her foot. She waves a finger in front of her face, at the world out-
side her disordered mind, in a gesture of negation or chastisement,
as if to scold or correct us, while her other arm hangs stiffly at her
side, hand cocked at an odd angle. In its setting—the exhibition
Futurism and Futurisms contains hundreds of paintings, drawings,
sculptures, photographs, books, documents, and assorted parapher-
nalia from the futurist movements in several countries—Balla's pic-
ture has two quite different effects. Placed in the rooms designated
"Toward Futurism," it helps to establish the formal matrix out of
which the language of futurist art was to evolve: the detonated col-
oring of Impressionism, the phosphorescences of Pointillism, and
the tension between documentary fidelity to subject and irreso-
lutely colored images characteristic of the Macchiaioli in the sec-
ond half of the nineteenth century. But the young woman's look of
bewildered chastisement also seems directed at the other pieces in
the show, as if she were registering real dismay at the carefully
scripted derangements soon to be staged by F. T. Marinetti and the
Futurists as they assaulted the complacent rationalisms of the past.

Balla was, after Umberto Boccioni, the most gifted among the
Italian futurist artists. Like other painters early in the century, he
wanted to record on canvas the new industrial expansion that was
carving out larger pieces of the Old World's landscape and chang-
ing the sense of time experienced by workers. The two panels of
Balla's *A Worker's Day* (1904) show laborers first on a building site
then later returning home on a lamplit street at dusk. Each scene
includes a house under construction, where the sign of the new age

* May 4–October 12, 1986.

45

is the gridwork of wood-rail scaffolding climbing high up the sides of buildings. By 1912, however, committed to a futurist program, Balla, as if by sheer willful self-conversion, ceased creating such moody realistic canvases and began to make a different sort of art. About halfway through the Venice show, one enters a room I think of as "Balla's Speed Shop." On the walls are the famous series of paintings whose titles are miniature manifestos: *Speeding Car, Abstract Speed, Dynamic Expansion and Speed.* The dominant forms are repetitive quarter-moons, scythes, swallowtails, nautilus whorls, all abstract figures sliced across by triangulated planes with other echoing forms revolving and coiling inside. The pictures are from 1913, when Balla was seeking to accommodate the form of motion that was proliferating with spectacular quickness in Western industrial societies—the wheel, in all its manifestations: cars, trucks, trains; pulleys, casters, bearings; the figure traced by airplane propellers and locomotive cranks. Balla was the purest anatomist of velocity among the Futurists, analytical, precise, and objective. Some of his early work prepared him for this. The closed doors in his picture *Bankruptcy* (1902) are defaced with scribbled spirals and curves, prefiguring the general futurist position that the past as a fund of wisdom and static forms was bankrupt, that the artist's only workshop and subject would be the present rocketing into the future. By the late 1930s, however, after a long association with Futurism (he signed two important early manifestos in 1910) Balla came out the other end, declaring that "pure art is to be found in absolute realism, without which one falls into decorative ornamental forms." The curse of the merely decorative was one that Futurism could never escape.

If *The Madwoman* was placed for its editorial effect, that would be in keeping with the self-conscious assertiveness of the entire exhibit, which fills the spacious three stories of the eighteenth-century Palazzo Grassi. The "Toward Futurism" section on the ground floor displays items by Edvard Munch, Picasso, Seurat, the Lumière brothers, Georges Méliès, and others who may have anticipated the various strains in futurist art. Viewers have to infer this, however, and construct their own historical argument, since the catalogue limits its commentary to a brief introduction and a "Dic-

tionary of Futurism." Above the dazzling marble foyer hang a monoplane and single-engine fighter, like profane versions of the Holy Spirit blessing the show and lending it the power of secular evangelism. Off the main foyer are two of the choicest objects in the show, an early model Fiat touring car with luxuriantly funereal black leather seats and a Bugatti one-seater that looks more like a tin country mousetrap than a newfangled speed machine. Like Futurism, the exhibit is so full of its own energetic theatricality that it cannot quite control either its range of reference, which becomes haphazard, or its ironic suggestiveness, which becomes confused and opaque. It is carefully programmed to allow for a generosity of reference and accommodation, to document what the curators obviously believe to be the omnipresent durable effects of Futurism. But like the movement itself, the show's infatuation with its own enthusiasm resolves into a recognizable modernist tedium.

The entire second floor is given over to Italian Futurism. While artists like Otto Dix, Mikhail Larionov, Duchamp, Gaudier-Brzeska, and Jacob Epstein might all be tagged as Futurists at some point in their careers, the most influential documents and "events" were produced by Marinetti, and none of those other artists can be treated so exclusively in futurist terms as can Boccioni, Carrà, Balla, and Gino Severini. Venice is the ideally ironic setting for the show. In their 1910 manifesto "Against Passéist Venice," the Futurists called Venice the "great sewer of traditionalism," which ought to be purged of all its rotting leftover antiquities and turned into a military, industrial power. They wanted to burn the gondolas ("rocking chairs for idiots") and wrench Venice into a new age: "Let the reign of the divine Electric Light come at last, to free Venice from her venal hotel-room moonlight." The town was already a museum in Marinetti's time, the kind of historical "jewel" loathed by the Futurists because it represented the crippling presence of the past, old achievements enshrined (like Roman Catholicism) to oppress the contemporary imagination. The mastering idea behind Marinetti's pronouncements was that *passatismo* must be attacked and routed wherever it appeared, that the new century was so utterly new that art could no longer look presumptuously toward memory as a restorative innovative power, that artists had to vio-

lently revolutionize their methods, choose new subjects, forge a new form language, if they were to redeem themselves from the wasteful obedience to, and worship of, past forms. All the old poeticisms naturally came under attack. The most abrasive and rudely endearing futurist manifesto is entitled "Let's Kill Moonlight." In place of the old cautious deliberations, the infinite refinements of sentiment, the laboriously arrived-at nuances of representational realism, would come heroical speed, *dinamismo,* and quickened bright metallic facts. The failure of at least part of the futurist program is bitterly apparent. Venice may be, for many, an island of eternally serene moonlight, but she is, first and always, Queen of Irony: cunning, indifferent, secretive, and greedy. She knows that her gondolas, most of them, are rocking chairs for idiots, but, unlike the Futurists, she does not care. More a museum than ever before and therefore more protective of her secret life, Venice has now co-opted her most virulent critics and is charging admission to view them.

A new form of attention was, at any rate, necessary. The mechanical means of producing images of reality (and of reproducing copies of images of reality) induced a new self-consciousness of the moment's composition in time. In his *Animal Locomotion* series of 1887, excerpts of which are in the "Toward Futurism" section, Eadweard Muybridge used the photographic image to analyze motion by recording its serial instants. One of the images on display is of a nude woman descending steps. When, much later, the coppery turbine vanes of Duchamp's *Nude Descending a Staircase, No. 2* (1912) enact one futurist obsession—that of registering the planes through which movement passes—the historical arc is neatly closed. Artists therefore needed to review and revise their awareness of the process of motion and of civilization's new life-altering products. Marinetti—poet, prose writer, and man of independent means— was the most tireless and best-organized advocate of accommodation. To reach the largest audience as quickly as possible, he spread the call by publishing his manifestos in newspapers. He was a resourceful promoter whose tone was unapologetically peevish, insulting, and belligerently ecstatic. His position as the most conspicuous representative of Italian Futurism was adversarial, subversive,

and intolerantly democratic. The events of the 1920s and 1930s, however, were such that what began as an earnest, and in many respects necessary, program for global, pan-cultural change became nearly indistinguishable from totalitarian ideology. The rigor of the Futurists' denunciations and their energetic, petulant enthusiasm for the new gave much of their work a strange double valence, at once blissfully liberating and punishingly authoritarian.

The double valence is shockingly apparent in the first image one confronts at the top of the staircase. Boccioni's 1913 statue *Unique Form of Continuity in Space* is probably the best-known futurist icon. We recognize at once the formal principles he explored so brilliantly in his futurist years, from 1910 to his early death in 1916. The tall, striding figure, with its monumental streaking-bronze effect in space, realizes Boccioni's desire to obtain what he called a "simultaneity" of duration and stasis, "a synthesis between what is remembered and what is seen." From his teacher Balla he had learned the new stress on dynamism, but against the more schematic representation of velocity in Balla's work Boccioni wanted time's quick stream seen and felt in the rhythm of its flowing. The statue is a stunning articulation of matter in motion. Installed in its niche, however, surrounded by tall black enamel panels, that human image with its abstract title is also the most powerful martial icon of the century. Up from the bronze platform, out of the thick bronze pedestals, toils a monstrously sinewy, invulnerable man-machine, a pure urgency of will untrammeled by meditative delay. Small wings, reminiscent of Balla's swallow forms, flare from the heels and calves like instruments of flight, but also like spurs, or scythes—the entire lower body looks like an unstoppable harvesting machine. The torso, all curvilinear flanks and planes, expresses at once the continuities of the human form moving through space and the armoring of that form in thick bronze folds that overlap like wings. In "Man Multiplied and the Reign of Machinery," Marinetti announced: "We believe in the possibility of an incalculable number of human transformations, and we declare without a smile that wings slumber within the flesh of man. When man is able to externalize his will so that it extends beyond him like an enormous arm, dream and desire, which today are vain words, will reign su-

preme in vanquished space and time." The Futurists believed that units of force composed the essence of objects and that these could be externalized in "force lines," the tensed vectors and radiating blades and gills so evident in their images. The force lines in Boccioni's statue describe, and celebrate, the exercise of Marinetti's transformational will.

Nonetheless, Boccioni was, for a while at least, something more than an exemplar or implementer of futurist ideas. This much is obvious from the selection of his pre-futurist work in a concurrent show, Boccioni in Venice, at the Chiesa di San Stae. The early portraits are particularly interesting because they dramatize a tense truce between the flesh of the subject and the thing world surrounding it. The crosshatched inner structure they both share, especially evident in the pastels, is always faintly visible as the common ground of reality. The flesh has to resist the necessity of surrounding matter. A portrait of his mother from 1906, in grays and half-whites, shows the subject's inertia flustered by the flyaway strands of gray hair that pick up the oscillating rhythms of the background. Although the sitter is heavily *there,* dynamism is yet tightly coiled within her form. Even this early in his career, Boccioni is painting a study in movement, but the dynamism waits to be set free from the figurative conventions of portraiture. In another *La madre,* from 1907, the action of the thing world is more fused to the figure; both are heavily scored by that under-form, that hatchwork (which in Boccioni's early house-under-construction scenes becomes fully externalized in the scaffoldings). The background in the 1907 portrait is now more tightly knit—the colors are becalmed blacks, grays, and smoky whites—to the life of the flesh. Again, wisps of hair float behind the mother's head. In *The Sick Mother* of 1908 the subject reclines on snowy linen streaked with green highlights, as if the quickened vegetable world were ceding to the candor of mortality. Only the smudged gray and powdery orange tints of the mother's face preserve her from being taken over by the geological scorings of the background. These early canvases are important, I think, because even while working within the conventions of portraiture, with all its tremendous stillness, Boccioni is developing a vision of the action of matter which

will lead him quite naturally toward the extreme kineticism of Futurism.

Boccioni held certain futurist convictions as early as 1907, three years before he met Marinetti, when he wrote in a letter that Italians were living in *un sogno storico,* a reverie of history that induced torpor and useless nostalgia. With his turn away from meditative portraiture, away from the endless and enervating inflections of historical reflectiveness, came an apposite change in his work. Around 1910, the year of his first one-person show at Ca' Pesaro in Venice (introduced by Marinetti), Boccioni began to change his style of drawing. He declared in 1910 that *The City Rises,* a large canvas completed that year, was "a transitional work and, I think, the last" (*un lavoro di trasizione e credo degli ultimi*). It was indeed among the last, for in its surging tidal forms of men and beasts heaving a city into existence, the force holding the elements together is centripetal. When Boccioni became a Futurist, he said that "the figure has to become the center from which plastic directions depart into space." The new force is centrifugal: the stress lines of matter radiate from the figure, they do not converge upon it. In 1912 he painted two more portraits of his mother, though now she is called *Horizontal Construction* and *Materia.* The finely tissued webwork of the early portraits has been transformed into steely, sheeted intersecting facets and angles. Boccioni's subject is no longer the flesh struggling in an object world but rather the action of an energy in the life of forms.

Much of what he and other futurist painters had to say about their practice focused on draftsmanship. In *The Salon of 1846* Baudelaire wrote that "pure draftsmen (as opposed to colorists) are naturalists, endowed with one excellent sense; but their drawing is a rationalist enterprise, whereas that of the colorists is a matter of feeling, an almost unconscious process." Boccioni was, in Baudelaire's terms, a pure draftsman. And the great strength of futurist art generally, from the antic angular caricatures of Fortunato Depero to the moody social documentary of Carrà, is its draftsmanship. A colorist depends too much on precisely the sort of irrational feeling and instinct for movement that artists with a program need to avoid, for fear of sabotaging the program. Moreover, the

traditions of the great colorists—the Macchiaioli had been the most recent in Italy, though their influence on the Futurists goes entirely unremarked in the catalogue—run counter to the antisentimental purpose of the Futurists. At its most debased, coloring for the Futurists was merely a sort of sensational violence exercised upon inventive draftsmanship.

The futurist program went beyond art. It meant to change people's hearts and minds. "Anarchists are satisfied to assault the political, judicial, and economic branches of the social tree," Marinetti declared, "whereas we want much more. . . . We want to tear up and burn that tree's deepest roots." Those roots were nourished by "cowardly quietism, love of the old and ancient, of what's sick and corrupt, the horror of the new, contempt for youth, the veneration of time, of the accumulated years, of the dead and the dying." Marinetti singles out his targets, but each one represents a general condition; taken all together they are so manifold that the futurist attack must be waged on a broad global front. Consequently, most of the manifesto literature produced by the movement has both a particularized aphoristic force (the force of tables of law) and the intimidating hysteria of wild machine-gun bursts. The exhibition catalogue, in keeping with the futurist spirit, suffers from the same overparticularized but blurred purpose. Its encyclopedic format offers a blizzard of facts, obscuring long, clear views. Since it is crucial to the show's public success that Futurism be shown to be the most influential and relevant "ism" of the early century, all sorts of names are enlisted under its banner. Nietzsche, Georges Sorel, Munch, Apollinaire, John Marin, Ungaretti, Charles Demuth, Dino Campana—all become, in the catalogue's retelling, near or distant figures in the futurist story. What neither the show nor the catalogue offers is lucid historical analysis (and because of the hundreds of documents on display, the exhibition had a real opportunity to do so) or a coherent argument. The curators offer instead more of what the Futurists themselves provided in abundance—self-glorifying publicity.

The most prickly issue, and the one most thoroughly botched in the catalogue, is the relationship between Futurism and fascism.

An essay by Antonello Trombadori in a recent special number of *Nuovi argomenti* argues that when Marinetti and the members of the Futurist Political Party broke from fascism in 1920, after their initial participation in the *Fasci di combattimento,* it was not because they felt that fascism had turned too sharply to the right, but because they themselves held to an "ultrafascism." Official fascism did not go far enough. The futurist position was even more nationalistic, antimonarchical, and anticlerical than the fascist line. In Trombadori's analysis, the Futurists at that time were more single-mindedly intolerant than the fascists of any divergence from their program to level the past and dissolve the fogs of "historical consciousness." Trombadori's argument is directed against those apologists who present the Futurists as leftist dissenters and early opponents of the regime. In 1923, at any rate, Marinetti publicly realigned himself with fascism, in 1929 was elected to the Academy of Italy, and as late as 1935 was a vocal advocate of a fascist future.

In the catalogue entry "Ideology," Renzo de Felice refuses to draw any equation between Futurism and fascism, insisting that Futurism had no ideology, only "artistic attitudes" and strategies: "On the whole Futurism had no ideology, nor did it want one. If to some extent it is possible to construct an ideology after the fact, this assumes contradictory, changing forms which vary according to the groups composing the movement, so it cannot be forced into the narrow limits of an abstract lowest common denominator." To explain Marinetti's announcements in the 1909 manifesto, "We will glorify war—the world's only hygiene—militarism, patriotism, the destructive gestures of freedom bringers, beautiful ideas worth dying for, and contempt for women," de Felice concocts the proposition that "war" be taken metaphorically, "as fullness of life and even as rejoicing, essentially as an individual and artistic fact, which became collective for the Italians in 1911 and more particularly in 1915–18 because it took on the value of a 'revelation' of the 'true Italian powers,' that is, of the triumph of 'futurism' over '*passatismo.*'" Those quotation marks are little nooses choking off the oxygen that might clarify de Felice's ideas. The hygienic purpose of war, as he reconstructs it, is to restore life—festively—individually and socially. But not "real" war. Marinetti could not possibly have

meant real war, since that is a tragic business, and Marinetti did not
believe in tragedy. (He looted Nietzsche's vocabulary of will and
power but dismissed Nietzsche as a retrograde classicist who be-
lieved in tragedy.) What de Felice refuses to acknowledge is the
strain of giddy nihilism in futurist thinking.

The torturous ambivalence of de Felice's explanation imitates
what I think was Marinetti's own fiery confusion. He wanted two
things at once: the artist as holy noisemaker, announcing and creat-
ing the future, answerable only to his responsibilities as a Futurist,
not obliged by norms that apply to established social and political
orders; but also the artist as inciter, as *provocateur* promulgating
the new program to the masses, shaping their lives with his vision
and his products (the Futurists made clothing and furniture, de-
signed advertising campaigns for Campari, wrote a cookbook,
etc.). The artist would therefore have actual power over the life of
the crowd, but because of his holy noisemaker status he was also
morally autonomous. The artist was thus a pure performer, intent
on changing the lives of his audience but feeling no sense of conse-
quence for that power. Many of Marinetti's pronouncements are
performances in that sense; his ideas are italicized by their manner
of presentation, and their exhilarating inconsistencies become gro-
tesque but unignorable. In the first famous manifesto published in
Le Figaro on February 20, 1909, he announced: "Except in struggle,
there is no more beauty. No work without an aggressive character
can be a masterpiece. Poetry must be conceived as a violent attack
on the unknown forces, to induce them to prostrate themselves be-
fore man." That beauty results from strife is, though Marinetti pre-
tends not to know it, a romantic article of faith. That poetry is
above all an "attack," offensive and assaultive, rather than a receiv-
ing or contemplative activity, is a more stringent (and attention-
getting) assertion. To believe that poetry is essentially imperialistic,
conquistadorial, and that its purpose is to subdue and subjugate
those coyly unidentified "unknown forces," is to model the pur-
pose of poetry so closely on the exercise of political force that it
may more readily and "innocently" become an instrument of state
power, of state "knowledge," of ideology. The tone here and in
other futurist documents (even in Valentine de Saint-Pont's *Mani-*

festo of the Futurist Woman, written in 1912 to oppose what Germano Celant calls Marinetti's masculine hysteria) is unremittingly aggressive and proclamatory. Even if we allow for Marinetti's occasionally sly bad-boy humor, the martial tone dominates: "Art, in fact, can be nothing but violence, cruelty, and injustice." The anti-sentimental impulse in Futurism became obsessional avoidance, and its emotional range was narrowed accordingly. The sort of world the Futurists called for was an emotionally impoverished and overlegislated one. They were not, all things considered, masters of the finer tones, not even Boccioni, whose paintings many years later would be dismissed by another poet of violence, Francis Bacon, as "hideous and vulgar." As ideology and practice, Futurism was in too violent a hurry to bother with nuance and discrimination.

The Futurists were driven by the need to pursue what Marinetti called the implications of new facts, which had to be absorbed and transformed by the artists. In their early paintings of workers and houses under construction, Boccioni and Balla were already coping with the implications of new facts. But later futurist pronouncements, along with the stabbing, overexcited vitalism of their canvases, suggest an even deeper anxiety: that the artist was being made more and more marginal by the new facts and by the velocity with which those facts came and went (or reproduced themselves). The artist had not only to keep pace but also to define (or improvise) his own position along the way. The futurist strategy was to adopt the manners of competing technologies—to be quick, aggressive, efficient, explicitly manipulative, unsentimental, and intrusive. Here, too, their methods were equivocal, insofar as they were adversarial in contesting the new "marginalization" of the artist but conciliatory and imitative in their accommodations. Moreover, for all of Futurism's urgency in changing old European ways through its interventions, there is a peculiar evasiveness in even the most stunning images the movement produced, in some of Mario Sironi's collages from 1914–17, for instance, and in Ardengo Soffici's good still lifes and landscapes from that period. Marinetti spoke of "the need to Americanize ourselves by entering the all-consuming vortex of modernity through its crowds, its automobiles, its telegraphs, its noises, its screeching, its violence, cruelty,

cynicism, and unrelenting competition; in short, the exaltation of all the savage anti-artistic aspects of our age." But Futurism, theoretically at least, depended so much on the acquisition of the newly modern and the immediate restoration of the experience to those undergoing it that it was too caught up in the actual; it was more obsessed with actuality than with reality, at the expense of the transformative discontent of the imagination that makes art, even at its most celebrative or most decorative (as in the case of Matisse's decorations), a criticism of reality. I think this accounts for the essentially illustrative quality of so much futurist painting. Boccioni wrote that "for the new conditions of life the Futurists intend to discover a new means of expression." The new expressive means illustrated the feeling tone of those new conditions. It was also the sort of illustration that a very different kind of painter, Morandi, worked to avoid. Though he attended a futurist event (Marinetti organized "happenings" that featured readings, exhibitions, and performances by *intonarumori,* musical instruments that cranked out acoustic effects like hissing, burbling, razzing, thunder-rolling, etc.) and was familiar with work by Sironi and Soffici, Morandi, with his patient discharging of formal debts to Chardin, Cézanne, and the masterwork tradition Marinetti deplored, was probably as remote from the theatrical dismantlings of Futurism as any artist of the time.

The attention to new facts, along with the importance they attached to *dinamismo,* led some futurist artists to investigate the nature of their materials. "Instead of *humanizing* animals, vegetables, and minerals (an outmoded system) we will be able to *animalize, vegetalize, mineralize, electrify,* or *liquify* our style, making it live the life of matter." Marinetti is speaking here about futurist poetry, but his intent to "destroy the canals of syntax" and rid poetry of its sentimental and historical excrescences had its equivalents in the practice of futurist painters. Severini's *Armored Train,* with its slashed multiple perspectives, discloses a file of infantry firing from what looks like a rolling, steel-plated trench, a mounted artillery piece blasting away from the front end. Embedded in sulfurous scissors and triangles of green and yellow light, the train looks encased in its own velocity as it cuts a swath through the teeming air.

New martial facts are the painting's subject, but more important for Severini the Futurist, the life of matter is being enacted in paint. In keeping with futurist predilections, however, the scene is empty of sentimental content. The faceless infantrymen in blue capes, like so many cowled anonymous monks at prayer, are presented by the artist's imagination as *matter equivalent to* the knobby rivet heads efficiently distributed around the train and cannon plates. The soldiers are thus nothing more than elements in a scheme of new formal facts. Like the vehicle they occupy, they have been made over into senseless instruments of a will not their own. The transformational activity Marinetti called for is indeed apparent here, as elsewhere in futurist art, but the discriminating faculty has been sacrificed to the enthusiasm for likenesses.

Contrived, programmatic excitement leads to terminal weariness. The Futurists' relentless brassy optimism, combined with all that elated moonlight killing, in an exhibit of this size leads almost inevitably to the sepulchral tedium and quaintness one feels in a wax museum. The "Futurisms" of Russia, Latin America, Japan, Germany, France, and other countries, which occupy the third-floor galleries, hammer futurist mannerisms into different shapes, with varying degrees of wit and anger (and, in the special case of Vladimir Mayakovski, with different political import). But the surprise comes near the end, in the room devoted to British Futurism, and especially in the work of Christopher Nevinson and Wyndham Lewis.

Two large canvases by Nevinson, *Returning to the Trenches* (1914–15) and *Troops Resting* (1916), exploit the formal resources of Futurism. (Nevinson's ties with the futurist movement, loose as they were, lasted until 1919.) *Returning to the Trenches* is nearly overloaded with the dynamism of soldiers scrambling for safety, ranks tilted and hurtling back toward cover, legs flashing through the serial "moments" familiar in futurist images. The panic, however, is palpable. The image is a design of mortal fear. It accommodates a world of new facts, but the quickness in the draftsmanship and coloring enacts the quick of feeling. In this work, unlike Severini's *Armored Train,* we can distinguish human from mineral fact.

In *Troops Resting* the angular planes of futurist drawing enact the exhaustion of troops slumped on a railway embankment. Each face has a singular character. Over their heads runs the telegraph line, hovering like an instrument of execution. In *A Battery Shelled* (1914–18), Wyndham Lewis paints a world in which nearly everything is or will soon become war debris. The stiff forms of the artillerymen imitate the bristling groups of stacked shells, which look like monstrous vegetables, whereas the soldiers' bodies (not those of the officers, who look on calmly from a distance) seem reptilian, armor-plated. Mineral ordnance assumes the look of vegetable abundance; the human is being transformed into mineral matter. The metallic folds of the human forms mock the shape of the landscape, the crudely terraced earthworks colored a sickened blue-green. Here, too, we have a chronicle of new transformations, but they are calibrated by a discriminating intelligence. Lewis's painting is febrile, angry, and accusatory; the passion is enacted in a recognizably futurist vocabulary of forms. But Lewis plays off the cool angularity and centrifugal movement of Futurism against the brittle dread being lived out through those forms.

Marinetti and his group loathed what they called the professorial past. As one arrives at the British room, however, the polemical program of the Futurists and its expression in painting have begun to smell of the lecture hall. For all their clamorous enthusiasm and announcements of passion, the art the Futurists made is eerily lacking in temperament—which seems somehow to have been edited out of their program—and this lack turns much of their work into academicism. The British room is, on the contrary, practically overripe with temperament; it is, in any case, stretching the issue to identify Nevinson, Lewis, Jacob Epstein, and Gaudier-Brzeska as Futurists. The four were also associated with Vorticism, which for a brief time had points of contact with Futurism. The Vorticists, too, prized energy, action, and force and insisted on claiming the world of new facts. But the new motion valued by the Vorticists did not exclude the velocities of the past; it welcomed, insisted on, all past "vectors" of knowledge as part of the vortex that revolved around the individual artist. A genuinely new work of art, for Gaudier-Brzeska and his friend and advocate Ezra Pound,

was inevitably worked on, shaped, by the action of the vortex. Art was an emergence *from* and *out of.* The Futurists, by contrast, had only the initiating ego. In his catalogue entry on philosophy Massimo Carrà says that "the Futurist ego, or 'I,' is its own act; it acts itself and is nothing without this acting." It acted, moreover, according to a program. The result was to bleed its art of temperament and mood, and to turn it into a new set of idealizations. Any quest for the sort of purity sought by the Futurists has to suppress, eliminate, or reduce to academic exercise the expression of passion for the human. In Boccioni's work after 1910 there is no longer any contest between the flesh and its surroundings because the sense of the carnal is entirely gone.

The British artists were also trying to reckon with world war, and when necessary they tried to enlarge the confines of older narrative conventions to accommodate the new efficiencies for creating what Elias Canetti calls the heaps of the dead. I've already suggested that futurist optimism was a cultivated ignorance, but that is obvious enough and perhaps simplistic. Back of that optimism was, I think, a neurotic fear of reflectiveness and moral consequence. The loud, belligerent generosity that runs through the Futurists' art and writings is also self-righteous protectiveness. They cared abundantly about what artists never ought to care about. They cared about being right. Marinetti called for the expression of a new consciousness, but he and many of his fellows were too impatient, and too obsessed by performance, to do the deeper work—to brood on the nature of that consciousness.

Miscellany I

B‎AUDELAIRE SAYS: *TOUT CE qui n'est pas sublime est inutile et coupable*—"all that falls short of the sublime is useless and reprehensible." Not the sort of idea any gallery dealer or publisher can entertain. It's also one that artists themselves incidentally redefine in their work. Baudelaire didn't know he was practically at the threshold of Impressionism and would have been appalled by the new attempt to master the sensation induced by nature's momentary appearances, modernism's recasting of the sublime.

Van Gogh's famous simplicity—his sister-in-law refers to it repeatedly in her memoir—leaps from his letters with rude directness and ingenuousness. "The world only concerns me in so far as I feel a certain debt and duty towards it because I have walked that earth for thirty years, and, out of gratitude, want to leave some souvenir in the shape of drawings or pictures—not made to please a certain cult in art, but to express a sincere human feeling. So this work is the aim—and given concentration on that one idea, everything one does is simplified in so far as it is not a chaos, but done in its entirety with one aim in view" (August 1883). The work was not a specialized or sectarian activity, it was not a profession; it was the fluid, harmonious exercise of an existence, and it took as its subject the fullness of existence. Art does not redeem existence or set itself at some invulnerable, ironic point apart from it. Maybe this explains why the action in Van Gogh's landscapes so often coils and oscillates toward convergences, the impossible point of Oneness. But it's not a placid, "oriental" action. Cypress trees, compacted and wrapped in their protoplasmic energy, convulsively shear away toward the ether, toward a bonding with nature's other elements. His painterly gestures were, in what he himself felt to be unequivocally moral terms, acts of driven reciprocity.

How much of Degas's temperament, his sardonicism, irony, soli-
tariness, and irascibility, is worked out in the figure arrangements
in his paintings? He is the supreme poet of detachment. In the
great group portrait of the Bellelli family you can feel the deflec-
tions of attention and the self-absorption that isolate the father
from his family, his pregnant wife from him, and each of the two
young girls from one another, from their father, even from the ex-
tended sheltering hands of their mother. The wife and husband are
differently designed fortresses of selfhood. It's a portrait of a family
in distress, of controlled, normalized everyday choking tension. In
his theatrical pictures, the synchronized work of orchestra and
corps de ballet is represented as a provisional, expedient commu-
nity held together chiefly by the self-regard and insular pride of
musicians and dancers. Throughout his career Degas dwelt on the
fragility, the reserve and rigid preservations, of self-esteem. The
most devastating vision of it, because we see the individual collaps-
ing into that center, almost entirely lost to the social world, is *In the
Café* (*Absinthe Drinker*) in the Musée d'Orsay. In an artist whose
work does not often show tenderness in human relations, the most
tender scenes are those of women trying on hats in millinery shops,
looking at themselves in mirrors.

When I was in grade school, once every two weeks the sister would
pass out our Picture Study books, thin but mysteriously weighty
pamphlets covered in heavy brown paper. Inside were small color
reproductions of masterpieces approved for eight-year-old minds
by the diocese. It was always a great moment, not for the rarity of
the experience, though that was true enough in a culture where the
only images on walls in most houses were devotional ones (and
where there were no books). But rather for the way so much hard,
clear fact could be presented, pictured, in a way that seemed to
transcend all fact. The colors in the images were so much beyond
what I knew that they seemed sacramental. Even now, when I look
at a painting by Millet I can't separate from my judgment the deep-
set feelings rooted in Picture Study time, when *The Gleaners, The
Sower,* and *The Angelus* were dominant images. It's not nostalgia,

because those pictures were turbulent experiences, ripping me from my familiar world. Though they weren't far from devotional images, they showed great passion for the world of sense and brute force. I'm moved in similar ways, and my judgment riddled, when I look at Courbet or Van Gogh, because of their coincidence, secular and religious, with Millet. With Van Gogh I always see some sort of devotional passion—manic, sacrificial, elemental, pious. A devotional passion that blows apart liturgical decorum. When I look at Matisse's *Red Studio,* or his big dance murals at the Barnes Foundation, or the Cézanne *Bathers* in the Philadelphia Museum of Art, or Pollock's *Autumn Rhythm: Number 30,* it's always the Picture Study child in me that first cries out to them.

———————

A party or fight is harder to appreciate and see clearly when you're a part of it. How can we tell who among the much discussed young American painters of the 1980s is really an Umberto Boccioni, one whose career coheres only as a series of rattling, excited, stylistic gasps? Boccioni's early portraits show off the brilliant student who mastered the realist lessons of Courbet. Then came the Divisionism and Impressionism of the landscapes and later, in the "States of Mind" series, the flurried dynamism and overdetermined forms of Futurism. When he executes a futurist portrait of his mother, it's a self-aware mockery of the sentimentality of his earlier realist portraits. His forms, over the course of his short career, don't have an internal, self-compelling passion. They are reactive. They don't make a history of their own, they accommodate the history enacted around them.

———————

No drawing by Caravaggio has come down to us, and for most of his canvases he did no preliminary drawing. Color was the initiating divination. He painted some canvases over with entirely different compositions, and his revisions were violently self-canceling. In his late pieces, starting around 1608, the paint gets thinner and lighter, the hues moodier. The weave of the canvas is visible as infrastructure of the thinned-out paint. He was sketching with color,

and the sketch was also the finish. When there's no preliminary drawing, none of what Baudelaire would call the anticipatory restraints of rationalism, the action of the paint becomes instigator and mediator, and it creates more volatile expressions of passion. The growth of forms, of the suffering flesh, is lived out in the coloring.

On the greatness of the less than perfect. "I have been quite overwhelmed today by a man whom I never dreamed of—Tintoret. I always thought him a good & clever & forcible painter, but I had not the slightest notion of his enormous powers. . . . I look upon him now, though as a less *perfect* painter, yet as a far greater man than Titian ipse" (Ruskin, writing from Venice to his father on September 23, 1845). He wrote almost daily, and the next day he's saying that Tintoretto needs a big canvas, "a canvas forty feet square—& then, he lashes out like a leviathan, and heaven and earth come together." Twenty years later Henry James was struck just as hard, calling Tintoretto in an 1869 letter "the greatest of them all, so much so that he ends up by becoming an immense perpetual moral presence, brooding over the scene and worrying the mind into some species of response and acknowledgment." James loved the amplitude of formal display and the "dark range of color." Tintoretto's subject matter bore the deep impress of his time, the lexicon of scriptural and apocryphal event. That stability made his invention and powerhouse colorism bolder. And what other painter so constantly gives us a universe driven by movement and change? Hundreds of *contrapposto* variations, legions of tumbling, overmuscled angels, the human body straining or tortured or in flight, the body bulking large and toiling at every level of earth and heaven. Tintoretto's universe is pure incarnate motion. Not even Michelangelo, Ruskin said, could "hurl figures into space" as Tintoretto could. And James thought him great because more than any other painter "he habitually conceived his subject as an *actual scene* which could not possibly have happened otherwise; not as a mere subject and fiction—but as a great fragment wrenched out of

life and history, with all its natural details clinging to it and testify-
ing to its reality."

Actresses, musicians, businessmen, athletes, clergymen—Eakins's
portraits always show traces of disturbed repose or challenged self-
possession, even, or especially, when his subject might be expected
to display self-possession in exaggerated form, as a wealthy indus-
trialist or famous surgeon might. Eakins's subjects present them-
selves with a recognizable courage, as if they understood better
than most the nature of the self made vulnerable to reformation,
refiguration. It's a peculiarly American openness, or availability,
curtailed to a critical sorrow by self-consciousness, by the feeling
for failure's catastrophe, for mischance or the failure of love in the
world—even while the subjects exist in emphatic encounter with
the world's occasions, as if personality and astuteness could colo-
nize all such occasions. In paintings like *The Actress, The Cello
Player,* and *The Thinker,* the sense of public destiny deepens the
melancholy already intrinsic to the practice of the life. It's not ar-
rogance or protective reserve that's so distinctive in the portraits,
it's the meditative depressiveness. How many of those figures seem
vulnerable, like William James, to psychic "vastations"?

In the 1850s Millet wrote: "Nature yields herself to those who
trouble to explore her, but she demands an exclusive love. The
works of art we love, we love only because they are derived from
her. The rest are merely works of empty pedantry." That describes
Van Gogh's devotionalism, though it wasn't only created nature he
explored and loved in this way. The force of space, the throbbing
channels and fibers of household artifacts, are palpable even in his
interiors. A floor, a bed, a table, a vase, a wall, even "denatured"
stuff quivered with the divinity that for Van Gogh lived in matter.
And he paints the stars not as distant objects moving away from us,
whose light always arrives so late, but as immanent presences, stir-
rings in consciousness. He narrates the ancient fact that the stars

are divine beings. The stars, the firmament, covered the walls of his most impoverished rooms.

Benedetto Croce, on the *macchia* and poetry:

> Every poet knows that inspiration comes precisely as a *macchia,* as a motif, a rhythm, a psychic motion, in which nothing is determinate and all is determinate: in which there is already that meter and no other, those words and no others, that arrangement and no other, that extension and those proportions and no others. And every poet knows that his work consists in working out that *macchia,* that motif, that rhythm, to attain at the end—in a shape that is fully developed and may be recited aloud, and transcribed in writing—the selfsame impression he had received, as a flash, in his first inspiration. The value of the poem, as of the painting, lies in the *macchia.*

Croce idealizes composition. He wants to heroize initiatory formal perfections. For a poet there is certainly the spectral presence of some kind of shape for some kind of poem that he has only just begun to write. It's the instinct for form reacting the moment the event of the poem is engaged. But very often a poem is finally formed—I feel it as an invincible incompleteness—only when its spectral origins have been so dragged and hammered by the actual words that the poem emerges as a strange, used thing. The words of poetry answer to, as they sustain, the initial stirring of inspiration, the "psychic motion." The answering task of the writing transfigures its spectral origins. The Macchiaioli were more respectful of the initiating motif, but even they were not so pure as the Japanese scroll painter whose first painterly gesture was a finality, the end of long meditation and preparation, and left unrevised. Even the Macchiaioli would take their *macchie,* their plein-air color sketches, back to the studio to "finish" them, to paint them *up.*

I love Courbet's drawing *Seated Model Reading in the Studio,* the subject caught "outside the frame" of formal studio work. How supple and thoughtless she is, slouching, a little distracted by what she's reading in her book. Another mood, violently unlike that one, is struck in his *Still Life with Apples and Pomegranates.* The teeming internal force of the pomegranates thins out the rind and makes it shine with fever-dream vibrance. They are full of some rage of nature, something left of Persephone's appetite, her passion and its consequences in the underworld. Courbet's realism is life lived twice, in the sensuous solidity of actual appearances and in the myth that memorializes it in another present.

What does a poet want?
—The thing life of paint, its immediate presence of image, without giving up the pure thought life of words.

Vasari says of Tintoretto: "He has surpassed even the limits of extravagance with the new and fanciful inventions and the strange vagaries of his intellect, working at haphazard and without design, as if to prove that art is but a jest. This master at times has left as finished works sketches still so rough that the brush strokes may be seen, done more by chance and vehemence than with judgment and design." Tintoretto's decision was more a kind of advanced abandonment. In a work like *The Removal of St. Mark's Body* in the Accademia in Venice the very sketchy brushwork is certainly intentional. Though it's now impossible to determine where Tintoretto's legendary haste and efficiency, his mercurial powers, became (if ever they were not) the testing of the margins of adequate representation. He pushed the representation of substance toward the spectral, toward the disintegration of corporeal solidities. And yet whenever he chose, he could be the most sensuous of painters, as in the Accademia's *Adam and Eve* and *Cain and Abel.*

Cézanne to his dealer Vollard, who was sitting for a portrait: "You must sit like an apple."

———————

You look at a hundred good pictures, then one begins to teach you all over again how to see. For me it's one of Degas's dancers, *essence* on an electric green ground of wove paper. Her tutu is just a zigzag gesture, the lower leg extended from the green, growing out of the color, defined only by the minimal outline of skirt. The mark makes a field of force. It's an image of a retinal impression re-emergent from memory—an act of exuberant, and maybe desperate, recovery. In the 1890s Degas's eyesight was going. He told a young painter: "It's all very well to copy what you see, but it's better to draw what you see in your mind. . . . Then your memory and imagination are freed from the tyranny imposed by nature."

———————

Caravaggio's *Sleeping Cupid* in the Palazzo Pitti looks like a dissipated miniature (or shrunken) adult, with his neat row of worn-down teeth and features already pouched and sagging with the delicious torment of too much pleasure. His wings are crushed, useless beneath the weight of his stupor. Although the turned, raised hip is conventional in putti, this cupid's moist, dimpled textures make his pose the stilled, seductive, exhausted repose after lovemaking. He's not asleep, he's drugged with tastes of pleasure and death: it's an image of exalted, slightly rancid existence. Caravaggio's two Emmaus paintings are identical subject occasions for expressing very different religious feelings. In the one in London, where Christ is a rather pudgy, unsolemn presence, the presentation is a journalistic thump, the thrill of an unlikely, unforgettable event. It's operatic in feeling—the stage set is elaborately dressed with a basket of fruit—and the light is a medium of surprise. The energy of the recognition that in Christ's presence the body has conquered death is worked out in the excited postures of one disciple gripping the arm of his chair and the other flinging his arms open. Both it and the version in the Brera are about the witness of restoration in the human order—restoration, that is, of the possi-

bility for redemption from the sufferings natural to the human order. In the Brera painting, less flamboyant and grandiose, less charged with newsworthiness, the disciple on the right whose face we see is almost incredulous, but it's incredulity roused by fright. At the moment of consecration, of the transubstantiating gesture changing bread into flesh, his hands grip the table in terror. The disciple on the left spreads his arms, but not in a plaintive or astonished way. Rather, it's a gesture of self-surrender. (His face is hidden; I think he's Caravaggio's self in the scene.) The innkeeper standing behind and slightly to the side of Christ is at least curious, but also skeptical and wary. He's more observer than witness, he's not so susceptible to the apparency of conversion, revelation, or awe. He leans away from Christ as if the power of the event were a contagion. He's the screen between Christ and the old woman, who has the look of readiness to abandon her consciousness to the resurrected God-man.

Van Gogh writing to Theo from Arles in September 1888: "I can very well do without God both in my life and in my painting, but I cannot, ill as I am, do without something which is greater than I, which is my life—my power to create." He could do without God but not without transcendence. What is that greater "something"? I think it is the consciousness which may be entirely one's own but which the artist, any artist, experiences and practices as greater and more inclusive than his own. That is how its reality is felt in one's working moments. It frees the artist into fearlessness and formal impiety.

Realism may be not so much the attempt, as Linda Nochlin says, to bring reality back alive, as a less conventionally mediated expression of eros, of the felt incompleteness of the artist seeking out the complementary incompleteness perceived in concrete reality. Painting is an act of marshaling and formalizing the evidence of that desire. Its passion is the engagement of that impossibility.

Delacroix in his journals exclaims, "How I love painting!" No artist ever worried so much about working hard enough. He counted and recorded the number of hours. He badgered himself into productivity. And he remained throughout an enthusiast, preserving himself from what might have become mastery mongering. (He didn't want to end up like Ingres, who was so preoccupied with good style that, in Delacroix's gleeful remark, "he preferred to be stupid rather than not to *appear serious*.") But love of the activity is not essential to the task of making good art. Did Cézanne love painting in the same way Delacroix did? Did Van Gogh, or Giacometti? Servitude, devotionalism, research, form finding, the obsession with impossibility and incompleteness and disintegrations—these are elements in the compound of modernist love and enthusiasm.

———————

In the Scuola Grande di San Rocco. It's with the faintest touch that Tintoretto's angel restrains Abraham, though the mortal's forearms are powerfully muscled—he has a Titan's god-defying musculature, here in service to divine command. Yet the faint touch of the messenger arrests all that force and will incarnate. In *The Baptism of Christ* the light the Holy Spirit sends down dissolves the flesh of the onlookers along the shore, turning them into scribbles of light. Below, at the baptismal pool, the Redeemer's destiny is already portended in the shadowy darkness, the meaty brownness of the earthly scene. The picture, as Matisse might say, is an image of the descent of light into the flesh.

———————

Lesser art does not challenge itself, does not become adversarial; it can only breed its own unquestioned, and sometimes quite moving, perfections. It's singular and meticulously idiosyncratic. Eventually it proves itself to be what its time wants, not what it needs.

———————

Baudelaire describes in the *Salon of 1845* the pleasures we can get from certain energetic but mediocre paintings: "Will-power has to be well developed, and always very fruitful, to be able to give the

stamp of uniqueness even to second-rate works. The viewer enjoys the effort and his eye drinks the sweat."

We attribute our own secular disinterestedness to Van Gogh when we think of him as a modernist saint on a mission to investigate forms. His impulses were as much religious and social as formal. He painted to offer his fellow earth residents some trace of redemption from the agonies of existence. We sometimes feel that desire in the arduous imaginative sympathy he showed toward his models. His intention was not to construct a formal portrait study but to make an image of an existence. When his models did not adequately meet this strain of existence, he filled the insufficiency with his own suffering resources. We hear it in the unsettling mix of knowledge, righteousness, and ingenuousness in the letters. To Theo he writes that his work "lies in the heart of the people, that I must keep close to the ground, that I must grasp life at its deepest, and make progress through many cares and troubles." When other artists speak of their working lives as a *via crucis* they mean it in a metaphorical, secularized sense: that the deep knowledge of forms or the realization of a work is an act of suffered redemption or justification. Van Gogh's mission was a more radical Christian one: he was artist of the Church Militant, the painter as pastoral warrior. The demands of love elemented his life and work. "The clergymen call us sinners," he says in another letter, "conceived and born in sin, bah! what dreadful nonsense that is. Is it a *sin* to love, to need love, not to be able to live without love? I think a life without love a sinful and immoral condition." (He was then suffering his unrequited love for the widow Kee, in 1881.) He possessed a radical Christian simplicity that in practice will often seem a derangement or idiocy. His painting was, of course, an attempt to achieve a right expression of a formal passion, but folded heavily into that was his effort to paint as an expression of love and of the need for love lest one (in his terms) be damned. The spastic riptide brushwork of some paintings bears out the rage of love. Paint's mass, color, and texture were love's substantiation.

The milliner's dummy in some of Degas's paintings is a little display platform for melting ribbons, crinoline, and plumage. The shop itself was a place where new facts of a bourgeois economy were displayed, as well as the relations between buyers and their desired objects, between the shopkeeper and her goods, between the owner and her assistant. Later on de Chirico, in his metaphysical paintings, takes over the milliner's dummy, undressed, for its stately anonymity, its muteness and abstractedness. (Even Morandi painted a still life with one of them.) The featureless head and upper torso become for de Chirico an item in a new sort of genre scene, the kind that exists in the artist's head, phantasmagorical and characterless. It appears not as an object of use but as a form from which features have faded. It's an image of erasure. The figures in his metaphysical paintings, unsurprisingly, look only this side of nullity.

———————

In the early portraits of his Uncle Dominique made with the palette knife around 1866, Cézanne was building by dismantling. It's unsettling, almost painful, to watch it happen, because he learned and progressed by turbulent, wrenching force. His undoing of the limpidities of likeness into broad viscous color armoring the picture surface—color heavy like shingles or reptilian plate, as if the paint's volume could be made equivalent to the voluminous density of the thing itself—was a necessary condition for constructing a painted image of nature. One of the excitements of the early paintings is the way we can see Cézanne trying to find his bearings, struggling with his instincts to perform the impossible task: to copy nature. In a painting like *The Black Clock,* with its oddly positioned cup and saucer and the tablecloth's gashed shadows and starchy folds, we can feel the exertion of his investigations. He was releasing into paint more immediately the bad humor and volatility he was known for. Up until the early 1870s, he was like a child in a contrary fairy tale who *throws* the stones he means to drop behind him to mark his trail.

———————

A Modigliani in the Barnes collection: a woman in a low-cut black gown, with the familiar cool, welcoming, aloof glance. The paint is all puckers and pinches. The surface—flesh and fabric and ground—is raked over. The woman's attentiveness is drawn with such controlled enthusiasm that, taken in at once, motif and execution pull us into the restless, serenely predatory presence of the subject.

———————

With collage the modern artist adds to his formal powers that of collecting. He becomes an archivist of the actual. He can take message givers, prescriptive signs, rhetorical persuaders of all sorts—wrappers, labels, newspaper clippings, photographic images, menus, printouts—and slant them into a defiantly nonprescriptive, unrhetorical painting. The private language redeems public debris; signs are saved to be made over into another existence. The master image also thus becomes a kind of archeological site seeded by the maker. The recovery of visual fact is fused in a figure-ground relation with oblivion. Collage may be an art form that thrives most in a culture that easily imagines every day its own ruins.

———————

There's often the spooked child, or wary forager, in Picasso's work. And he practiced the antagonism of magic. Sometimes the magic was apotropaic. He told Malraux that *Les Demoiselles d'Avignon,* which he called his first "exorcism painting," first came to him the day he went to the Trocadéro Flea Market and saw African masks. For Matisse and Derain, he says, they were sculptures, but for him they were instead magic items, useful *intercesseurs.* ("Ever since then I've known the word in French," he tells Malraux.) It was their power, and the contrariness or adversarial quality of that power, that appealed to him. "They were against everything—against unknown, threatening spirits. I always looked at fetishes. I understood, I too am against everything. I too believe that everything is unknown, that everything is an enemy! Everything! Not the details—women, children, babies, tobacco, playing—but the

whole of it. . . . [The fetishes] were weapons. To help people avoid coming under the influence of the spirits again, to help them become independent. They're tools. If we give spirits a form, we become independent." As a form maker he was sustained by his flaring rage, antipathy, paranoia, and superstition. For him the act of painting was a crueler, and at the same time more shamanic, activity than it was for Matisse and Derain. He rejected the idea that painting is a search or quest for forms—it was pure antagonistic making, inventing, striking out against the great emptiness of the *not me*. A good deal of his work comes directly from the sort of combative fear he saw given shape in those masks. The mask mediates between human need and self-knowledge and survival, and the sacred. Picasso said he wanted to find the mask of God, to make painting that would be the finding of the mask.

———————

For a long time Western artists expressed their sense of the sacred by depicting the shared subject matter of Christendom, which connected them to their audience. Eliade says that the sacred, in all times, is "the revelation of the real, an encounter with that which saves us by giving meaning to our existence." The emergence of nature, I mean of the natural sublime, in eighteenth-century painting, by which time traditional scriptural subject matter had dissipated into mannered pieties, was a reclaiming of the sacred. For Courbet and later realists, the purest revelation of the real was in the physical world, in what Courbet called the concrete, especially in human toil, in the material fastness of landscape, in the luminous sexual gravity of the female form. By the end of his century, the sense of the sacred is expressed in the visible manipulation of artistic forms and material. John Berger says in his book on Picasso: "The artist who finds his subject within his own activity as an artist did not exist before the end of the nineteenth century, and Cézanne is probably the prototype." The one god finally dissolved into a vague polyvalent presence available only in the action of paint, stone, line, etc. Form itself became a sacred subject, the *other* reality the artist sought. The motif could be familiar—still life, portrait of a gardener, landscape, bathers, dancers, laborers,

businessmen—but the real topic was the artist's way of seeing and imaging forth the given. The axis shifted: the sacred no longer inhered in the sublime, absolute presence of things, it was *worked* into manifestation in the forms made in response to that presence. The image wasn't a mediator, it was a generator, or genitor. It did not constitute a new liturgy, it expressed the reality of transcendence without the articulation and sacramentalism of liturgy. Someday it may all seem a massive nostalgia for what Western culture felt to be its home in gods who then fled.

In a 1930 portrait of his wife Elinor Gibson, John Graham builds the paint in puckered layers. The modeling is more energetic and inventive than in a lot of his other work. (He was mostly concerned with eccentricity of image.) Half the face is creamy rose except for the blackened eye socket that was one of Graham's pictorial signatures; the other half, picking up that darkness, is burnt-cork black. Half the face, therefore, looks like patient technique, maybe a little mechanical and overdetermined; the other is emergence and formal surprise. In his 1937 book *System and Dialectics of Art,* Graham wrote that a work of art is "a problem posed and solved." His work is engaging insofar as it slips that overmethodical definition. His women, with their crossed or walleyed gaze, look dazed but serene, a little stupefied, stunned momentarily by the fact of their consciousness, without the remote, unsurprisable intelligence of Matisse's women or the ravenous allure of de Kooning's. His women's stare hasn't much visionary tension or awe; it's mostly just odd, bent, off center. The oddness carries over into the later paintings that encode hermetic devices, lore, magical formulas, and occult imagery. They're alive with a playful intellectual hysteria, but I never have the sense that they're realizing themselves at the margins of some formal wilderness, despite his assertions about art posing and solving problems. There's not much menace in the work, as there is even in the depthless stare of Modigliani's women. But there is that charming, mysterious cockeyed look. His women keep the world in view only by half looking away from it.

Rilke, writing in 1907 about Cézanne: "[He] lays his apples on bed-covers which Madame Brémond will sorely miss some day, and places a wine bottle among them or whatever happens to be handy. And (like Van Gogh) he makes his 'saints' out of such things; and forces them—*forces them*—to be beautiful, to stand for the whole world and all joy and all glory, and he doesn't know whether he has succeeded in making them do it for him. And he sits in the garden like an old dog, the dog of his work that is calling him again and again and that beats him and lets him starve." The painter forces his motifs to be beautiful, as a poet forces his subject to be beautiful. But what does it mean to be beautiful? To remake in a language the full complicated intensities of existence. Then feel that you are even further than before from adequate completeness.

———

Two tiny bronzes by Giacometti from 1940–41. Mounted on large bases, the forms are smooth, and you can still see the rotundity carried over from the earlier surrealist work. But now, before he has gone over entirely to the figuration of his major style, he's still finding his way out of the conceptual harness of Surrealism and toward the confrontation with nature that will defeat and frustrate him for the rest of his life and will result in his greatest work. Within two years he begins to model the clay with an erosive passion that seems a helpless self-destructiveness. The roughed surfaces of the "new" work, after the sleek, curvilinear features of his surrealist period, become one register of his most constant anxiety—the anxiety of making an adequate finished copy.

———

Cézanne's *réalisation:* nature reported to us as fused existence. We see the fused whole of Mont Sainte-Victoire, or of a plate of apples and pears, or of a hillside with birch trees, as they are imagined to exist, not as one sees them. Cézanne insisted that he painted things as they are, for what they are, as he saw them. I think he meant he painted them as they are one thing, one image in consciousness. But the realization was also nature-in-its-becoming; therefore any painting was a volumetric history, geologic, stratified, streaked with

traces of emergence, fossil retentive. His short brushstrokes are willful, investigative, emotionally laden units of mass. What's made "real" in the reality of his painting is the buildup and incipient breakdown of nature's consistencies. In landscapes and even in some of the still lifes he pulls the hidden into view, onto the plane of the picture, and shows us the stress lines of that exertion. What is nature in captivity in a Cézanne still life? We not only see the surface of the fruit but also know that some surfaces and the masses they define are being pushed out at us. He paints the action of the desirous imagination as it seeks to know its object. He liked to say how badly he wanted to emulate in paint, in a still life, a tablecloth described somewhere in Balzac: a tablecloth like snow, with the little hills of rolls spread upon it. And yet why do we feel a momentary completeness of being when we look at his work, with all his constant self-confessed failures, his endless unsatisfactory "researches" (Vollard sat 115 times over three years for a portrait), the grinding habitual unhappy inadequacy of it all? Despite all that, which in Cézanne's case is to say because of it, *the all is there.*

Out of Eden:
On Alberto Giacometti

SAILING TO NEW YORK IN
1965 for the opening of the big retrospective show of his work at
the Museum of Modern Art, Giacometti wrote a preface to the col-
lection of drawings later published as *Giacometti: A Sketchbook of
Interpretive Drawings*. For many years he had made copies of im-
ages originated by others—a Rubens at the Borghese Gallery, a
Pinturicchio at the Vatican, a Matisse or Egyptian sculptures in
Paris, a Japanese print at his family home in Stampa. During his
transatlantic voyage, in his mind's eye he suddenly saw those im-
ages as an interfused but not undifferentiated community of forms:
"How can one describe all that? The entire art of the past, of all
periods, of all civilizations rises before my mind, becomes a simul-
taneous vision, as if time had become space." To his consciousness,
any interval of time could be transformed into a concentrate of
space; that continuous transformation was the purpose of his daily
work as an artist. His painting and sculpture do not represent or
dramatize time's passing and the changes it exacts. They translate
the feeling of time—of present, past, and what his friend Sartre
called the "project" of the future—into spatial relations, the most
crucial being the changeful pressure of an empty immensity on the
figures that inhabit it. The forms for which Giacometti is best
known, the skinny bronzes that seem unconquerably alert to the
unhoused distances on which they fix their gaze, are leached of an-
ecdote. Though many of the figures are in some gesture of motion
or stand in an attitude out of which motion might ensue, they have
been exiled from narrative time. This could be said about most fig-
urative sculpture. But in Giacometti's things time is converted into
the turbulence of matter laboring against the flaying, laving pur-
gatorial force of space. It is the torment of contingency. Giacometti
wanted to cast or fix the action of the pressure ("as if time had
become space") that he described in his preface. But in the course of
his life's work he achieved something else of profound importance
for the life of forms in our lives. In the dizzying, cavernous oil por-
traits and the fibrous bronze stalks of men and women standing,

walking, pointing, Giacometti made manifest the heroism of the encounter between the visible world and the testimonial eye, an encounter unavoidably inaccurate but driven by a fanatical self-revision and endlessly readjusted decisiveness. That was the empowering torment of his career, the products of which remain, in their startling resoluteness, magisterially unfinished.

As an undergraduate in the mid-1960s I used to frequent a small gallery in Philadelphia that once had on sale a small Giacometti pen-and-ink drawing of three figures. I remember it now as a skeletal revision of one of Cézanne's cardplayer groups. (Giacometti in fact made copies of *The Card Players* in the Metropolitan and also the one in the Barnes Foundation.) It called attention to itself not only because a master was being candidly answered by an obviously fervent admirer but because the answer was rendered in the feverish idiosyncratic exploratory style of a great successor. Like so much of Giacometti's work, even that unambitious sketch manifested the very process that brought it into being; the racing loops and slashes conjured figures that argued themselves into existence from the creamy void of the surround. As a "copy" it was a portrait of emergence. Probably dashed off like most of his drawings—he threw away bins full of those preserved from the hundreds more he drew, incessantly, on newspapers, napkins, magazines, tablecloths—it was as complete, as finished, as anything else he did. Which is to say that it was a completely realized failure to reproduce what his eye actually saw. Cézanne was in this, as in so many things, an exemplar. "Cézanne never really finished anything," Giacometti once remarked. "He went as far as he could, then abandoned the job. That's the terrible thing: the more one works on a picture, the more impossible it becomes to finish it."

An artist's confident feel for his materials can induce a chastening persuasion of failure, because a feel for materials intensifies one's vision of the perfectibility of the work. Giacomo Leopardi, one of the most diligent students of the failure of aspiration, wrote in his daybooks in 1821: "The more you understand the materials of your work, the more you see them and feel them in your own hands, the easier it becomes to push beyond, farther and farther, and to perfect even that which seems already perfect." This is also a

condition of self-nurturing despair: so long as everything is in pro-
cess of the realization of perfection, perfection is impossible. For
Giacometti, perfection was the accurate representation in plastic
forms of his retinal vision of reality. His vision, he insisted time and
again, was not penetrative, not a seeing into the essence of things.
Nor was it illustrative of a view of the human condition. (On my
visits to that Philadelphia gallery I sometimes carried with me
William Barrett's *Irrational Man,* the cover of which bore a repro-
duction of one of the tall walking figures that had had the unfortu-
nate effect of ordaining Giacometti existentialism's resident ico-
nographer.) Giacometti's task was not expressionistic. He wanted
merely to re-present the look of the object as he viewed it in its
space. His vision of things, in his plain and direct terms, was his
own kind of idealization. The oldest description of this desire
and frustration is probably Vasari's remark about Leonardo, who
"through his comprehension of art, began many things and never
finished one of them, since it seemed to him that the hand was not
able to attain to the perfection of art in carrying out the things
which he imagined." The persuasion of the unfinishable is not
therefore an exclusively romantic or modernist trait. It is the qual-
ity of a particular kind of artistic intelligence, one that treats all its
products as projects; its intentions are always in process of redefini-
tion or of merely provisional resolution. Giacometti's art is heroic
because the struggle with impossibility is emergent and fully articu-
lated in the actual work of his hands, undeflected by ironic elu-
siveness or righteous declamation. His way of looking at things was
so intense that his conception of a possibly perfected representa-
tion of a dog or cat, a human head (the dome, he called it), an arm,
leg, nose, wheel, "base" or *place,* was impossible to realize. He was
fated by the plasticity of his materials never to succeed at anything.
"Everything fails," he said. The only difference is of degree. He
complained, perhaps a little impishly, that if only he could find an
artisan with the technical virtuosity to represent what his own eye
actually saw, *then* he might be able to satisfy himself.

The crisis of representation was complicated by his working
methods. In a sense, his methods were the motor that drove the
machinery of failure. More than earlier artists like Leonardo, Gia-

cometti was caught up in the changeful life of his materials. The process of plastic emergence—the kneading, the paring, the hacking and gouging with knife and spatula—was an enactment of the stress of distance between his eye and its object of vision. Every figure he made in his later period acknowledges and measures that stress. Many kinds of representationalism follow, in their effects, the program of Browning's protorealist, Fra Lippo Lippi: "We're made so that we love / First when we see them painted, things we have passed / Perhaps a hundred times nor cared to see; / And so they are better, painted—better to us." Art, under this prescription, restores to us the timeliness of visible reality, which is morally improved in its representations. It is art as visual and moral enhancement that stuns us momentarily out of the dulled wits of habit. Though we know from his youthful drawings and paintings that Giacometti from the beginning possessed prodigious skills as a realist, he was concerned not so much with imaginative enhancement as with the process by which new images are forged. If realists of Lippi's (and Browning's) persuasion are most concerned with resolution of image and moral effect, Giacometti is instead committed to impassioned, inconclusive deliberation. For him, the measure of the image-making process is the squeeze or exhalation of space around the figure, and the continued snags and ravelings of stress within the material itself. From roughly the mid-1940s until his death in 1966, his chief work was to make manifest the strain of pure becoming. Because his paintings and statues record for us the quickened movements of his imagination—interrogatory, abrasive, reclamatory, nurturing, corrective—we become second witness to the way the imagination may be lived in and through. When he traveled to Stampa to visit his family, and on the few occasions when he was hospitalized, Giacometti always took along in shoeboxes (or matchboxes) clay figurines wrapped in damp rags, which he would work on whenever possible. He was always working. And it was not a mere busyness or neurotic activity, for "work" was the constant formative exercise of skills on material that might eventually, miraculously, coin the perfect representation of what he ordinarily saw. I do not know of any other artist of our time who,

crowded by the exempla of the enormous simultaneous past, so matter-of-factly conducted his art at the margins of what is possible.

The more than two hundred paintings, drawings, and sculptures that have been on view at the Gianadda Foundation in Martigny, Switzerland,* show the entire crisis-laden stream of Giacometti's career, from the crayon sketches done in his teens, through the tough uncertainties of the surrealist period, to the wise and solemn busts of Elie Lotar in 1965. The problem of the fated failure of his materials emerged in 1921, when he was trying unsuccessfully to finish a simple female bust. He later described his feeling of doomed ineffectuality as an expulsion from paradise: "Before that, I believed I saw things very clearly, I had a sort of intimacy with the whole, with the universe. Then suddenly it became alien. You are yourself; and the universe is beyond, which is altogether incomprehensible." He felt himself cast out of the familiar community of representational forms. The loss of clear vision meant the loss of the primordial home where there was an immediacy of relation, almost a simultaneity, between the thing seen and its imitation in paint or clay. Once expelled, he had to bear the curse of work, and his major chore would be the recovery of that now lost oneness. By 1925 Giacometti was already in exile from the figural in his sculpture, though not in his painting, where he managed to sustain sculptural feeling in his way of working the paint. In a self-portrait of 1921, the artist's three-quarter profile twists back toward us over his shoulder, his gaze defiant, void of wishfulness. The quilted coloring, both here and in a larger, more frontal self-portrait of 1923, is strongly suggestive of Cézanne's, but the action of the paint is muscular, the textures so dense that you feel the image has been modeled out of paint.

In his sculpture, however, Giacometti at that time was feeling more and more estranged from the human figure. Familiar definitions began to melt away. The features on the series of heads that he did of his father in 1927—in marble, granite, and bronze—are

* May 16–November 2, 1986.

nearly reabsorbed into the blank of the material. All suggestion of skeletal and carnal expressiveness is being planed away. The figure retreats more and more furtively into the anonymity of stone slugs. It's astonishing that, feeling himself expelled from his Eden, Giacometti did not collapse into chaos or despair. Instead, he struck his own temporary bargain with vision by resorting to a thesis: Sculptural representation is not emergence, it is *arrangement,* of concave and convex surfaces presented as idealized abstractions of natural forms. As a consequence, many of the pieces he produced in the late 1920s and early 1930s are spookily clean—polished and purged of all traces of the artist's exertions. They are a kind of willed (or trumped up) deliverance. The Gianadda show displays two versions of *Tête qui regarde* executed between 1927 and 1929. (The English title, *Head,* doesn't suggest the activity of looking which Giacometti intended; several of his early works are entitled simply *Tête.*) These are rectangular broadside slabs of glassy marble or bronze, druidic, anonymous, recondite. On the left side of the slab is an upright lozenge-shaped depression, on the right a concave ovoid. The effort behind these works is, I think, primarily to smother or conceal figural inflections. Their energy is all invested in a tremendous holding back of the will to externalize, to manifest. These are not negligible works, nor are they formal dead ends. Thirty years later, in the busts of his brother Diego and his wife Annette, that slab, ridged and roughened by the swarming return of human features, will turn to face us, like the jagged blade of a ruined ax head. Convinced as he was in the 1920s and 1930s of the failure of his vision ("Before that, I believed I saw things very clearly") Giacometti coded into those near-blank forms, into the *Tête qui regarde,* the disappearance or unfindableness of the human gaze.

The concave impression became a more important, and less mystifying, physiological sign in Giacometti's female figures. In a hermetic monumental bronze like *Woman* (plaster, 1927–28; cast in bronze, 1970), the round scoop of the feminine occupies nearly half the statue's surface. It's an abstract work insofar as it is abstracted from, not representative of, the image in nature, and like much of Giacometti's work from this period it is guarded and

affectless—it might be a signpost, menhir, or club. The best known and most statuesque in this family of forms is the large bronze *Spoon Woman* of 1926. Her entire torso is a concavity, a cobra hood spread atop a narrow pedestal. The *Spoon Woman* has a strange talismanic effect. You sense sexual force momentarily in check, but with possibly tremendous engulfing power. Formally, it is assertive, exercising the traditional sculptural sovereignty of matter dominating and restructuring its surrounding space. But its stolid forms take the edge off sexual menace. The torso catches available light in its shallow bowl, but there is nothing reactive in that encounter. The avoidance or difficulty of giving more immediate expression to sexual force led Giacometti finally to the operatic expression of sex fear in *Woman with Her Throat Cut* (1932), probably the most notorious of his works and the one that draws more shocked, titillated attention than any other single work he produced.

The sprung ribcage lies in shattered repose, but it is also a sex trap, the sharpened staves triggered to snap shut. The woman's legs, splayed wide as if hooked in delivery-room stirrups, push her pelvis up in a hideously ambiguous attitude of torment *and* availability. The impossibly long chain of neck vertebrae arcs forcefully upward like the legs and the inverted ladle of her belly. It's as if the studiously determined concavities of Giacometti's spoon women had been angrily pulled inside out. The almost hysterically expressed sexual dread in this image might be less outrageous if it were not also so programmatic. The horrific sentiment is worked out in contrived, semiabstract terms, the skeletal contortions, gruesomely pictorial, played off against the featureless abstraction of the upper torso and head. There's a vaguely spiteful glee in the tone—a woman murdered in what seems a moment of self-offering—which is the Surrealist's glee in overdetermined shock effects meant to outrage the norms of bourgeois pictorialism. *Woman with Her Throat Cut* is not a frivolous or wicked piece of work. Giacometti was temperamentally incapable of frivolity and uninterested in moral effects. But this and other things usually listed in the roster of his surrealist works (*The Palace at 4 A.M., No More Play, Hand Caught by a Finger [Main prise], Disagreeable Object*) seem to

me productions of an artist so stricken by his fall from the Eden of innocent representations that he elects a program of contrived images as a stay against inactivity and as a willed continuance while he tries to find his way back. In any event, Giacometti lacked the snickering bad-boy wit and antic buoyancy of the surrealist intelligence. His troubles in the late 1920s and through the 1930s are evident in the impoverished plasticity of his materials. We do not see the clay and plaster toiling in the finished work. This is most conspicuous in the stacked angular catwalks of *Reclining Woman Who Dreams* (1929) and in the crossbarred penitentiary grid of *Man (Apollo)* (1929), the two most industrial and architectural of his works in bronze, where his subject is not being reimagined in and through the material. Giacometti's exile from the garden is truly an Adamic drama in that he lost faith in his ability to model nature in clay. His chore thereafter, and his curse, was to win back that enabling faith. And that in turn required a journey of self-restoration toward a new Eden where he would never, could never, arrive.

He once told his biographer James Lord that all during the surrealist phase he knew he would sooner or later be obliged to go back to nature: "And that was terrifying, because at the same time I knew that it was impossible." There are signs of that return as early as 1932–35, the years of the tall tubular *Nude* and *Invisible Object (Hands Holding the Void),* with its owlish, contrite female visage. Though the spookiness of the surrealist mood is still on him, and although he even experiments with cubist volumes in *The Cube* and *Cubist Head* (both executed in 1934), Giacometti is being more attentive to the model. His return was contested at every point, however. The more he looked at the model, "the more the screen between his reality and mine grew thicker. One starts by seeing the person who poses, but little by little all the possible sculptures of him intervene. . . . There were too many sculptures between my model and me." His relation to the natural figure was hopelessly complicated by all the mediating serial possibilities of representation. That kind of plenitude freezes progress. In the searing magnificence of his later work we can actually read or imagine, in the heft and texture of the final "abandoned" product, the inter-

vening forms that mediated its progress. In light of the crisis he had to work through in the 1930s, it's remarkable that Giacometti did not seek shelter in self-glorifying parody or the preciosities of an "art of exhaustion." Instead, he absorbed the very threat of dissolution, or dissipation, into his newly developing form language as a kind of apotropaic act, to make his despair breathe deep within the formal life of the work. Around 1937 he tried to model a complete figure in plaster, a standing woman about eighteen inches tall. The figure grew smaller and smaller beneath the exertions of his knife until the needle of chalk crumbled. That was no self-canceling gesture. It was the as yet unredeemable consequence of an artist's desire to answer to his vision by interrogating his materials. It was form pulverized by the desire for form. In this respect, too, Giacometti is Cézanne's great successor, for both of them made the action of their materials—their *work*—supremely and devastatingly answerable to what their eye saw.

The emergence of the famous late style required a purging of vision. It required revelation. In 1942–43 Giacometti produces the first *Woman with a Chariot*. (The "chariot" is a nurse's cart he had seen in a hospital.) The figure already suggests the new sculptural form he is working toward: the woman stands upright, legs closed, hands locked to her sides, with little definition of feature except for the rather innocently exposed bulge of sex. In 1945 he produces two figurines, each mounted on an oversized square pedestal; both are about four inches high, including base. The figures are mere slivers, fantastically reduced versions of the human offered up like sacrificial victims on altars, or chopping blocks. In 1946 came the revelation. Watching a newsreel in a movie house, Giacometti suddenly realized that the screen image was just a montage of dots on a flat surface, whereas the reality around him, which until that moment he had always viewed photographically—as if the world were a composite of colored figures and swatches of light on flat surfaces—was something altogether different. He experienced what he called "a complete transformation of reality, marvelous, totally strange." Space thickened around bodies, pinching and abrading them. The body's topography roughened into sinewy, craterous exposures. The head seemed at once islanded and enraptured by its

aura of emptiness—the stricken skyward cry of *Head of a Man on a Rod* (1947) is one answer to that aura. Giacometti's new vision, to which he brought the intensity of gaze that he had been sharpening since childhood, was of a preternatural embodiment of the human form in nature. He was witness to, and forger of, a baffling restoration of appearances. The stress of space determines form, but space as a measure is itself changeful, indeterminate. That indeterminacy is caught in the molten eruptive surfaces of all Giacometti's later works in bronze, and it is momentarily held in check by the tentative housings—the boxes, bird-cage halos, and cloisters—that frame the heads in his oil portraits. The things from the major period seem to have been let go, released, only moments before we bear secondary witness to their becoming. The blistered erosions of the busts seem still to be cooling. The isolated gestures—the head on a rod; the outstretched arm with its bony, panicked hand; the alarmed stillness of a cat; the dirt hunger of a dog—seem each a pause in the stream of pure becoming. If Giacometti's is an art of agony, it is because at its heart is an agon, the contest between space and matter, and the intelligence that seeks to represent it. The slabs and blanks of the earlier work are gone, replaced now by the armature, the stake, where the work of the agon takes place.

With the emergence of the major style in the 1950s comes a more complex and fine-toned presentation of the female form. Each of the five statues from the "Women of Venice" series on exhibit at the Gianadda (Giacometti produced ten of them for the 1956 Biennale) bears a different sexual character. One figure's breasts are splayed, another's bulbous and low-slung, another's melted nearly flat. In each, though, the breasts are sexual eruptions on an otherwise disinterested heraldic stillness. The ambiguous sense in each is of power restrained *and* a haughty indifference to that power. The measure of sexual availability or offering varies statue to statue. One figure's hands are fused to her thighs, the pelvic area recessive, protected, with no hint of sexual availability. In another, the entire torso is brittlely concave, punched in, the belly reminiscent of the spoon-woman form; her shape bears an unembarrassed sexual welcome, but her face is twisted into a sneer or grimace. The apparently candid invitation is chilled by her sar-

donic, faintly contemptuous reserve. Giacometti's female figures never express the somnolent ecstasies of Brancusi's women, and they don't have the archetypal bombast of many of Henry Moore's queens and mothers. And yet the inflections of sexuality in his work are surprisingly rich. He commands nearly all the registers of the testing or trying out of sexual feeling, sexual mood. And unlike Brancusi's and Moore's representations of women, Giacometti's are not so easily owned by the male eye. Even when a figure seems most welcoming, its feeling tone is never pure; it is inescapably mixed with suspicion, regret, sullen withdrawal, or clenched aggressiveness. All this becomes painfully obvious by comparison with the most disconcerting and vulgar piece in the Gianadda show, the bust of *Mlle Télé* (1962), where coquettishness is rendered in such conventionally vampish terms—the lifted shoulder, the cocked head, the "fetching" expression—that the figure's sexual charm is trivialized. There is plenty of sexual charm in Giacometti's work, but it is effective (and true) only when blended with the sort of black magic that promises transformations at the edge of a darkness.

Like the free-standing constellation of the "Women of Venice," the *Four Women on a Base* (1950) is remarkable for the painstaking differentiation of the figures. One pouts, one grins (rather mischievously), another cringes as if fear-struck. The fourth and tallest is clearly the dominant member of the clan. Each sexual gesture is different, measurable by the half-closed hands flaring from the hips. The attitude of the figures, their stance, is a way not of occupying space but of inhabiting it, as if the air were their culture, shaping them while they shape it. Giacometti painted this and many other bronzes—often at the last minute just before an opening. After his breakthrough in the late 1940s, he could never leave his work alone: once back in his sight, "finished" paintings and sculptures were sucked again into the vortex of his desire for the impossible perfect representation. Usually, as in *Four Women on a Base,* he streaked or daubed the bronze with reddish, creamy, and grayish tints. The first effect is to dramatize the topography of the figure, to provoke a reaction from light's impingements on matter. But the effect is particularly odd with female figures, because it

makes them at once gaudier and more intensely secretive, their sexual character enfolded more cunningly in disguise. For all their diversity, the four figures share their platform, the elevated rail or ledge that anchors them in space and also binds them in a tribal relation. It locates them, naturalizes them, in what we can imagine to have been an unpopulated waste. From the 1940s on, the form that becoming takes in much of Giacometti's work is a risenness; the standing figures seem recently emerged from the ground—they are The First Ones. Before anything else they are expressions of vegetative force. Thus Giacometti gives the title *The Forest* to a group of seven standing figures and a small shrubby bust arranged on a shallow concave ground; and *The Glade* to a tribal grouping of nine odd-sized reedy figures. In both ensembles the human stalk rises from a warped, seething earth.

The genesis poetry prevails also in city representations. In *Man Crossing a Square* (1949) the forward lean of the figure across his public space is retarded by the strangely crystallizing elasticity of the ground. He uses his spatulate hands like paddles to coax his way freer of the earth's pull. The viscous space he moves through drags him back even more. And yet his head and face are gnarled with resolve, beautifully detailed in the knot of muscle at his jaw. Giacometti's walking figures inevitably have a purposefulness which the standing figures lack. If the standing figures suffer the air of contingency, the walking figures lean into it, resisting its sorrows. The movement of *Walking Man II* (1960) is the quotidian tilt of curiosity tensed toward some destination; it is the will impelling matter away from the mud pool. The squared, big-booted feet of walking and standing figures alike are the gritty, magmatic residue of material creation. The tree that Giacometti designed for a production of *Waiting for Godot* seems grown out of *The Leg,* which is seven feet high and looks like a young tree shattered by lightning. The two essential facts after the loss of Eden are that nothing is ever finished and everything in some way fails.

Giacometti's movie-house revelation deepened the sense of estrangement that followed his earlier loss of intimacy with nature, but it also initiated his journey into the mysteries of otherness, to-

ward a recovery of the visible world in the forms of sculpture and painting. In his late work the will to encounter and recover takes the shape of auroral greeting. Not a gesture of hopeful anticipation and not anything as vulgar as optimism, the greeting is a primeval moment in the strenuous task of becoming, in which the figure acknowledges and goes out toward that which is other. The mood of the greeting, especially in the busts Giacometti produced in the mid-fifties, changes from work to work—stoical, impatient, wondering, fear-struck, quizzical, arrogant, bemused—each expressing some sort of pained attentiveness on the long morning after the fall from Eden's golden unities. In *Diego in a Jacket* (1953), *Diego with Sweater* (1954), and *Head of Diego* (1955), all the inchoate force of the Titan's torso rises up and concentrates in the roughened, charred ridges of the narrow head, which inhabits only a slot in space. And yet we cannot see past it. Its gaze stops us. Its acute attention is so aggressively outwarding that it traps our attention in its greeting. The tragic energy of these works is plied into the gashed, restless textures of the bronze.

The relation between Giacometti's sculpture and painting is one of the major conversations in modern art. On canvas he could shape and color the action of space around his subject, then translate those relations back into the volume and elasticity of clay. The pressure built up in the sheer bulk of a sculpted torso could not be achieved in the frontal, two-dimensional presentation of portraiture. The auroral greeting in the portraits is therefore fanatically concentrated in the face and eyes. In *Diego* (1958), *Head of a Man* (1956; Plate 5), and *Portrait of Yanaihara* (1959), the head unscrolls from a bituminous murk—the greeting is an arduous attempt to see out of an enveloping darkness. We can feel Giacometti trying, unhappily and with his typical sense of fated failure, to hack resemblance out of the resistant mass of undifferentiated colors. In these and later oil portraits, as you look away from the wiry loops and nodes of the darkened face—the eyes are craters, instruments nearly burnt out by overuse—the paint thins out, the scarifying blacks and blue-grays run a feebler smoky white. Portraiture, like sculpture, was for Giacometti expressive of the agony of its making. Just as he painted his bronzes at the last minute, he could not leave

his paintings alone so long as they remained in his studio. In three portraits of Diego done in 1964, the image is a history of the passionate self-corrective energy that brought the image into existence. Giacometti made a whole art out of *pentimenti.* First to finishing stroke, each act of figuration was in some way a *pentimento.* It was the only way he knew to arrive at a representation of what he called "the simple thing seen."

Around 1964, the emotional tone of the paintings changes. The febrile gaze of the portraits from the 1950s softens to a more aloof self-containment. The greeting is not so electric with the possibility of surprise or revelation. By this time the sculptures have changed, too. The heads thicken, broadening and filling out into more classically spherical forms, no longer so whittled and crimped by space. The two busts of Diego from 1965 included in the Gianadda exhibition show at once tormented exertion and withdrawal, the neck craned forward, face buckled and sour, skull and shoulder cavities emaciated, cadaverous. The greeting is sustained only at great physical cost; the human form seems to be collapsing into itself, such is the effort to preserve its attentiveness. In an oil portrait of Diego from 1964, the subject's head is nearly lost to its black ground; out of the little dome shine splinters of light, like bird bones. The following year, however, Giacometti produced three of his finest works, the busts of Elie Lotar. Lotar was a sad, familiar figure in Giacometti's circle, a failed photographer, destitute and alcoholic. (Giacometti not only used him as a model but also more or less took him in, letting him run errands and do odd jobs around the studio.) The torsos of the Lotar sculptures are more combustive than ever, but out of that turbulence rises a solemn, piercingly handsome, imperial head. The calm, alert eyes, welling out of deep pouches, cast the unsurprisable gaze of a being who greets the world by awaiting its manifestations. Desire, expectation, anticipation, all evaporate in the dispassionate regard of Lotar's gaze. The human figure is not resigned, certainly not self-abandoning, but it is no longer driven or terrified either. The strain of becoming so elaborately inflected in the previous work momentarily resolves into a fearless *amor fati,* a condition just this side of irrational joy, though the figure expresses no joy at all.

Two of Giacometti's heroes were Giotto and Tintoretto. Early in his career he was overwhelmed by the Scrovegni Chapel frescoes, the figures "dense as basalt, with their precise and accurate gestures, heavy with expression and often infinitely tender." The weighty tenderness of the Lotar busts has its source in that early discovery. Giacometti said that Giotto replaced Tintoretto in his affections, though he had loved the Venetian's work "with an exclusive and fanatic love." And yet I think it is Tintoretto's influence that was most formative, especially for the work of Giacometti's later period. In formal terms, he took over the geometries of passion he found in Tintoretto, the smallish heads yearning from overmuscled, squarish bodies, the human figure—as in *Cain and Abel*— a bundle of volcanic torsions. And it is Tintoretto, not Giotto, who in his decorations for the Scuola di San Rocco gives us the carnal immediacy of mysterious emergences, transformations, and manifestations—image after image of agonized greeting. Giacometti, the least devout of men, possessed that sense of life as a suffering toward recognitions of reality which I think is the essence of heroic religious feeling. He believed not in redemption or arrival but in the fully experienced continuity of existence, in the need and desire to return to our imagined source, to the lost garden of perfect recognitions and representations.

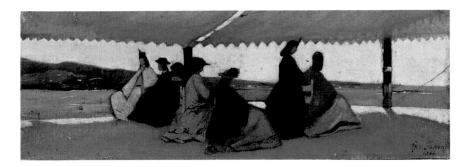

1. Giovanni Fattori, *Rotonda di Palmieri,* 1866.
Oil on wood, 12 x 35 cm (4¾ x 13¾ inches). Galleria
d'Arte Moderna in the Palazzo Pitti, Florence.

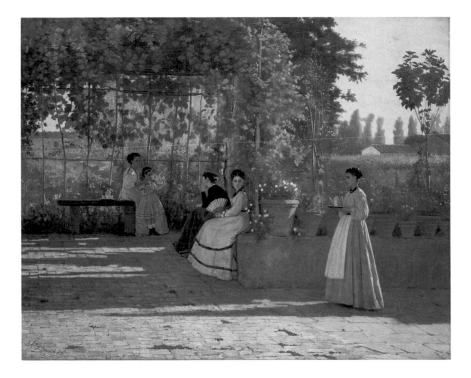

2. Silvestro Lega, *The Pergola,* 1868.
Oil on canvas, 75 x 93.5 cm (29½ x 36⅘ inches).
Pinacoteca di Brera, Milan.

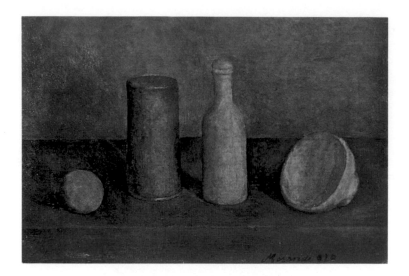

3. Giorgio Morandi, *Still Life,* 1920.
Oil on canvas, 30½ x 44½ cm (12 x 17½ inches).
Galleria Comunale d'Arte Moderna
"Giorgio Morandi," Bologna.

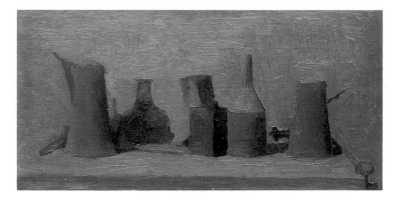

4. Giorgio Morandi, *Still Life,* 1935.
Oil on canvas, 30 x 60 cm (11⅘ x 23⅗ inches).
Private collection, Mestre.

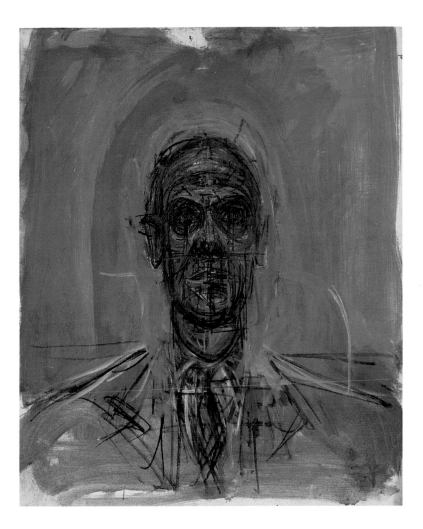

5. Alberto Giacometti, *Head of a Man,* 1956.
Oil on canvas, 42 x 33 cm (16 ½ x 13 inches).
Private collection, Switzerland.

6. Henri Matisse, *The Rococo Chair,* 1946.
Oil on canvas, 92 x 73 cm (36⅕ x 28¾ inches).
Musée Matisse, Nice.

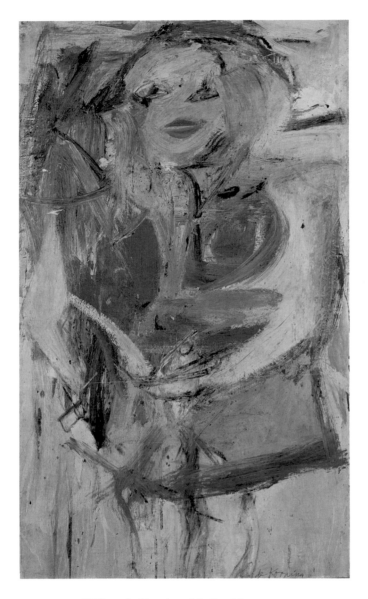

7. Willem de Kooning, *Marilyn Monroe,* 1954.
Oil on canvas, 50 x 30 inches. Collection of Neuberger
Museum, State University of New York at Purchase, gift
of Roy R. Neuberger (Photo: Steven Sloman).

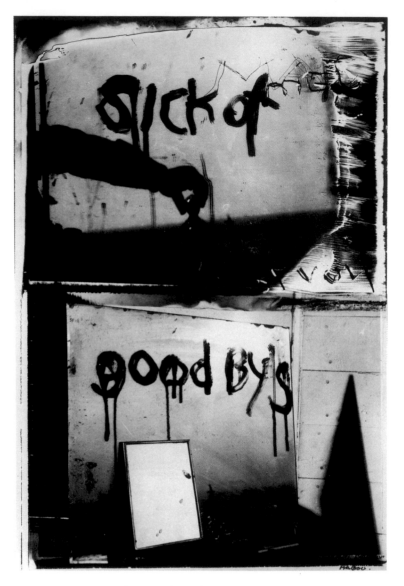

8. Robert Frank, *Sick of Goodbys, Mabou 1978.*
Copyright 1986: Robert Frank. Courtesy of Pace/MacGill
Gallery, New York.

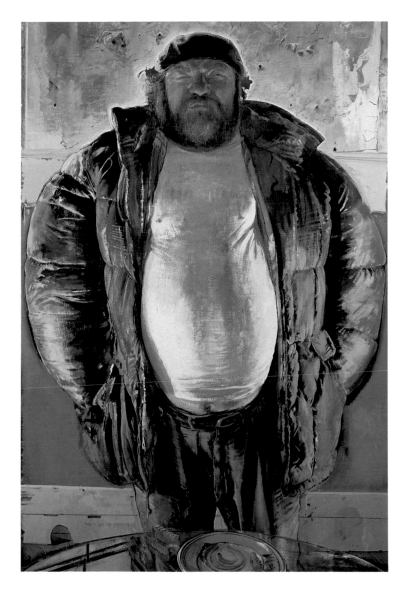

9. Jerome Witkin, *Jeff Davies,* 1980.
Oil on canvas, 72 x 48 inches. Palmer Museum of Art,
The Pennsylvania State University.

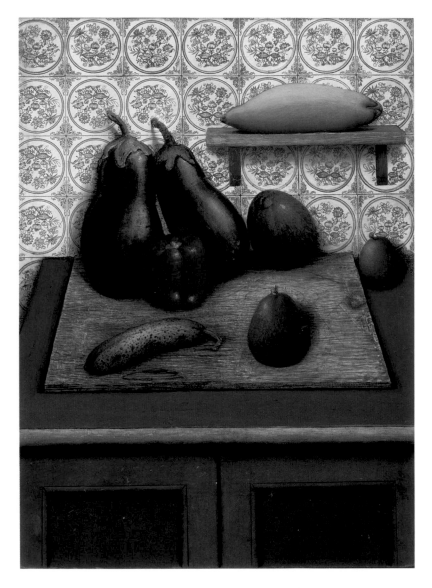

10. Gregory Gillespie, *Still Life with Eggplants.* 1983.
Mixed media on panel, 41¼ x 30⅛ inches. Private
Collection. Courtesy Forum Gallery, New York.

Notes on Photography

IN ITS CHILDHOOD PHOTOGRA-
phy was already a memory garden of antiquities. Many of the earliest images were of ancient ruins and religious monuments in exotic locales, like Captain Linnaeus Tripe's huge monochromes of the palace in Madura, India, taken in 1856, or Francis Firth's pictures of the pyramids and the Temple of Karnak. The subjects were in part determined by the limited technology of the view camera, with its delicate chemically treated plates that required long exposures. But when we look at a picture like Maxime Du Camp's *The Colossus of Abu Simbel,* where a human figure slouches minutely against the shoulder of the huge pharaonic pile as a measure of its immensity, we feel some of that rapture for mass which early photographers must have experienced. The desire to "view" a piece of civilized antiquity or ancient wilderness was also a memory act to interrupt the procession of the world before the eye and ritualize its moments. Photography intervened more purely and innocently than painting because it took material reality as its form language. The physical scene, received by the ground glass and fixed on a support, could then be reviewed. Natural forms were thus restored in memory by a new kind of representation, new because it was more an act of transmission than of transformation. The new representation was a fossil language.

One of the first tropisms of the photographic imagination was toward the race's earliest memories, the relations between mortals and gods. Any tropism is articulated by the view framed by the image maker. In Firth's pictures of Egyptian monuments, in Carleton Watkins's and Eadweard Muybridge's photos of the Yosemite wilderness, we see preserved an archaic vision of the universe's design: the ether separated from the underworld by the earth platform on which the work of civilization is enacted. Men like Firth and Du Camp were, I realize, "just making pictures," and having an adventurous time of it, too. (Early photographers were an odd frontier company of adventurers, bemused amateurs, pioneers, gentlemen of leisure, and professional scientists.) Yet when I look at those old monochrome prints I'm convinced that the instinct be-

hind that documentarian activity was to steal out of time the image
of a relation time itself has determined. John B. Greene's *Algeria,
Village and Cliffs of Constantine,* taken around 1856, shows a vil-
lage running along the narrow shelf of a high cliff; that human con-
struct meant to relieve the terrors of contingency and necessity oc-
cupies a tremendous pressurized space, spread like a sacrificial
offering between sky and earth. The village is an image of mediat-
ing human consciousness and of its interventions grown (or, as it
looks in the picture, erupted or oozed) from those two forces. It's a
vision of the episode in a genesis story when mortals contrive their
first habitations between the sky gods and the sunless corridors of
the underworld.

One early American genesis is narrated in Timothy H. O'Sulli-
van's *Indian Pueblo, Zuni, New Mexico, View from the South* (1873).
The Zuni structures seem momentary resolutions of contingency
built upon sacred earth. Ladders run like pickets along the terraces
of stacked adobe apartments, and thatched lean-tos spike heaven-
ward across our line of vision. The image articulates religious con-
sciousness. One version of the Zuni genesis tells how the sky god
Awonawilona, mixing his flesh with water, compounded into exis-
tence Mother Earth and Father Sky, who then conceived all life in
the womb of the earth, out of which emerged the first human be-
ings. O'Sullivan, manipulating the time-absorptive machinery of
photography, fixes a memory of human tenancy and stewardship.
He had worked earlier with Mathew Brady, and his picture *A Har-
vest of Death,* taken after the Battle of Gettysburg, is a terrible im-
age of the devastations of that stewardship. The four corpses spread
upon the stubble field seem to have been newly shaped out of that
same ground and soon to be reabsorbed by it. To document and
remember the death of nature is the correlative tropism to that of
viewing genesis and the primordial relations of mortals to gods.
One does not have to believe in divinity to believe in the way forms
generated by the traditional religious imagination have determined
the directions and contents of consciousness.

Those photographers were enthralled, too, by the frontal, wholly
available innocence of their subjects, and their craft was at such an
early stage of development that their own curiosity inhaled some of

that innocence. The drama the photographic image represented, then and now, was often that of the apparently unmediated encounter between photographer and subject. It wouldn't take very long for photography to become also the most brutally sardonic witness to that encounter. Certainly the memory and possibility of innocent witness still haunt the contemporary photographer. The most endearingly spooky image I've ever seen is one of the earliest, Fox Talbot's calotype *Articles of China,* done around 1840 and included in his pioneering book *The Pencil of Nature.* On the four shelves that occupy the frame sit cups, tureens, saltcellars, bowls, vases, and other bric-a-brac. A startling innocence beams forth from them, they are such pure offerings to the gaze of consciousness. Milk pitcher, squat crystal vases, ceramic figurines of a country lad and maiden holding flowers—they possess a presentness undisturbed by any history of use. The lad and maiden are utterly unsuggestive; they do not return our attention to the life of nature. No object has the enfolded, flexed surfaces that might draw us into the life of those stilled forms. (Nearly a hundred years later, Edward Weston tried to create precisely that invitation into the formal life of the image.) Talbot's little things arrive in their image moment with no chronicle of use, no natural history. This purity of presence is another mystery photographers feel driven to document: the look of things as if they had never been seen before, never been possessed by consciousness. And yet most image makers are equally compelled to derive from the given subject a singular formative vision. One way we can get at any photographer's work, after we've identified the tropisms that guide him or her to certain subjects, is by trying to articulate the artist's inevitable disturbance of the primitive innocence of an object in its place.

Several years ago I saw a series of pictures of Chicago's deep tunnel project (a public-works euphemism for the world's biggest new sewer) taken by Patricia Evans. Down inside those huge vaulted channels, illumination is supplied by enormous beacon lamps that solarize the air and in the pictures create phosphorescent blasts that chafe against the tunnel workers, the heavy machinery, the ridged and buckled rock wall. Evans follows Lewis Hine in exam-

ining the situation of workers whose job is a sort of provisional interment, but unlike Hine, who was primarily a social reformer and documentarian, she is enthralled by the artificial incandescence played against the rock-bound dark. Her eye is keen on the life source of the overworld brought down there to help humans find their way as they go about the work of civilization. The cables that coil and shoot into the distance and across our line of vision are delicate, life-sustaining arteries. In a way, Evans's curiosity is disturbingly exclusive. What interests her are not the conditions of work so much as the declensions of light upon that task of making systematic use of a chaos. In one picture, taken from what must be a catwalk or elevator about forty feet high, several workers below have just walked out of a dark foreground into the shivering definitions of the middle-distance lamplight. Another worker is blotted out by the darkness except for the luminous coin of his hard hat. The massive rock bulking everywhere at the illuminated perimeters at once stops light's progress and gnaws back at it.

The great predecessor of Evans and Hine was Nadar, who in 1862 made a series of images of the Paris sewers and catacombs. (He really drew the compass of the photographic enterprise: he also took the first aerial photographs.) Nadar's tropism, the direction of *his* imagination, was not so much toward the light source transported (at great expense and, in 1862, superhuman effort) from the overworld, as toward the look of the space where man-made contrivances—the struts, frames, and braces that organize the underworld for practical use—resolve to oblivion. In one image we see lopsided archways telescoped down toward a nearly perfect rectangle of blackness. That's the compositional center around which all the human interventions are tensed. In Evans's work the light is seen as a constant, necessary scouring against the encroachments of rock; in Nadar's the light is sucked away by the void at the center of those braces. Since the very activity of drilling and gouging channels in the earth and constructing formal passageways, apertures, clarifiers, and retainers is an analogue for intellection, both image makers are giving form to the desire to know.

The human arrangements down there are provisional, and photographers who make the descent are archivists of disarray. The

starkness with which photography represents disorder (or the absence of an order imposed by intellect) is always more charged and shocking because it works with the given fact of the scene. A painter seeks to master subject. A photographer's work depends on the willingness to be mastered by what's given. In Nadar's own time, as if to close the circuit of vision photography would henceforth command and investigate, American photographers like Watkins and Muybridge were acting as archivists of the pristine jumbled orders of the wilderness. In Watkins's images especially we see at once how diversity—the smallest inflections of mass, height, and girth in a stand of pines—resolves into magnificent likenesses. Within the blocked-out uniformities of pines are countless minuscule differentiations of sunlight stripping and exposing the textures of bark, branch, canopy, needle. The tangled disarray of untouched wilderness presents itself as huge jarring harmonies. In Watkins's images of Yosemite, so different from the obsessively self-conscious magnitudes and exaggerated epiphanies of Ansel Adams's work, the sharply defined entanglements of moss, grass, streambed, brush, and gully create a webwork that strikes the eye as a haphazard interfusedness so meticulously designed that the mind, acquainted with contingency and becoming, strains against that vision. What is conspicuously not knit into that world stuff is the human figure. When he appears in Watkins's images, he looks like a not very bountiful sack of potatoes, all sags and burlap bulges. Like the human figure slouched against Du Camp's colossus, he's there only as a mindful, disharmonious, puny measure of the earth and sky.

One of the revelatory enterprises of photography has been to see the human figure as material reality grown out of or worked into a place, rather than merely inserted there as a measure of the surround. Some of the most astute and unforgiving visions have come from photographers like Robert Frank and Paul Strand, who were just as much strangers to their subjects as were Firth, Du Camp, and Greene. When I first saw Robert Frank's *The Americans* in the early 1960s, its images had already acquired an almost primitive religious force among college students like myself. We passed around our one battered copy, narrated and quarreled over its images,

whose disquieting guilelessness seemed not irony but a roughed-up innocence. The locales were nearly as exotic as Lampur and Madura: Arizona, New Orleans, Mississippi, and (for a South Philadelphian like me) Hoboken. And yet for all the moody angularity of the images we recognize the forms of a distinctly American feeling, perhaps because as a people we feel as if we are always arriving at new recognitions of our strangenesses. Frank, of course, is a European, a Swiss. His images were made in a kind of permanent exile, and he eventually went off to settle in Nova Scotia, land's end.

Another book we read and quarreled over as if it were revelation was *Let Us Now Praise Famous Men,* less for the too meticulous pathos of James Agee's prose than for Walker Evans's pictures of impoverished Alabama tenant farmers. Evans's vision was more concentrated and "naturalized" than Frank's. He documented faces whose adult ages were often impossible to guess, the result of a cruel system of using the earth. The emotional register in those pictures is intense but narrow, since their effects are so exclusively determined by moral selectivity and reformist impulse. (We see the same narrowness in Lewis Hine, and for the same reasons.) Frank's pictures were not of a specific economy or society under duress. They range across class and racial lines, landscapes, social groups, public and private events, and ceremonies. The tones are more mixed, therefore, and vexing. I think Frank actually saw more in his viewfinder, or allowed a wider possibility for what might be given, because he was most of all concerned with the action of forms on the photographic paper. And this is the essential liberation from the documentarian purpose. Walker Evans's pictures have an evangelical force, and they memorialize a particular kind of hunger and want in its historical setting. But it is Robert Frank who possessed the more innocent, inquiring, visionary eye.

I recently saw again, after many years, a large print of Frank's *U.S. 66, Arizona.* It struck me as an image that must have entered my dream life, it seemed immediately so familiar yet unaccommodated, something once slipped from memory now vividly restored. Great photographic images perform this sort of visitation more keenly than paintings because the representational forms are printed directly from the forms in nature. They come more immediately on

to our nervous system. *U.S. 66, Arizona* looked now like a modified version or "imitation" of O'Sullivan's Gettysburg picture, though all the horror in Frank's image—the scene is a highway traffic accident—broods in the folds of the blanket that covers the victims stretched across the broad central foreground. Behind the bodies stand five people, each angled slightly differently toward the corpses, each attitude disclosing a way of receiving the event, a ceremonialism of feeling. They stare at the blanket. No one weeps. Behind them, in the distance, an architectural procession spans frontier history: a 1950s ranch house with a picture window and venetian blinds; left of it, the mouth of a garage; then a squatter, older, more makeshift house; then a structure that looks to be an outhouse, and next to it a tumbledown wooden shack. The structures, contrived to cope with necessity, graph the civilization built in the wilderness by people like those in the picture. But like the five figures, like the telephone wires that high and faintly skim the horizon in the background, those structures are snowed over by woolly flecks, like wind-blown chaff or weed dust, that not only come to rest in the solid stuff of the blanket covering the corpse but also swarm from it.

Fox Talbot said that his china cabinet calotype was better than a written inventory, for if the collection were stolen the picture would be "mute testimony" to its reality and contents. It would be "evidence of a novel kind," a record of an existence. A little later in the century, the public equivalent of such witness was Atget's grand project of photographing the old and new Paris. Once the cabinet's contents leave their niche, their household museum, they become commodities whose assigned values may be documented. With Atget, photography became the witness and transcriber of economic relations and of the commodity life of objects. Many of the ten thousand pictures he took were of the new Paris created by Baron Haussmann, Napoléon III's prefect of the Seine. By 1870, one-fifth of Paris's streets were Haussmann's creation, and more than a quarter million of the city's inhabitants had been displaced by the destruction of old buildings. A new economic order was emerging. The manufacture and merchandising of objects were

consolidated into more centralized operations; large-scale suppliers assembled goods speedily for large retail outlets. In *The Painting of Modern Life,* T. J. Clark describes this change as one form of capital replacing another. The change was mounted and displayed in the windows of the *grands magasins* which by 1870 had created their own "views" for Parisians to study and absorb. Those frames presented and enclosed objects of desire.

The nature of Atget's witness, however, is more complex than his predecessors could have imagined, because of the peculiar mediating quality of the shop window, the squinting view of commerce. The glass that clarifies the objects of desire also reflects images of the social matrix outside, the larger, historically determined context. In many of Atget's images of shop windows, the street scene swims in the middle distance of the glass. We see not only the objects of desire but also their "support," where often the monumental processional stones of Haussmann's Paris lie imprinted on the image of the new shared public life of desire. But it's a glass support. Atget, in documenting the new life of capital, dramatized the transparency of prohibition when we confront things we desire.

Constellated, the images become complex witness to the new system of dependencies, of plenitudes and deprivations. The prosperity that ignites and sustains desire, announced in so many of the pictures Atget's tremendous archivist passion drove him to take, is pinched by images he made in 1912 of plump, overdressed prostitutes outside their cribs, and of the mean shanties of the *chiffonniers* and the coach-cart dwellings of *zoniers;* these were some of the populations who had been literally marginalized, pushed to the city's outskirts, by Haussmann's demolitions and by the new wealth that was driving up rents. Atget's encyclopedist zeal resulted in a photo-history of the economic processes implicit in free-market prosperity. I don't mean that his images are illustrational. They are representations of stress patterns the photographer saw as he spent those many years moving literally from the old Paris to the new, corner by corner, quarter by quarter. It helps to see images like *Bitumiers* and *Paveurs,* the badly paid work gangs wreathed in vapor who paved the way for the new century's automobiles (Haussmannization, Clark says, made fast fortunes for manufacturers of tar mac-

adam), in proximity with an image like *Boutique automobile, avenue de la Grande Armée,* taken in 1924. Behind the welcoming glass facade stands a new car, broadside, its spare hanging from a fender like an earring; two other models face parade-front. Bold white lettering claws across the glass: OCCASIONS CHENARD RENAULT. The cars are already museum spooks rendered nearly transparent in the glare of the glass.

In its function of bearing witness, photography can deliver to us—more piercingly than we are often prepared for—the hard solid presentness of material civilization as memorial to itself. When the photographic image recalls the substance of material reality, it delivers also the immaterial wraith or larva of that substance. Atget's image implicates not only the vehicles on display but also the pavers and street workers and steelworkers, and the glazier, and the sign painter, whose newly created job was to enhance the glazier's work by naming the new objects of desire and who did so in the hope that he too might enter the cycle, obtain such an object, enlist his energies in that system of dependencies. The image is particularly disturbing because in the window, on the support, are reflected the sidewalk trees. In the spectral depths of the treetops where they diminish toward a point deep in the image, we see autumnal decay, the sparse leafage and branches that seem to grow into and through those lovely gawky machines.

The street vendors Atget photographed around the turn of the century hold their own place in the system of change. He saw them as already casualties of the new capital and haunting vestiges of the old. The man in *Marchand abat-jours* bears a basket crammed with tiny lampshades slung from his back, a counterweight to the body's effort to stand erect. You can see traced there (as if Atget were applying a stylus) the tensile strength of the spine laboring to heft, and not be rolled back by, the weight of its wares. The tension of the new capital replacing the old is felt even more palpably in the famous 1899 image of the ragpicker, where the counterweight, balanced like a scale behind the subject, is bales of rags stacked to nearly twice his height, a coordinate image to those of small humans posing next to mighty heaps of stone. The ragpicker's wares are proliferating at a staggering rate. (If you spend too long looking

at Atget's shop-front pictures, with all those blouses, shoes, petticoats, corsets, trousers, hats, gloves, shawls, you're liable to feel department-store vertigo, or nausea.) But his very livelihood is at the same time being outdistanced by the new consolidations of scrap collecting. My favorite image of the passing of the old economy is the *Marchand de paniers de fil de fer,* whose metal cages bubble and foam down the length of his entire arm. They make for a buoyancy that weighs him down. And his face is nearly obliterated by the round puff of pipe smoke blooming from his lips. He's exhaling a cage of smoke.

Photography's alertness to relations between the human subject and its context has an erotic intensity. The camera, both receiver and transmitter, determines that the piece of physical reality selected by the image maker will be documented before or while other inventive activities are exercised upon it. A photographer's imagination more than a painter's is crucially defined by its selectivity and discrimination, and its exclusiveness is like a lover's fanatical attention. In straight photography the receiving is more immediately determinant, because more vulnerable, than the transmission. The shape of feeling created by an image may be completed even before the subject is made over into an image. In his *Daybooks* entry for April 24, 1930, Edward Weston wrote: "I start with no preconceived idea—discovery excites me to focus—then rediscovery through the lens—final form or presentation seen on ground glass, the finished print previsioned complete in every detail of texture, movement, proportion, *before exposure*—the shutter's release automatically and finally fixes my conception, allowing no after manipulation—the ultimate end, the print, is but a duplication of all that I saw and felt through my camera."

The image existence of a black-and-white photo is obtained by exiling matter's primary visual quality, color; a photo doesn't so much copy its subject as it takes an imprint of its sketchwork. When we see a news picture showing us the death of the body, the pathos is piercing but forgettable: although we recognize at once

the exact "print" of the event, of death's actuality, the signs of the life of the flesh have already fled from the image.

We remember many of our century's events in black-and-white images. Their archival accuracy exceeds that of previous forms of visual documentation—paintings, coins, graphics, tapestries. Photography can also process magnitudes. And yet, like those other forms, it has become inevitably conventionalized as a representation merely. The historical imagination, which is the way consciousness represents past reality to itself, has absorbed perhaps too quickly these new abstractions. What if the pictures of the death camps and of Hiroshima and Nagasaki preserved some facsimile of the look of the flesh? How would that affect our recognition and memory of the horror? (Has the documentation in color photographs of the Vietnam War made our consciousness of that bloodshed different from that of previous wars?) In 1857, when sepia images were the norm, the Goncourt brothers, who themselves sat for a portrait by Nadar, declared: "Everything is becoming black in this century; photographs are the black clothing of things." The ceremonialism of black-and-white images has become so central and commonplace in our lives that we accept familiarly in pictures what our imagination unassisted would resist. Black leaves, black water, black roses. Or the reverse. In Minor White's visionary landscapes—they are really meditations on nature's forms, whose essence he sought to expose on film—trees are blanched, solarized to cottony white, not as if they lack or wanted color but as if all color had rushed to those green lives with such force and concentration as to vaporize them.

And yet, black-and-white photography can powerfully reveal the shaping streams around the human figure. Like Robert Frank, Paul Strand did his best work when he was stranger to the place. A 1933 image from Mexico, *Woman, Patzcuaro,* presents a peasant with a broad Indian face sitting in three-quarters profile, back to a wall, a long shawl wrapped around her head and draped down over her shoulder. Her blouse, torn and patched, the basket she holds, and the white cloths fluffing from the basket form a visual common-

wealth. The weave in each article is startlingly pronounced. The patterns define her material existence and also contain it. Even the speckled plaster wall behind her looks like unraveling knitwork. She is woven into her place in time. Like most of the portraits Strand did in Mexico and Italy, that image is a whole, pressurized environment. We see the action of the world on the subject.

Strand liked to use the framing rhetoric of windows, doors, and gates to double the pressure already created by the vulnerable, selective housing of the viewfinder. Probably the best known of these is *The Family* (Luzzara, Italy, 1953), where the various expressions of poverty fold out beyond the definitions of the funereal door frame. The gazes of the mother and her five grown sons (who are barefoot, their trouser legs rolled up) are cast in different directions. Each gaze—defiant, wistful, confused, surrendering—expresses a different way of absorbing circumstance. In *Women of Santa Ana,* two young women, one with a babe in arms, are framed in a courtyard gate. They look rooted there, held, though not trapped, since the energy of the space is not constraining. It's the frame of material necessity that holds them. The look on their faces, as in most of the Mexican portraits and certainly in *The Family,* is barren of expectancy, futureless, with nothing migratory about it. A straight photographer like Strand lives unequivocally in the country of the seeable, of what's merely given, and what he sees is the substance of flesh in the stream of its place. But that is also part of the natural history of photography: the pang we feel when looking at snapshots of dead loved ones is partly due to that rush of presentness, of seeing a father, friend, child, in the world-stream while we're locked to the knowledge that the person has disappeared.

The mood of most fashion photography is migratory, a readiness to escape necessity or pretend it does not exist. I feel that mood in the portraiture of Richard Avedon, Diane Arbus, and Cindy Sherman. Avedon's images practically quiver with the anxiety to flee the material present toward a future, any future. His subjects are posed without a world-stream. The shaping forces are instead internal, eruptive, florid, as they are in much of Diane Arbus's work. In her extreme close-up *A Young Man in Curlers at Home on West 20th*

Street, N.Y.C., 1966, we can see the plucked stubble beneath the skinny black gull's wings of the young man's penciled eyebrows. An identity is being coaxed into being; the man is "at home" in the self he is designing, since there's not much material context in the picture. In *Tattooed Man at a Carnival, Md., 1970,* the matted filaments of hair on the man's chest and abdomen look as if they've sprouted from the animal and bird tattoos there. And the tattoos look as if they bloomed from his blood or appeared the way a photographic image appears in a chemical bath. Arbus often selected her subjects because they were decorated or disguised by circumstances rather than inhabiting them. Even the famous image *A Jewish Giant at Home with His Parents in the Bronx, N.Y., 1970* is essentially a domestic context turned into theatrical artifice; the image is shaped so that it seems a display window or sideshow platform. Cindy Sherman goes even further. Her self-portraiture as different personalities in different "stagings" is expressly theatrical, and it's the manner of impersonation that is the real subject of her images. The impersonation, the melodrama of self-consciousness, has greater plasticity when she uses crushed, dreggy colors, because the colors intensify the unreality of the presentation.

These kinds of images borrow from fashion photography the primacy of arranged or carefully determined contexts. And the human subject is often selected because it is "dressed," as a movie set is "dressed." The figure must volatilize all suggestion of necessity so that it may stand as something triumphantly singular, free of contingency, and therefore essentially worldless. It is the purest expression of irreligion, since its presentation of the human cannot allow for any suggestion of emergence from something greater (or more inclusive) than itself. In its skittish present, the fashion figure colonizes everything around it. I recently saw a very large print of an image of a slaughterhouse worker from Avedon's *In the American West* (1985). It's an example of the kind of working-class photography practiced by Hine made over into fashion photography. A wiry Oriental figure in a spattered apron strikes the familiar Avedon pose, at once confrontational and disengaged. He has a pigsticker and other tools stuck in his belt. He's embellished, dressed, with the bloody residues of his job, but against the white

backdrop he has no context to stream him into the nature of his work. He's exiled, historyless, utterly abstract. The title, *Blue Cloud Wright* (his name), suggesting in fact a long, troubled, perhaps deeply religious racial history, is a smug enhancement: the irony sits on the picture waiting for some intelligible, enlivening context. But the more exact purpose behind the presentation lies in that pigsticker, the tattoos, the leather apron, the gore dripping from the subject's fingertips, all of which have the singularized, fragmentary insularity of belts, earrings, shoes, or watches in a fashion spread.

Arbus's figures are less orphaned, to be sure, and their poses are attempts at emergence. In so much of her work we see people—lovers, circus performers, street people, transvestites, a "Lady Bartender at Home with a Souvenir Dog" or a "Child with a Toy Hand Grenade in Central Park"—overcontrolling their bodies, striking poses that the camera receives as near mockeries of fashion modeling. But there is always the felt sense that those ritualized poses, those aggrieved self-enhancements reaching out toward the inquiring lens of the camera, are the gestures of humans who suffer such strain living in the present that they would flee it so as not to be damned or abandoned to its contingencies. Her finest and most disquieting images are those made in 1970 and 1971 of people with Down syndrome. They are presented mostly out-of-doors, in Halloween or bathing costumes. The images have a softened, almost pictorialist glaze. Because the figures possess such uncertain motor control and lack therefore the ritualized self-possession of most of Arbus's subjects, their spastic, overcommitted jubilance seems an agony. They suffer the present with no thought of flight.

The workers in the depressed smokestack towns of Ohio and Pennsylvania that Lee Friedlander photographed in 1979–80 are possessed of a somnolent patience. A welder slouches nonchalantly across his workbench; in gray coveralls, wearing a slit-eye mask, he looks like a postindustrial gnome or miner-dwarf, a completely subterranean creature, and yet his torch shoots brief white acetylene wings. In another image, a man and woman stand with numbed watchfulness behind the square iron mouth of a drop forge, arms

raised in a ritualized, almost matrimonial, gesture. Though they are framed by the machine's aperture, nothing suggests they are trapped in their activity; their look is one of effortless disinterestedness, neither crushed nor redeemed by work. Their composure, in fact, has more in common with the portraits of middle-class professionals that August Sander made in Germany during the early decades of the century than with conventional American working-class photography. On this side of the drop forge lies a glittering puddle of identical punched-out slugs. Friedlander views his workers as fully implicated in their labor but aware that its uniform products pass beyond them. It's a professional's awareness. The system of material relations—the interdependence of worker, machine, and product, an extension of the new capital that Atget documented—is quietly stated, while crucial discriminations are held intact: the workers are not automatons, and their activity is not represented as grindingly reductive or demeaning. What we see in the racial and sexual variety of workers at various tasks, however, is a form of human industry vanishing from the American economy. The images make very clear that while these laborers are doing the work of a civilization, the world context (figured forth in the messy, underpopulated shops where the work is done) is changing dramatically. The form of capital, if it is not being replaced, is at least being severely redefined.

One image in particular, of the most apparently innocuous scene, offers a summative vision of changed relations as astute and as "innocently" archivist as anything by Atget. The statue of a World War I soldier stands profiled before a VFW or American Legion post. Behind (from our view), a flagpole grows straight up out of the soldier's breastbone. At his back, to the right, in doughy white sky, a rank of smokestacks looms like a quote of Weston's famous *Armco Steel.* Across from the bronze soldier are beefy American cars parked in front of shabby redbrick and tar-shingle buildings. Deep left is another factory, its presence announced by boulders of smoke in the distance. On the meridian dividing that factory activity from the rest of the image is a SUZUKI billboard. The soldier, crimped coppery highlights chipping across the folds of his uniform, has the easeful, exaggerated purposefulness of offi-

cial martial images. But that ceremonial regard for high moral purpose and civil restorations is bristled all around by images of actual material contingencies. The emphatic SUZUKI message stands as an admonition to the older, manufacturing-based, economic order memorialized in that statue, an order whose dismantling was already well underway in 1979, when Friedlander took his pictures. His welders, drop-forge operators, wire rollers, small-parts assemblers, and all the rest are trying to hold their place in an economy's debris. Their professional regard, so explicit in the images, is an expression of their knowledge that their labor is practically obsolete. The answering images in the series are the weedy, desolate autumnal and wintry landscapes in those towns—the series is entitled "Factory Valleys"—where even the natural order looks like scrap that must be either collected or allowed to rust away.

Edward Weston's *Armco Steel, Ohio, 1922,* is in the family of images that present human industry as a mediating activity between terrestrial and celestial constraints. The smokestacks above the mill rise like church spires or campanili, an expression not of religious aspiration but of commodity desire. The foreground stacks are voluminous, solid; deeper into the image the duplicated forms begin to melt into air. The picture is famous in Weston's development because its direct presentation of the subject marked his turn from pictorialism to straight photography. The early portraits were conventionally pictorialist "stagings"; usually the human figure served as a light receptor inserted among mansard wedges of shadow. In *Epilogue* (1918), a woman holding a fan is caught in a trapezoid of shade on which are pressed darker, grittier shadows of two vases with tall leggy flowers. It's a preciously wrought essay on the way light's aggressions are deflected and absorbed by matter. Although Weston declared his conversion in 1926 with the remark, "Once my aim was interpretation, now it is presentation," I don't think the change was as absolute as he claimed. He never entirely abandoned the pictorialist's willfulness regarding the arranged drama of a subject; at the same time, even in the early pictorialist work there was already the straight photographer's alertness to the stress lines of

physical reality. The result was a peculiarly exegetical, sometimes too studious, curiosity about the givenness of subject matter.

Weston's career acts out what I take to be the two essential melodramas of photography: that of the Designer, who cultivates a manner of seeing that is an intentional manipulation of the subject in accordance with some predetermined vision of beauty or good order; and that of the Seeker, who waits for the subject to reveal its mysteries so that he may, as Weston himself said, "grasp that intangible something that haunts my ground glass." Both are melodramas because no sensible artist works by such narrowing determinist expectations. But as general dispositions they suggest the brilliant irresoluteness I've always felt in Weston's work. He in fact wrote scripts for both melodramas in his voluminous *Daybooks,* which documents his own fluctuations as he negotiates his way among various instincts and purposes. In 1924, for instance, he wrote that "the camera should be used for the recording of life, for rendering the very structure and quintessence of the *thing itself,* whether it be polished steel or palpitating flesh." He's speaking for the documentarian, inquisitive impulses of straight photography and the clarities it can reveal; essence is not an occult quality, it's fully disclosed in the appearances of a thing recorded by the camera. And yet in 1929 he can also say that "subject matter is immaterial—the approach to the subject, the way it is seen and recorded is the critical test of a worker." Here it's not the act of receiving and recording the thing itself that matters, it's the manner of the seeing. I think it was this odd marriage of mannerist and confrontational photography that pushed Weston toward abstraction during his later career.

In many of Weston's images of Mexico from the 1920s we can see the way in which, even as he pursued his conversion to straight photography, he internalized and found a different expression for his pictorialist instincts. In *Pissing Indian* (also called *Calley Mayor,* Tepotzotlán, 1924), the human figure, viewed slantwise from above, is isolated by the intersecting lines and planes of the road, the dirt plot abutting the road, the brickwork of the building, and the stone slabs leaning against the wall. In *Casa de Vecindad II,* 1926, bright

shirts and linens lie on the ground and hang from tiers of clothes-
line strung across a courtyard. Both photographs confront their
subjects in the unassisted, unmanipulated method of straight pho-
tography, but both are also rather self-consciously determined by
the extreme angularity of view and are dominated by the abstract
patterns laid down by the gridwork in each. The selectivity of man-
ner eclipses the other deliberations engaged in making the image.
Some of the *pulquería* pictures show the same strain. In *Two Chil-
dren in front of a Landscape,* the children at the bottom of the frame
(they look deposited there) are dwarfed by the mural of a lush, hilly
landscape with a farmhouse in the background. It's at once presenta-
tional and interpretive, though the intervention is enacted through
selectivity and angle of response. The too available irony is not only
that the (presumably impoverished) children are minuscule in the
presence of that imagination of wealth, of a *latifundia,* but that the
imagination itself decorates a cheap bar where the parents of such
children would be expected to drink. Weston said that he did his
pulquería series "before I ever heard of Atget," with whom he was
compared; their work, in any event, was different, Weston ex-
plained, because Atget was "a great documentary photographer."

I've used the term *pictorialist* to set Weston's career in a formal
context, but finally pictorialism or theatricalism is my perhaps in-
judicious way of identifying the roots of what I believe was the
mastering impulse in Weston's work: the making of an image exis-
tence, the self-conscious *putting* of a representation into a refined,
completed state. This might describe the ambition of different
sorts of photographers, but for Weston it meant that formalist cere-
mony took precedence over everything else, and this meant sacri-
ficing some of the powers inherent in the "mere presentation" of
straight photography. Many of his pictures of natural phenomena,
for example, express awe or passion, but those expressions exist in
the image as quotations of feeling rather than as immediate, sus-
tained, self-restoring *acts.* The mysteries of innocence have been
bred out of them, as they have not been bred out of images by
Robert Frank, or Minor White, who intervened even more radi-
cally in the realization of his images but whose sense of formal re-
finement wasn't subject to the ritualized restraints found in Wes-

ton's work. Weston's sense of form was often so self-consciously theatrical that he could not achieve as often as he hoped that expressiveness of emotion in line, volume, and texture, which Matisse regarded as the essence of form. (It was Matisse who, when asked by Stieglitz to contribute some remarks on photography to *Camera Work*, replied: "Photography should register and give us documents.") Nor is it finally the raw presence of the "thingness" of the world that unequivocally claimed Weston's imagination, as it seized O'Sullivan's, Atget's, and Nadar's. It was instead the conquest of what he called the supreme instant, when the subject was received, claimed, worked, completed.

By 1930 Weston had arrived at his understanding of the photographic image as analogue, not copy, of his subjects, and this freed him to pursue more ambitiously the life of natural forms. His investigations also drove him to push the image beyond resemblance, beyond subject matter. Of one of his pepper images he wrote, "[it is] more than a pepper: abstract, in that it is completely outside subject matter. . . . This new pepper takes one beyond the world we know in the conscious mind." The pepper images don't transport me in that way, because the forms are too bound by conventional sculptural definitions already developed by Rodin, Brancusi, and Matisse. Weston (who justifiably hated being compared to painters and sculptors) had an answer to my complaint: "Actually I have proved, through photography, that Nature has all the 'abstract' (simplified) forms Brancusi or any other artist can imagine. With my camera I go direct to Brancusi's *source*. I find *ready to use,* select and isolate, what he has to 'create.'" He is here announcing again, I think, the two magisterial prerogatives of photography: to document purely, preserving and recording subject matter as primordial evidence; and to pass through the veil of resemblance into the life of inner form "beyond subject matter," which can be achieved only in the image existence. The great realization of this, at least for me, comes not in the pepper images but in the cutaway views of vegetables. In the fleshy corrugations of *Kale Halved,* or the moist, circuitous canals of *Onion Halved,* or the vulval feathering of *Artichoke Halved,* the presence of sheer vegetative force, of *physis,* is revealed in the actual documentary resemblance, which

acts as a mysterious transparency. We also see gathered up and foli-
ated into the form of the moment an entire history of growth. Sub-
ject matter in these pictures really does vanish, or rather phases in
and out, in the presence of a force we certainly do not know in our
conscious mind.

Those images also reveal the exertions of a Seeker investigating
the quality of the analogy. It was an obsession with the formal per-
fections of the image that led Weston "inside" those onions and
artichokes. What mattered finally was the photographic look of the
thing, its imageness. His cloud studies of 1936 were the most en-
thusiastic and brilliant expression of that impulse. The tonal con-
sistencies in any one image might run from flaked, jagged slate to
silky marble. The textures of immateriality go from leather to rock
to foam. In the cloud studies, and also in the images of those
broad, eddying, scalloped stone formations at Point Lobos, Wes-
ton succeeded in expressing emotion with every nuance of line and
light. His best subjects, in other words, were those that stood at the
frontier where resemblance becomes abstract transparency.

Matisse's Broken Circle

I N THE HISTORICAL ANALYSIS
of abstraction in modern art proposed by Frank Stella in his 1984
Charles Eliot Norton Lectures, published in 1987 as *Working Space,*
Matisse is practically a nonentity. Stella presents art history as a
chronicle of progress articulated in the recurrent problem of pic-
torial space. The challenge met by the early abstractionists was that
of exploiting the flatness of the picture plane; for later generations
it became that of generating dimensionality rather than merely
illustrating a surface. Caravaggio is the first hero in the chronicle
because it was he who responded to the enfeeblement of pictorial
space in mannerist painting by creating what Stella calls projective
space, the deepening of the isolated image in a painting without a
correspondent illusionist deepening of scenic elements. The mod-
ern heroes are Kandinsky, Mondrian, and Malevich, who redefined
abstractionist space in ways that pushed beyond the spatial re-
definitions of Cubism and, as a consequence, prepared the way for
a new generation of problem solvers—Hofmann, Pollock, and
de Kooning. Picasso's presence in this story is an ambiguous one,
because the inventive extensions of his cubist work were followed
by a retreat from the dynamic abstractionism to which the cubist
work was leading him. Matisse's role, in Stella's scheme of things,
is as a negative adjunct to Kandinsky's efforts to consolidate for
abstraction the pictorial expansiveness of Expressionism. Had it
not been for Kandinsky's rescue efforts, the exuberances of Ex-
pressionism "would have hardened into the compressed planes of
Picasso, Malevich, or Mondrian, or would have simply dispersed
themselves into the turpentine washes of Matisse."

Matisse's peculiar absence from Stella's long and detailed argu-
ment is especially odd because in some historical accounts his work
represents the contest between representation and abstraction, with
the latter winning out toward the end. His investigations of line
and color, from the early apprentice work, through the dissonant
colorism of the fauve period and the sunny decorative essays of the
Nice period, up to the murals and paper cutouts of his last years,
constitute (the argument goes) an exemplary career that demon-

strates how the dissipating energies of representationalism yielded to an inevitable emergent abstractionism. Stella seems to have the reverse of this in mind, that Matisse was evading the most pressing formal question of his age by practicing an art that was lethargically dispersive and that thinned out pictorial space to an almost etherealized representationalism. Blended into Stella's passing remark is Matisse's notorious description of his ambition in *Notes of a Painter,* the theoretical statement written in 1908 when he was thirty-nine: "What I dream of is an art of balance, of purity and serenity, devoid of troubling or depressing subject matter, an art [that would have] a soothing, calming influence on the mind, something like a good armchair which provides relaxation from physical fatigue." I don't think any modern artist has suffered so much praise and vilification for any confession as Matisse has for his "armchair" defense; and the significance of the facts of his career, including, of course, his own commentary on it, is more radically determined by the historical perspective of the viewer than the career of any other modern painter. For Pierre Schneider, Matisse's most astute, comprehensive, and exasperating commentator, that career was a constant struggle to negotiate the contrary demands of image making and representation, abstraction and realism, East and West, the Eternal and the quotidian, religion and the world. For Frank Stella, so far as the rich, crooked vein of abstraction is concerned, Matisse is practically irrelevant.

I do not share Stella's advocacy, and I am not persuaded by Schneider's argument that Matisse's art recapitulates and advances nearly all the religious and formalist questions of representationalism since the Middle Ages. In trying to account for what I feel to be the almost nightmarish tenacity of Matisse's images, I am less concerned with his place or "role" in one or another historical reconstruction of modernist experience than with the specific unprogrammatic ways he chose to answer to his materials, his subjects, and his religious sensibility, all of which he shares with certain crucial predecessors. I take him to be a painter whose "evolution" or development is beside the point, whose career is a tidal attentiveness, constant but shifting, not to historical "problems" but to emergent consolidations and dissolutions of forms. He was, with Picasso

(though without Picasso's theatricalism), the most self-aware artist of the century. He knew how his images might be, and indeed have generally been, received as immediately available occasions for joy without consequence. But acted out over his long life was a less serene, and certainly less consolatory, drama: the will to joy straining against the distances of eros.

If we need a historical matrix to clarify Matisse's activity, we can find it in the Renaissance controversy between drawing and color: *disegno* versus *colorito;* Florence, where cartooning or drawing was the essence of imitating nature accurately, against Venice, where artists like Giorgione and Tintoretto often painted directly on the canvas without preliminary drawing. In his superb book *Painting in Cinquecento Venice,* David Rosand frames the quarrel by citing Vasari's definition of painting as "a plane the surface of which is covered by fields of color . . . which by virtue of a good drawing (*buon disegno*) of circumscribed lines define the figure." Though he was an apologist for Florentine values, Vasari accurately represented Giorgione's view that "painting only with the colors themselves, without any preparatory studies drawn on paper, was the true and best way of working and *il vero disegno.*" Drawing as the discipline of nature impressed upon the working imagination held a tremendous appeal for Matisse, but so did the textural immediacy of emotion expressed in color.

A historical matrix is not determinant, however; it is an illustrative, explanatory pattern that might help us see into the life of forms as it is lived out and expressed by an artist. Matisse's relation to Italian art was the ostensible subject of Matisse et l'Italie, an exhibition in Venice that included nearly sixty paintings, a dozen or so paper cutouts, over a hundred drawings, and sixty-three sculptures, most of these materials on loan from the Musée Matisse in Nice.* The exhibition drew fire from the Italian press because of what some writers found to be its dubious premise and lackluster, thematically incoherent content, and others felt it to be an instance of art-as-spectacle boosterism. In his catalogue essay, Pierre Schneider concentrates mostly on Matisse's documented encounters with

* May 30–October 18, 1987.

and imitations of Italian art, his occasional use of Italian models and subjects, and the nebulous matter of Italian influences on his work. He reports what Matisse saw during his two extended trips to Italy in 1907 and 1925 and speculates about what Matisse may have absorbed from the examples of Mantegna, Piero della Francesca, Tintoretto and from the Byzantine mosaics. (Matisse's son-in-law, Georges Duthuit, an expert on mosaics, went with him on the 1925 trip to Sicily.) Matisse's curiosity about certain Renaissance artists is evident enough in the copies and adaptations he made of Pollaiuolo's *Hercules and Anteaus* and *Hercules Battling the Hydra,* and in the drawings *Day* (1922) and a nude from 1935, which were modeled on Michelangelo's figures from the Medici tomb. His interest in the mosaics achieves its fullest expression in the paper cutouts of the late period, especially *The Bees,* where the image likeness is indistinguishable from the brilliant, clustered particulars of paper "bits." But Matisse's remark in a letter in 1941 that he always had to cope with the "eternal conflict between line and color" suggests that the shaping impulse in his career was not a progressive, developmental, historically determined one but rather one of struggling emergent form answering to the forms of nature as they are felt by the artist. In a sense, a great artist is never directly influenced by any other artist and is certainly not the creation of historical necessity. Other practices, exempla, and problems are chiefly enabling occasions by which an artist can look more deliberately into the skeins of what is, momentarily, inexpressible.

The peculiar spatial stress in Matisse's painting resulted from his compound need to analyze (or atomize) and to fuse. In the 1914 painting *Marguerite in a Feather Hat,* gobbets of color define the subject's face and costume: pink cheeks and nose ridge, slate jaw line, yellow forehead, black choker with golden bits. Pasty white outlining isolates each color patch. The atoms of color in the composition are pushed apart, islanded by the lines of force created by the contouring. There is not much tension among the colors; they are not poised to snap back into place. The painting is not a pictorial field in jeopardy as it is in Giacometti's paintings and in some of Cézanne's late work. Matisse's forms are placidly rotund, unperturbed by the tentative distensions they constitute. But it is an im-

age of separation and estrangement, and of nostalgia for an impossible coherence. That same year he produced *Head, White and Rose,* where the color compounds are arranged in vertical red, black, and cream stripes. Spearing down through the draped, steely colors are the V's and triangles that structure the drawing. The draftsmanship disciplines the pudgy colorism into rigorous schematic planks. The color has not been built or dressed on the drawing; it has been welded to it, and Matisse boldly lets the seams show.

The *disegno* element is, almost from the beginning of Matisse's career, a sculptural modeling. In early paintings like *Male Nude* (1893–95) and *Seated Old Man* (1893–95), he was working to convert volume and mass into contour. He was trying to realize in the draftsmanship of those paintings the muscularity we see in the actual sculptures he executed between 1900 and 1910. (In *The Serf,* for example, the planes fold and buckle into sharp ridges; the slave's back, with its big rocky lumps, is overmuscled with work, deformed by exertions.) The bulked-up, contracted musculature and heavily creased definition of the *Male Nude* become, in the painting of the old man, flaccid expansions. In his copy of Philippe de Champaigne's *Dead Christ* (1895), the anatomy is assembled in blocks of drawing and streams of paint; shoulder joint, rib cage, kneecap, all seem modeled in advance, then mounted on the canvas. It is painting as joinery, not as florid, plastic emergence. It is also patiently accumulative, a characteristic of Matisse's productions generally, even the colorist ecstasies of the fauve period. The dead Christ is not just an exercise in anatomy or historical revisionism. Working within the conventional formal restraints of a "copy," Matisse at the very start of his career is making an image of religious feeling. I cannot follow a mind like Stella's that celebrates Caravaggio's innovative use of "projective space" as if this formal quality could be dissociated from the drivenness of Caravaggio's religious imagination, which wanted a more violent plasticity of the picture surface precisely to accommodate the wild desire to be summoned, chastised, wracked, saved. When Matisse remakes a Dead Christ, the expression of religious temperament is more compelling than its initiating formal source in Mantegna's famous can-

vas. Matisse's dead god is in a state of repose. The flesh seems about to stir or twitch; it is not the death of a singular nature. Consciousness has been only momentarily adjourned. Matisse's Christ is a conquered deity, not one who has languished into death. In the darkest, plummiest patch of flesh, where light barely surfaces, a pursed smile hovers on the god's face.

The religious imagination is a respondent, form-making act of consciousness back toward and into that which it believes has shaped *it*—the force of otherness. It replies to the givenness of existence by reshaping the forms of nature into the forms of work. It desires a complete expression of particulars, which are absorbed but not disintegrated into a welded whole, an allness. It assumes and is aware of a reality greater and more inclusive than individual consciousness, and it allows that awareness to shape its products. It seeks fusion even while it sedulously practices analysis and individuation. In such terms, Matisse's career was the most sustained and variegated exercise of religious imagination of our time. Even more than Cézanne and Giacometti, and in a more methodical and self-conscious way than Van Gogh, he practiced painting as an expansive ceremonial of consciousness. And the eternal conflict between line and color was for him a medium of erotic desire. The presiding precursor of Matisse's enterprise was Giotto. Matisse's remarks about him arc over the long middle period of his career. In *Notes of a Painter* he wrote: "When I see Giotto's frescoes in Padua, I'm not worried about knowing which episode from Christ's life I'm looking at, but I immediately understand the feeling triggered by them, because it's contained in the lines, in the composition, in the colors, and the title serves only to confirm my impression." He saw in Giotto a comprehensiveness, an integral completeness, that was both preliminary and summative, which possessed the preparatory definitions of cartooning and the conclusive exaltations of color fields. Matisse had already described in 1907 the two preoccupations that sheared off from Giotto's unities as Sienese primitivism and spirituality (*disegno*) and Venetian physicality (*colorito*). Giotto remained the model of achieved completion and must have come to seem even purer as Matisse worked his way, decade by

decade, through all the formal consequences of the breakup of that unity. As late as 1946 he writes to Pierre Bonnard, "Giotto is the peak of my aspirations. But the journey toward something which, in our time, would constitute the equivalent is too long for one life." In that statement seethes his own awareness of the inevitable incompleteness of the task he had set for himself. Modern unities equivalent to those achieved by Giotto were clearly impossible. What he could do, however, was make art out of the desire for such completions.

Some of the pieces on display in Venice demonstrate the small, discrete operations by which Matisse conducted his investigations. The pigment in the orientalized *Poppies* (1908) is buoyant, airy; the drawing matters less than the gestural coloring. Drawing with the brush, Matisse is trying to fix in a momentary "Japanese" way his feeling for the brevity of that natural existence. (He often said that he painted not subjects but the emotion stirred in him by subjects.) In *Still Life with Negro Statuette* (1908–9), the dusty red patch of ground on which stand a green-black flask, a jug, and crimson statuette, seems rubbed or burnished into the sooty primed canvas. The friction of color against the support ignites a kind of drawing. Neither of these has the frontal, heavily colored presence, however, of the 1909 portraits of Matisse's son Pierre and of Nono, the daughter of one of Matisse's best friends. The drawing of Nono's chin, jaw, and high, constrictive collar is an entrenchment, a held line that determines and restrains a muscular, physical coloring. The red of Nono's lips, like the creamy yellow bow in her hair, is explosively ornamental against the constraints of drawing. Pierre's chalice-shaped head with its liquid flesh tones suggests immediately the vivacious ethereality of Botticelli's youths, but the drawing is so thickly banded and the color so voluminous that the delicate veils of drawing in which Botticelli and other cinquecento Florentines encoded Neoplatonic idealizations are reduced to a more physical, less idealized Venetian concentrate. In *Notes of a Painter* Matisse says that he was interested in painting the human figure more than still life or landscape because the figure "best permits me to express my almost religious awe toward life." For him the

image-making activity was steeped in immanence, in the saturated immediacy of color fields whose stressed elasticity was governed and contested by line.

The contractions and expansions of this process are starkly apparent in the many drawings exhibited in Venice. In *Seated Nude with Drapery in Her Lap* (1924), the shoulders, neck, upper arms, and head look like cutaway views of sinew and muscle tissue, while the breasts and abdomen are literally more fleshed out, dressed, corporeal. The *Portrait of a Young Girl* (1920), by contrast, shows a more finished and conventionalized exactitude of anatomical detail. In the 1923 *Nude Standing before a Mirror* Matisse's attention is concentrated almost entirely on the colorist quality of the shading and not at all on anatomical delineation; it is a study of light changing the flesh into a negative image of itself. The smudged gray substance of flesh in the figure before the mirror is contained by a white nimbus. *In* the mirror that figure is blanched, unfleshed, defined entirely by the strong outlining. The darkest surface in the image is the mirror that mediates the definitiveness of the drawing and the "colorism" of the charcoal shading.

Important artists of the past century have had to live out in their work some version of the fall from the innocence of realist representation. Pierre Schneider has noted that from 1917 to 1919 Matisse was intensely interested in Renoir's painting because Renoir was really the last painter for whom a picture was a representation rather than an image. Matisse was looking for a guide to the recovery of "the innocence which makes realism convincing," says Schneider. "It was a vain hope: once it has been lost, there is no way of recovering innocence. Once the gap between what is seen and what is painted has been laid open, the artist can no longer pretend that he is not a prisoner of painting; once he has made the transition from representations to images, he cannot turn back." In Matisse's case it was not so much a transition as an interrupted circuit, a now snapped fictive loop that had once connected nature to consciousness to expressive forms. Matisse had no nostalgic illusions about lost innocence. Of his portraits and nudes he once said,

"I do not create a woman, I make a picture." A painter makes forms on surfaces, he does not create; he forges images, he does not counterfeit nature. If those images represent anything, they represent the state of emotion infused in the artist by his subject. Emotion is the inwarding of the subject; Matisse sought a fully respondent image for that complex of emotions initiated by the subject. This aspiration is quite different from the one practiced by Giacometti, who acted out his own fall from innocence. Giacometti wanted a retinal purity and accuracy of representation. For Matisse, the process was heightened by his own peculiarly intense and certainly unorthodox religious sensibility. In 1951, three years before he died, he closed the parenthesis opened by his 1908 remark about religious awe: "All art worthy of the name is religious. Be it a creation of lines, or colors: if it is not religious, it does not exist. If it is not religious, it is only a matter of documentary art, anecdotal art . . . which is no longer art."

The Italian Woman (1916) has the formal rigor and aloofness of a devotional image. In this, as in most of Matisse's female portraits, there is a mysterious grace that transcends the quotidian norms of courtesy. The female image enacts attention but not curiosity: the visage, the representational presence, does not invite us into the formal life of the image, as it does, for instance, in the glamorous hungers of de Kooning's women, or the pliant curiosities of Modigliani's. Matisse's female images are recessive, self-withholding, largely because figuration is given over so entirely to formal invention and variation. Only Picasso rivals Matisse in this, but Picasso's imagination was more imperious, colonizing, and acquisitive, Matisse's more inquisitive and elusive. In The Italian Woman the black bow-sweep of nose and browline—a form Matisse worked throughout his life: it reappears even in the large, architectural, brush-and-ink Acrobats and Plane Trees of his last decade—is drawn with iron severity. It's a figure of erotic refusal. But the painting also makes one of the shattering gestures in Matisse's career, though like his other extraordinary gestures—like, most of all, the plasmic throbbing ground of Red Studio and Harmony in Red—it's executed with unsettling quietude. The fall of black hair drawn like a

half-keyhole over the *italienne*'s shoulder thins and lifts outward in a winged opaque yellow-green veil covering the clearly visible shape of the arm beneath it. The painting generates this second plane, a second "flatness," with no coy trompe l'oeil effects. The figure of the woman streams from the peeled surface, which is itself an extension of the picture's primary surface. The drawing of the figure mediates that pressurized confluence.

Most of Matisse's female portraits present an image of worldly consciousness on the far side of surprise. The *italienne*'s stern countenance is an extreme case. The grace of his female figures lies in their fullness of consciousness as it meets the world in a casual, cunning repose. The quality of surprise abides instead in the image making, and it is the awe that survives the fall from innocence. In *The Italian Woman* it takes the form of the picture plane's second skin. In the 1937 *Odalisque* hanging in the Philadelphia Museum of Art, the blue-and-purple wallpaper stripes behind the figure are squeezed directly from the tube in ridged pigment chains, percussing the decorative order of the image. And the woman's ornaments—a hairpin, white flower, rings, bracelets, anklet—are likewise built up with squibs of paint. The already intensely colored image of an odalisque is thus decorated with its own materials: the ornamental value of the paint is indistinguishable from its expressive use.

Woman with a Turban (Portrait in a Moorish Chair) (1929–30) is an answer to the Laurette paintings of 1916–17, with their marshy greens soaking large areas of the canvas, and the ripe, full-fleshed face of Laurette an image of voluptuous patience. In the later work Matisse evacuates the very space that he had made vibrate with color in the earlier paintings. The image suggestiveness of corporeality has been violently retracted. The faintly sketched woman and her chair seem an afterimage; the conventional signs of corporeality have been reduced to minimal gestural drawing. All except for the ends of the moss green turban that flare out behind her head like mismatched wings. That image of flight, of the leavening of substance, is the most sensuously *present* element in the picture, and it harmonizes—lurchingly—with the green floor and wainscoting that surround the phantasmal figure. Matisse thus grounds,

domesticates, binds that sign of flight in the composition. This is one announcement of the end of innocence. And yet the decorative ornament, the turban, carries a celebratory charge. That suggestiveness becomes all-governing in the blue nudes of his last years, where the carefully segregated forces of drawing and color, of emotion and emblem, are melted into cropped color fields; in *Blue Nude II* we can see the seams, the memory of the task worked through after the loss of innocence, where the sculpted sheets of color have been tacked or stitched together to make an image of a contrived whole—since nothing could ever be whole or complete again.

Matisse's nebulous, instinctive religiosity ("I always let myself be guided by my instincts") expressed itself as a cult of eros. The dialectic stress between color and line, the dramatic readjustments of the elasticity among elements in a picture, the compulsive enjambments of colorist jubilance and the structural asceticism of drawing, were all practices of that cult. *Cult* is not too strong a word; it delivers the force and inflexibility of Matisse's discipline of work. To the question in the self-interview in *Jazz* of whether he believed in God, he replied, "Yes, when I work." Eros is the god force described by Aristophanes in Plato's *Symposium*. Ever since Zeus cut humans in two ("like a sorb-apple halved for pickling or an egg sliced with a hair") we have been guided and driven in our choices by erotic desire, which is the felt need to reunite our original whole nature, "to make one of two, and to heal the state of man." Matisse, we know, wanted his art to be of a comforting, healing kind, but that intention is inseparable from a poetics of divisive expectation.

The large canvas of *The Joy of Life* hanging above the staircase in the Barnes Foundation is Matisse's most complexly detailed image of erotic desire. Nude figure clusters in the bottom half of the picture make a platform or pedestal on the center of which is displayed the circle of six dancers. There is no depth to the image; the compositional elements are displayed on the canvas as upon an arras. There are a shepherd piping to his flock, two recumbent females facing each other on the grass, a musician, and two pairs of lovers in near embrace, one member of each pair resisting or turned

slightly away from the greeting of the other. Out from these figures grow trees that form the canopy of the upper hemisphere, enclosing and framing the dancers. Each figure enacts an episode or disposition in the tidal stirrings of eros: the deflected or postponed bonding of the lovers; the perfected language of music replacing imperfect speech; the ritual preparations of desire of the female fastening a garland while another crouches to gather more flowers. The drawing asserts the circumstantial enthrallments of desire, while the color images assert the stilled sensuousness of flesh—Matisse painted the body's eager fullness as both a desired and desirous thing. The separate figures are particularized renderings of the condition summarized in the core group. As in the *Dance* paintings in the Museum of Modern Art and the Hermitage, each dancer in *The Joy of Life* suffers a different erotic quality induced by the spinning movement. One leans away as if bullied by centrifugal force; another pitches into the turn, its leaning angular shape a figure of self-abandonment; another turns in *contrapposto,* upper body toward the center of the ring, feet turned away, as if negotiating lashing counterforces.

In each of these paintings, however, the circle of the dance is broken, or incomplete. The pitching figure leans toward the welding spot that would unite the dancers in a closed ring, in the image equivalent to Plato's original human beings: "The man was originally the child of the sun, the woman of the earth, and the man-woman of the moon, which is made up of sun and earth, and they were all round and moved round because they resembled their parents." In *The Joy of Life,* the dancer's outstretched hand melts into the oblivion of the color ground. In The Museum of Modern Art's *Dance (First Version),* the ground is divided into two monochrome fields, dense royal Titianesque green and blue. Upon those holy ceremonial fields are drawn figures caught up in the movement toward union in which the god announces himself, when the individuated self disintegrates into the allness of the fused ring.

Matisse's expressions of desire are not heated or satyric. He is, as Clement Greenberg once said, a cold painter. But if his tone is cooler or at least more temperate than Picasso's or Modigliani's, his images of desire are more insinuating, for he painted that broken

circle not as a tumultuous, sensational event, but as a normal, ritu-alized, droning, piercing fact of existence. The huge gray solitudes of the dancers in the Barnes Foundation lunettes—viewed from below they look like celestial forms stirring toward union—refuse to allow the eye to gather up the entire form or to linger on any detail. For all their billowing, voluminous color, the dancers are elusive, almost fraillly so, a sweeping afterthought of color left be-hind by the velocity of the drawing. They are erotic partners enact-ing the graceful but arrested expectations that Keats expressed in "Ode on a Grecian Urn": "Bold Lover, never, never canst thou kiss, / Though winning near the goal—yet, do not grieve." Each figure strikes a position of receiving or giving familiar to us both from images of the Graces in Renaissance painting and from the contentious earthbound rituals of modern dance. In Matisse's ren-dering we see a dance pose or attitude in a purely mobile, fluid state. It is an image of the agitated, repetitious anticipation and fa-natical attention of erotic attractions. But the most personal ex-pression of that kind of fanatical attention is the *Nymph and Faun with Flutes* (1940–43). The faun looms over the reclining nymph, calling her to wakefulness by the language of his music. His song is a representation of the desire to close the distance between them; the entire scene is an image of intensely delayed union. The numer-ous versions of this scene that Matisse produced are his most auto-biographical works, because he was presenting his vision of his own faunish musical activity as a maker of images.

Less starkly autobiographical are the many domestic interiors where completion of an interfused domestic community is ren-dered in the direction of the gaze. Attention is the medium of rela-tions among things. "I paint not things," Matisse once said, "but the relations between things." In *The Music Lesson* (the version in the Barnes Foundation) the boy at the piano reads music while his teacher looks over his shoulder; both gazes converge on that shared language. Near the piano a male figure sits smoking, reading a book. On the piano, the violin—so familiar in Matisse's interiors—lies exposed in its case, and there is also a score by Haydn. On the wall hangs a woman's portrait; the painting, product of the artist's attentive desire, is integrated as decorative artifact into the larger

scheme of attention. A large window opening onto a garden frames a woman embroidering in a chair, and beyond her an "exterior" artifact, a recumbent statue gazing down upon itself. Each isolated patch in the image refers us to others; the interior and exterior spaces, the private and the public, the space of culture and that of nature, converse in the objects. Illusionist depth is collapsed so forcefully that these attentive postures—we bear witness to both the activities of consciousness and its formed products—are stood upright like elements in an icon. The degrees of attention range from the clarities of music to the coarse delights of what I take to be a dime novel being read by the seated male. The piano lesson and the embroidery are, like the painting and statue, idealizations of an object of desire. Each discrete solitude is an extension of consciousness toward something else, the most ceremonialized being the picture, the statue, and the Haydn score, all products of form-giving consciousness. The summative ceremony, the big unifying effort, is the picture entitled *The Music Lesson.*

For more than thirty years Matisse owned Cézanne's *Three Bathers,* and from that example he learned quickly—having begun to paint at the age of twenty-one he had to learn everything quickly—that a painting is a made pictorial thing, an expressive likeness originating in, but not representative of, primary nature. One of the pictures in Venice, *Vase of Flowers* (1898–1900), is an obvious homage to Cézanne's way of building up a surface with choppy, richly pigmented brushstrokes and animating it with thickly inflected colors. But the great lesson he learned from the older painter was always to defy what is already known, to break down what is too available or "workable." So that although Matisse learned something of color plasticity and the dimensionality of the picture surface from Cézanne, his own defiant curiosity led him to investigate the spaciousness of separated forms.

The different practices are stunningly evident in the arrangement of their works in the Barnes Foundation, where historical relation matters less than structural correspondences. Petulance fueled by unlimited capital produced, in combination with Dr. Alfred Barnes's often shrewd and daring tastes (shaped in part by his ad-

visors William Glackens and John Dewey), a great and very idio-
syncratic collection of early modern art. Because the Barnes Foun-
dation was meant to serve not as a museum but as a study center
(and showpiece of Dr. Barnes's educational theories), the standard
gallery arrangements—by period, geography, or artist—are broken
up into what Dr. Barnes called wall-pictures, whereby a Renoir, for
instance, is flanked by a Tintoretto and a Giorgione in order, as
one of the foundation documents explains, "to foster understand-
ing of objective investigation and to help in demonstrating the
principles of aesthetics." In the main hall is Matisse's *Seated Riffian*
(1913). The square green-robed figure is laid on a yellow and green
background—or backdrop, since it is another of Matisse's color
fields hung on the canvas like a decorative veil. The face is an as-
semblage of ocher, green-blue, and mustard swatches tenuously
stitched together. Color and line are not compelled into their pat-
terns by a conceptual structure, as they are in cubist compositions;
they seem instead to have arrived there as the accidental result of
the artist's desire for new enjambments. The face, as in so many of
Matisse's portraits, contemplates its own incompleteness, its provi-
sional imageness; it does not return the attention of the outsider.
On the wall opposite is a portrait of Madame Cézanne, *Woman in a
Green Hat.* Cézanne draws us into the subject's posture of atten-
tion with brief silky swabs of color built up and fused in such a way
as to invite into the pictorial event the erotic participation of our
own attention. The life of eros in the painting, as in Cézanne's work
generally, thrives in the plaited, slatted, crosshatched piling up of
color. In Matisse, eros thrives on separation and detachment; it
lives in the stressful estrangements of color and line—of line yearn-
ing for color and color for the "natural" restraints of line.

For an abstractionist like Frank Stella, who figures in all this be-
cause he is such an articulate, systematic apologist for the ex-
tremely deliberate art he has chosen to make (and because, as the
most conspicuous artist of his generation, he is the presumed heir
to discoveries made by the two older painters), such contentions
and defiances as I've been describing must be seated in a historical
program, a sequence of progressive, problem-solving advances.
Artists, in his view, work primarily according to laws of historical

necessity, though those laws are formalist rather than social or materialist ones. (According to this peculiar compound of Marxist inevitability and evolutionary progress, representationalism will eventually disappear.) But for artists like Cézanne and Matisse, and for viewers engaged in the same search for an imagining of primal innocence and the consequences of its loss, there is no history, at least not the mechanistic kind proposed by Stella. There is only consciousness, in its constant present moment, groping always through and toward the nature it is a part of and the life of forms that absorbs all pasts. I think this is why a rigorous formalist critic like Clement Greenberg regards Matisse as one of our greatest artists. But an *artist* who views the past as a series of determinist formal problems will most likely produce an art of merely strategic surprise, where pictorial expression can only be an image of the artist's overstudied intentions.

In some of his late works, Cézanne left exposed sections of the canvas or paper, not as marginal fields to crop the colored areas but as active compositional units. In a few of those still lifes and landscapes, the flatness of the exposed surface buckles toward and into the painted area. Each brushstroke thus becomes a skirmish with the sculptural encroachments of emptiness. Landscape painting did not interest Matisse, but his still lifes and interiors have, by contrast, an aloof depthlessness. *His* reply to the historical situation described by Stella—namely, the collapse of illusionist depth—was to create a surface not built up but spread out as sheeted scalings. That's why his colors so often look either rolled or paved, as in the magnificent fields of *The Red Studio* and *Harmony in Red,* or else diaphanous, shaken loose, as in *Three Sisters.* He was not interested in following Cézanne by making images of the geologic accretions of line and color. Matisse's way of making images was, more than any other modern painter's, a tentative, unsentimental detachment of compositional elements. *The Moorish Screen,* for example, from 1921, displays the familiar contents of Matisse's interiors: table, books, open violin case, human figure, elaborately ornamented screens and carpets, all disinterestedly made available to us on the plane of the canvas. For all his religious feelings, Matisse, unlike Cézanne, did not *offer up* the contents of his pictures to the gaze of

consciousness. All those items have a decorative purpose in the room, and as painted images they are decorations on the canvas. But absorbed into the cool deployment of those artifacts is the emotion Matisse was trying to image: the expectation that out of the coincidence of familiar objects a fused whole may suddenly result, where relations among things are dissolved into immediate undifferentiated erotic presence.

In Matisse's late years these separations and expectations become both more drastic and more playful. His career was not summative or recapitulative. Like Shakespeare's late plays beginning with *Antony and Cleopatra,* with its breakneck velocities and wiry, brittle language, Matisse's late works are not so much a culmination of what he had already done as they are an even more inventive testing of the limits of structure and idiom. When he paints *The Rococo Chair* (1946; Plate 6) and *Still Life with Pomegranates* (1947), he is still the painter of the sacramental stillness of domestic furnishings. But the saturated and diluted color fields of his earlier work are here defied by muscular green canals of color powering through the chair's arms and legs and by the diluvial congestiveness of the ocher upholstery. Each pigment stream is banked, *drawn in,* by white edges; the colorist energies surging against them are palpable. The expansive force is intensified by the violent cropping of the image: our gaze is not allowed to take in the wholeness of the decorative artifact. What matters is its cool, impassioned incompleteness. In the still life, a plate of pomegranates and scattered fruit lies on a table from which rise two columns, a drape and a shutter, which form the right margin of a window. In the window— or, more properly, *upon* it—is worked a pictorial gesture, from an artist who would soon no longer have sufficient physical energy to continue painting, comparable in magnitude to the lifted planes of *The Italian Woman* thirty-two years earlier. Leaves and branches burst like boreal streamers from a white core. The consolidations of the natural world, a tree's physicality, are blown into the isolated exaltations of those darting green forms. Nature's erased consistencies are entirely replaced by Matisse's iconographic poetry: the showering green of the nonexistent tree upon the window answers the blackened scarlet pips of the one split pomegranate, Perse-

phone's fruit, the seeds of which weighed her down; and from the sexual inertia of her underworld existence she rises yearly in vernal plentitude. In paintings of the Madonna and Child by Fra Lippo Lippi, Botticelli, and others, the pomegranate was the sign of restoration held by the Christ Child. In Matisse's image, the sign of vernal return, of the overcoming of sexual inertia, is the rootless, trunkless spray of green leaves painted as decorations upon that window.

As he got older, the more clearly Matisse perceived erotic relations, the more serenely poised and separate the images expressing those relations became. One of the great works of his old age is *Nude with Oranges* (1953). Decoration is here refined to its purest properties. The central axis is a female nude executed in thickly brushed India ink outline; suspended around the figure are the planetary oranges, two on the right, one on the left. The nude is drawing reduced to its most gestural, denotative force. We see the lineaments, the act of attention in the turned but featureless head, the slope of the belly toward the groin, which is half-tucked behind the forward thigh. The paper cutout oranges are sculpted, kiln-fired color, the nearest Matisse could come to infusing thing life into the quality of color. The nude drawing shares its field with pure color. The center of the invisible triangle that the eye draws between the oranges is the figure's enfolded sex. The four images are inviolably separate but just as inviolably joined to the erotic relation created by that anonymous shared blank support. It is the most serene image Matisse produced of the pleasurable, desolating feeling of the incompleteness of all perfectly formed desire.

The Americans

A FLAG, PICTURESQUE BUT drab, flapping across the brick face between two windows. Behind each window, a woman: one visible only up to her shut mouth, the other buttoned tight in an overcoat, her head unseen. Both are nearly absorbed by the porous darkness of their rooms. The flag, with its shivering stars and stripes, is a blazon joining those two anonymities; its crushed browline hoods what those windows on solitary lives might reveal. The entire image, from Robert Frank's "Hoboken" series in *The Americans,* suggests furtive innocence. It broods on the pathos of what's given. The image maker found the scenic moment, copied it, and worked his material until he coaxed from it a mood, a texture, a feeling tone, and the dimension of a world context. The picture expresses a hiddenness not only in the way the two women recede into their separate darknesses, away from daylight's exposures, but also in the odd diffidence in the action of the flag itself. The heroic, sunlit values normally attached to our national symbol, especially its designation of unity in difference, are cautiously cross-grained by the depressive, guarded tone of the image and by the disturbed symmetry of the two windows set nearly lopsided by the slanting movement of the flag. As a representational act, the photo expresses the form-giving encounter between the artist and our most salient public sign. It has political significance because the symbol of the democracy is set in relation to actual constituents of the democracy, which include not only the two women but also the imaginations that stand back of the design and construction of inner-city brick tenement housing. In straight photography the given is deterministic. Against that, Frank presses his own desire to shape the form of the event—the event which is the photograph—into a vision of relations. The images in *The Americans,* taken in 1955–56, are also, most immediately, acts of witness to certain facts of American experience.

The first picture in Made in U.S.A.: An Americanization in Modern Art, the 50s & 60s, which has been on view at the University Art Museum in Berkeley,* is Jasper Johns's *Flag on Orange*

* April 4–June 21, 1987.

Field (1958). Johns was not interested in the flag as a symbol with shared public meanings to be received and viewed in a world context. It was a design appropriated and investigated for its formal possibilities. (The inspiration for all his flag paintings came to him in a dream in which he saw himself painting a large American flag; it wasn't a dream of the flag, it was a dream of the artist painting.) The textures in the flag paintings are voluptuous. In *Flag on Orange Field* the traditional colors are set on a summery orange field, and because of the peculiar materials (Johns used encaustic, a mixture of pigment and hot wax which sets quickly) the textures look blistered but cool. The flag's pristine geometry seems threatened by the hundreds of small surface eruptions. In a 1965 painting, *Flags,* two renderings of the image are suspended on a gray background: in the upper half are black stars on an orange field with green and black stripes; in the lower half, a gray flag barely emerges from the machine gray ground. As formal exertions these paintings are impressive, especially since Johns depletes the image of its normal meanings, although those meanings are vestigially *there* in the husk of the form. The pictures are also virtually moodless. They have burnt off, along with the flag's public meanings, the artist's temperament. The presentation—frontal, annunciatory, self-absorbed but unperturbed—has the open-faced ingenuousness of advertising art. There's a brash and strangely charmed innocence in Johns's taking the flag as a subject, as if it could be treated as a neutral arrangement of formal elements without any interruptive angularities of latent historical or social ironies. In its way, it was the most hermetic sort of appropriation. To act as if a shared political symbol could be taken over as just another visual fact, void of felt public meanings, is to assert the imperious privacy (and inviolability) of art. That assertion, in its different manifestations, becomes one of the vexing issues of the exhibition.

American technological ingenuity had begun manufacturing uniform products in huge volume during the Gilded Age, and even then, before the turn of the century, advertising was already a shaping influence on public taste. By the 1950s and 1960s, however, plentiful uniformity had itself become a grotesque, gigantic caricature of American imagination. Recording tape, photocopying,

long-playing records, TV sets, Polaroid photography—the new means for representing material reality, in infinite replications and with astonishing speed, began to influence our understanding of the public and private life, and of the life of imagination and memory, in ways that we haven't even really begun to sort out. Middle-class economies in the 1950s certainly came to depend more exclusively on uniform products and tools. The hermetic, socially exclusive (and discriminating) automobile was beginning to replace the bus and train—with their mixed social populations—as a preferred means of transportation. And to accommodate the family automobile and the growing trucking industry, the stupefying uniformity of the interstate highway system was engineered. Beneath such increasing material uniformity and standardizing, which were hawked to consumers with the ruthless cheer that is American advertising's most salient tone, there were old hatreds, resentments, and failures of faith that ran along racial and class lines. The versions of perfectibility marketed by advertisers were mocked by events in Korea, Selma, Detroit, and Vietnam; moral perfectibility and the obscene righteousness that endorses it were the real issues behind the McCarthy hearings. Out of that matrix came many of the artists represented in Made in U.S.A., whose work, the catalogue argues, "stands not as propaganda but as a telling reflection of America's postwar obsession with expressing, defining, analyzing, promoting, and criticizing its Americanness."

The show is divided into several sections, each given over to some aspect of postwar culture: "American Icons" (the flag, the dollar bill, monuments, and historical figures like Washington and Lincoln), "Cities, Suburbs, and Highways," "American Food and American Marketing," and so on. Thematically the works match up neatly with their designated categories, but the thematic arrangements (a little bombastic in any case) do not interest me as much as what the paintings and sculptures reveal about the way the artists answered to their moment. Much of the work is too calculated a reaction to already calculated manifestations of American culture, and the encounter between subject matter and the form-giving desire of the artist is rendered nearly passionless by a conventionalized (and enfeebled) curiosity. For all their diverse talents,

artists like Robert Rauschenberg, Claes Oldenburg, Andy Warhol, and Wayne Thiebaud are essentially collectors, antic archivists of American facts. There are exceptions in the show. Larry Rivers's *Washington Crosses the Delaware* is more than a modernist quotation or revision of Emanuel Leutze's famous nineteenth-century painting, though Rivers has said that he reimagined that historical moment as "nervewracking and uncomfortable" and that he couldn't picture anyone "getting into a chilly river around Christmas time with anything resembling hand-on-chest heroics." The coercive anecdotalism of Leutze's portrayal of the event is literally undone, scrambled, in Rivers's version. The spotty, nebulous brushwork and the drawing that shows through the half-realized figures like wiring enact not a historical event so much as a skepticism about the way history's tones are determined by stylized facts.

But on the whole, for a viewer like myself who believes that the most profound disharmonies (and cautious accordances) with one's moment are enacted in the innovations, constraints, refusals and assertions and contestations of an artist's form language, too many of the pieces in Made in U.S.A. give testimony above all to the manipulative publicities of postwar culture. Attention to American things is not new. Thomas Eakins, Charles Demuth, Edward Hopper, regionalists like Reginald Marsh, Winslow Homer, George Bellows, and naive painters like the Louisianan Clementine Hunter have absorbed idiosyncratic American facts into their work. And, more to the point, the first-generation Abstract Expressionists in their heroic willfulness and push-it-to-the-extreme flamboyance— the field of paint for them was a wilderness frontier to be violently organized into form, into completed feeling—were in spirit perhaps the most peculiarly American painters of all. Jackson Pollock combined tactlessness and cunning, and though he practiced an anarchy in the face of conventional figuration, he was also driven to realize new economies and orders in paint. And Mark Rothko meant *his* paintings to bear a weight of sublime moral feeling. The pop artists who began to emerge a little later wanted instead a culture art, fact laden, actuarial, representative of what seemed to them the dominions of culture in their time. Consequently, for subject matter they were drawn to uniform images and standardized

products; in re-presenting them, however, they also borrowed from the methods, tonal register, and moral intent of those who broadcast the products. Absorbed into the very assumptions of Pop Art is the conviction that the artist is a pitchman. That makes for a sort of artist very different from Robert Frank who, obsessed with the same materials, remains at least inquisitive, curious, receptive, open to the most complex and unexpected feeling tones that might emerge while he's working an image into existence.

The pitch that Pop Art makes is sometimes a cry of alarm. That's the dominant tone of many of Rauschenberg's huge fields of canvas on which hectoring one-way signs and torn veils of color angle nervously around news photos of army helicopters, flags, political leaders, and all sorts of cultural debris. His pictures, which I will come back to later, are graphs of American nerves at moments of violent disturbance or change. A more subdued alarmism seethes in the chromium glare of candy-shop colors in Richard Estes's work. His *Welcome to 42nd Street (Victory Theater)* (1968), a frontal across-the-street view of a pornographic movie house, doubles the pitchman's plea. The marquee's program is so intensified by the deep-grooved ebon shadows behind each letter that the message pulses its own afterimage: "She Takes Off Where Her Mother Left Off: THE NOTORIOUS DAUGHTER OF FANNY HILL." Estes's vision enhances the delirium of commerce. In *Food City* (1967), a frontal sidewalk view of a supermarket, the interior signs ("Beauty Aids," "Dietary Foods," "Spanish Foods") and the customers lined up at check-out stands are pasted over by reflections of exterior signs and commercial activity laid on the market's plate-glass window. The laminar appeals are clamped, with rigorous formality, between the upper and lower jaws of the picture: above are banner announcements ("CHUCK STEAK 39¢ lb"); below are squat tiers of canned and bottled foods.

The sort of projection we find in Estes's paintings is yet cool and bemused when compared with the extravagant pitch of Edward Ruscha's *Standard Station, Amarillo, Texas* (1963), where hot-iron reds and whites blaze up from the lower right-hand corner of the frame like something carved out of a headlight's funnel beam. I don't share Sidra Stich's belief, proposed in her catalogue essay, that

the service station is depicted as "a monumentalized edifice, an apotheosized shrine." Or rather, if this were Ruscha's intention, it was defeated by his very choice of subject, something so purely the expression of capitalist economics that any notion of its being monumentalized or viewed as sacred must be rooted in a complex, critical, political irony that pop artists did not possess. Ruscha's subject is too peculiar to a historical moment, and too secular, to be in any way sublime. Most pop artists were so cautiously knowing and so caught up in the stylistic niceties of presentation that subversive satire was generally beyond them. And I think that was because the subtleties of feeling tone available to representational painters were co-opted by the pop artist's mixed impulses as archivist and pitchman.

Displayed next to Estes's movie-house picture is Rauschenberg's *Choke,* and although formally they are quite different (next to the disruptions of Rauschenberg's painting Estes's work seems a city-of-glass dream of reason) there are exaggerated culture facts gathered in each. The liturgical exactitude of Estes's picture palace makes its signs—a tall billboard caps the marquee: "WELCOME TO 42ND STREET THE WORLD'S GREATEST MOVIE CENTER"—both welcoming and assaultive. Its appeal, like the action of much American advertising, is an abrasive hugginess. In Rauschenberg's picture a One-Way sign rockets up the middle of the painting's upper half, trailing yellow streamers all the way to the bottom of the canvas, where a mess of traffic signs leers from a red patch. Left of the rocket is some kind of meteorological instrument, its gauge barely legible, as if battered by overuse. To the right are more indicators, signs, indecipherable public messages. An army helicopter and the Statue of Liberty, both worked out in the muzzy tones of news photography, occupy each side of the painting's upper half. The aggressive images, however, are almost furtively held back by the fine textures of the silkscreening. Rauschenberg's art is an enthusiastic answer to American experience, and one of his projects is to catch the way we beam instructional signs and messages back at ourselves as if in punishment for some as yet undetermined primal misdeed. We never tire of teasing announcements that instruct us on what to do, what to buy, where to go, and how to get there. It's

not so much the sheer abundance of signs (bumper stickers, T-shirt declarations, billboards, and on and on) that are peculiar to American culture as the frantically meliorist conviction they bear. We have a wilderness in our soul, and one of our felt errands in civilizing it is to remind ourselves of some presumed covenant with perfectibility.

That persuasion is reflected in some strains of Pop Art as an overdetermined meticulousness of representation, whereby subjects drawn from the quick of social and political life are then sealed into a hermetic envelope. Cézanne and Giacometti, Eakins and Rothko, all worked toward an impossible completed *réalisation* on the canvas; and the laboriousness of the task was part of the expressive finish of the work. In paintings by Estes, Allan D'Arcangelo, James Rosenquist, and others, where sterling enhancement of the subject is paramount, the macadamized steel-and-glass colors and enameled clarities of image begin to seem painterly equivalents of the 1950s American kitchen, of whose perfections Richard Nixon boasted to Nikita Khrushchev. George Segal makes immaculate simulacra of human figures, which for all their unsettling lifelikeness show no traces of consciousness and personality. A work like Duane Hanson's *Motorcycle Accident* (1969) horrifies because of its anatomical specificity of broken bones and torn flesh. In Abstract Expressionism the most crucial act was the turning of world feeling into picture feeling. The full emotional and intellectual life of the artist in his moment was lived out in the exploration of open, public, nonrepresentational forms; and the enterprise bore at least vestiges of what once had been belief in transcendence, in some Other, in an imagined consciousness more inclusive than the artist's own.

Against that the pop artist proposes a copyist's art, annunciatory and legislative, that rejects (or evades) the transcendent. As a consequence, the sign or culture image—Coke bottle, hamburger, car, flag, or highway sign—takes on a determinist authority and deflects anarchic curiosity about forms. Even Rauschenberg's explosive pictures frequently seem contrivances because of the theatrical manipulation of his subjects and materials, though he and Jasper Johns have exercised more formal curiosity than culture-bound art-

ists like Warhol and Oldenburg. Johns's peculiar hermeticism gave him, in fact, the freedom he needed to produce a mud-mystery painting like his 1962 *Map*. Like many pop paintings, it is a "treatment" of a familiar cultural item. But reassuring cartographic clarity and definition, familiar to many of us from the plastic map puzzles we played with as children, are precisely what melt away in Johns's painting. It's done in encaustic, like the flag paintings, so the whole field of color looks just recently stirred and boiled onto the canvas. Borders once fixed are slipping, the emblems of land masses bleed into incoherent blues and grays, state names are stenciled (smeared, streaked, sometimes doubled, IOWA printed over I O W A) like destinations on boxcars. In treating the emblematic form, Johns revitalizes it as a field in formal disarray and dissolution. Although the work remains in the pop stream, the artist is taking some pains to challenge the given culture fact in bringing the painting to its own realization.

Wayne Thiebaud's paintings of food pose another, wittier, challenge. *Trucker's Supper* (1961) is fastidious and rigorous in its arrangements: red countertop, glass of milk, sliced bread with a pat of butter, a plate of steak and fries. The stylized pattern, its scenic repose, is resisted by the delirium of the paint. The countertop is a tremulous, rubbery belt, the fork and spoon swim in the fevered grays of a paper napkin, and the steak is a wedge of river-god brown threaded with blues, yellows, and beef-blood reds. In its effort to realize its subject, the painting quivers just this side of representation. What at first seems typical Pop (especially in the catalogue reproduction, where the action of the paint is unavoidably deadened, and the outlines hardened), because of the subject's high, plaintively American definition, after a minute's viewing becomes an expansive and nearly abstract quarrel with what's given. Thiebaud's *Lunch Table* is less anxious, and funnier. It shows a self-service display of joyous ranks of lemon meringue pie wedges, bowls of soup, layer cake slices, dreadfully inert cottage cheese salads, and watermelon quarters that sit up on their plates like overeager children, all bathed in arctic fluorescent light. The scene is possessed of a fantastic candor and earnestness that we, certainly more than modern Europeans (who have taken over "self-service"

as a term and marketing procedure), feel to be part of our character. That innocence—the food looks self-offering, ingenuous, anxious to be liked—is momentarily stilled in Thiebaud's thick, pasty forms, as if it were the most fragile of conditions, as if those cheery shapes were about to decompose into light's frigid immateriality.

Andy Warhol favored the iconography of self-offering, but in his presentation of the human he was careful to pound senseless every vestige of pathos in the image. His *Twenty-Five Colored Marilyns,* an acrylic on canvas, is like a colossal botched sheet of postage stamps, with smudged outlines and mismatched tints. Even the blandest stamp portrait of a historical personage, however, preserves traces of the activities of consciousness. Warhol's Marilyn, like the human figure generally in his work, is devoid of consciousness. His *Triple Elvis* is a husk of appearances; all the powers of attention have been methodically refined away. Warhol's replicated images are modeled on mechanical processes, so successfully (and profitably) that I don't believe he was speaking as ironically as Sidra Stich says he was when she quotes his famous remark: "Everybody looks alike and acts alike, and we're getting more and more that way. I think everybody should be a machine." As an artist, he took his own advice and followed the course of least resistance. In representing the human figure he borrowed or copied the primary vision of others, usually a photographic one. And he passed the image through his nervous system with minimal friction of curiosity, resistance from his own shaping imagination, or concern for preserving (or re-forming) the look of consciousness. The eventfulness of painting, for an artist like Warhol, is beside the point. The point is the bland, stammered second-telling of an already told image. That's why his most charming works are of already determined products—Campbell's soup cans, Brillo pad boxes, Coke bottles. When his subjects are politically volatile, such as *Jackie (The Week That Was)* (1963), whose grainy silkscreened treatments of news photos of Jackie Kennedy are usually presumed to be more refined and sensitive than the leering streetside blasts of Weegee, or *Race Riot* with its tinted opaque replications of Bull Connor's dogs being set loose on black demonstrators in Birmingham, Warhol vacuums from the photographic image the feeling tones of suffer-

ing, social relations, and violence. He wants the image to be both glamorously contemporary and affectively neutral. Warhol and pop artists of his persuasion become the naughty but perfectly house-broken pets of our postwar consumer economy because while they did indeed reflect the material obsessions of American culture, they borrowed too deferentially its means of publicity and played back too uncritically the products that were both subject matter and models for what an artwork product might be.

The eyes in Roy Lichtenstein's comic-strip operettas are em-blems of sight; they disclose no activity of consciousness. And the pinched, blank gaze of Mel Ramos's 1961 *Superman* suggests that instead of answering to that extraordinary pop figure—his mes-sianic heroism, his alien but "Americanized" nature, his adoption by and of the Earth, his vulnerability to mineral matter from his home planet—the picture is content to bear witness by citing like-ness. The event of painting has been conceived in a pop indif-ference to and disengagement from the political and moral force of the image. The same intention stands behind Lichtenstein's comic-strip art: the artist's image-making faculty seems driven exclusively toward a perfect aestheticizing of the culture fact. Comic-strip characters are titillating and hypnotically charming because they are presences to which language, the articulation of conscious-ness, is fastened. Language is laid on; it doesn't issue from human sources, it's suspended in or pasted to their context, their frame. The only artist in Made in U.S.A. whose work has subversive politi-cal force is Jess. In his "Tricky Cad" series he scrambles frames and dialogue snipped from the Dick Tracy Sunday comics, re-editing story and speech. The collages are grotesquely funny, acerbic, de-ranged enactments of the manipulations of pop images and idioms. In *Tricky Cad—Case I* Dick and Sam stalk some (unidentified, un-seen) villain in a snowy forest. Dick shouts: "Halt! His! Her! Halt!" His partner answers: "Fire bearing the baby in the doll—." Prefabricated language attached to consciousness is one definition of propaganda, and in his idiosyncratic comic tones Jess is ques-tioning (by dismantling) that kind of political and social authority. He turns Dick Tracy's snarling do-goodism into a riot of busted consequences and misfired intentions.

Rauschenberg does not have Jess's canniness, but his ambitions are more grandiose. He uses silkscreening to fuse ready-made images to the field of the picture, thus fastening world debris to an imagined context. He wants the ghost of what's given, the hard definition of debris turned almost phantasmal in the decomposing, thinned-out consistencies of silkscreening. In the book *Off the Wall,* Calvin Tompkins described Rauschenberg as an inclusive, voracious sort of artist. He's certainly not interested in the monastic, cautious deliberations of Warhol, Robert Bechtle, or even Jasper Johns (though Rauschenberg has always thought Johns the more skillful technician). In *Kite,* a snapshot of a Boy Scout flag parade is ruptured by another showing army troops, one kind of uniformity disrupted by another. Above that scene rises a buoyant, sky blue column; at its base an army helicopter hovers over the broken parade, and at its top sits a bald eagle, river-clay red. Flanking those images—the helicopters and eagle are fastened signatures in much of Rauschenberg's work in the 1960s—are ivory pillars streaked with jet that seeps, like oil or blood, from a black cylinder high in the picture. The gusto and breakneck rhythms in this and other Rauschenberg canvases are checked a little by the repetitive, programmatic borrowing of available politically encoded facts— street scenes, soldiers, policemen, J.F.K., astronauts—as if they were control devices to prevent an all-admissive delirium. In *Kite* this tension is palpable. The studious borrowings by other pop artists seem at best formal niceties when compared to the congestive turbulence in Rauschenberg's work, which looks to me, more than anything else on display, like an accurate, if incoherent, answer to the wild nerves of the 1960s.

But the single most powerful image in Made in U.S.A. is de Kooning's *Marilyn Monroe* (1954; Plate 7); it makes most of what surrounds it seem tame, conventionalized, dispirited. The full force of de Kooning's rage for form is lived out in the action of the paint, which registers the encounter between the painter and not only the husk of appearances of his subject but also the subject's consciousness. This is brutally apparent in the show, where his *Marilyn Monroe* is displayed alongside Warhol's *Twenty-Five Marilyns.* For de Kooning what mattered was not so much the glamor-bound em-

blematic quality of his subject (he didn't confer the title, apparently, though he admitted that Marilyn Monroe, whose picture he kept in his studio, inspired this and other women paintings of his) as the aggrieved, proud, helpless, and nervously giddy offering of pleasure's promise. Built up from a field of winged, angular planes of red, yellow, white, and green, de Kooning's Marilyn emerges in her picture existence as a consciousness at once desirous and fearful. The image shows none of the coy self-regard that mutes most of the other works on exhibit, and it is certainly unconcerned with taking on for its own purposes of enhancement the glamor inherent in its subject. Such glamor is feverishly neutralized and displaced by de Kooning's desire.

Miscellany II

M

Y MOST FREQUENT CHILD-
hood dream was of blocky masses of spongy graywhite vapors.
They were terrifying because they could possess me, absorb me
into their mass, though that also seemed inviting, even desirable, a
return to pure, undifferentiated beginnings, a flight from the pains
of unlikeness. When I first got to know some of Rothko's painting
in the 1970s, I was moved in ways I could not understand or articu-
late. Something in them exercised what D. H. Lawrence calls "the
insidious mastery of song." Their claim had to do with that old
dream and also with the paintings' nonanecdotal quality, whereby
the very abandonment of narrative, of figural and scenic sugges-
tiveness, became a dense presence, a sumptuous forfeiture. I think
of Rothko's sacred decorations for the chapel in Houston. The
place turns you back into yourself. The images, their paint films
eroded and cracked by lighting and humidity problems over the
years, are yet meditative objects. They don't return us to nature, to
the massiveness of material reality; they restore us to our means of
spiritual preparedness, to disciplines of awareness. Rothko said he
wanted high moral themes. He wanted to make tragic painting. We
experience tragedy not as themes but as dramatic situation, charac-
ter, anecdote, momentous event and consequence. But tragic feel-
ing may be an inchoate stirring or condition not attached to a spe-
cific experience, and it's that feeling—of loss in the fullness of
knowledge, of the force of destiny, of a yearning to find in our-
selves sacred knowledge and to suffer the consequences of the dis-
covery—that Rothko tried to cast in those forms. (Can they be
Keats's "huge cloudy symbols of a high romance"?) It's more a
dream feeling than a waking one. No less intensely lived but not
consciously so. It is not lived in time. We experience it out of time,
or in the Great Time, the Beginning Time that we are so much
closer to when we're children. I can't follow the critics who see in
his paintings figures or recapitulations or "traces" of the figurative
art of previous centuries, especially when they make the case that
he is essentially a religious artist recapitulating or transfiguring tra-

ditional religious motifs. If anything made him an artist of the sacred it was his mission to paint the facelessness of transcendence. He pursued (and illustrated) the post-romantic consequences of Shelley's statement in *Prometheus Unbound* that "the deep truth is imageless."

A useful definition of "imaginative," in Bergson's *Two Sources of Morality and Religion:* "any concrete representation which is neither perception nor memory." I think that means categorically neither one nor the other. An amalgam, but infused (I would add) with the instinct for form.

Over the years Frank Stella has achieved a programmatic novelty, surprises so strategic that they feel more like methodically worked-out theories than actual physical events. His is the kind of abstraction that lives entirely for others (and for the systematic advance of art history). Years ago he said, "For a painting to be successful, it has to deal with problems that are always given to painting, meaning the problems of what it takes to make a really good or convincing painting." An artist naturally folds into his expressive work a historical awareness of predecessors and an awareness of formal problems. But the superior artist will not be so concerned with the correctness or aptness or timeliness of his response to those pressures. And yet Stella's career is taken as exemplary by many younger artists, even nonabstractionists, insofar as they are more preoccupied with making art that explains or justifies its own existence than with art that is essentially emotive, appetitive, expressive.

Museum going. In Philadelphia, in the Cézanne room with its great centerpiece of the 1906 *Bathers,* a father bustles through the far doorway, two children tugging his hands, bubbling about something. The father, trying to get above their voices, nearly shouts,

"But in those days, Jimmy, they didn't have things like VCRs," while they pick up speed and hurry across the room and out the far door. In New York at the Degas exhibition the dense weekday crowd, funereal in its attentiveness, paced in silent procession from one image to the next. Rippling the surface of that quiet was the chittering of headsets. More explanations. When we go to a big show, we can acquire more prepackaged information about the artist's work—its social and biographical setting, its art-historical "place," etc.—than ever before. Because of the educational mission of our museums, I suppose this sort of instructive processing of art is inevitable, though I think it must somehow impede the natural streaming of beautiful images into our emotional and spiritual lives. How close are we, though, to believing finally that, in our cultural lives, information is edification? Access sufficient data, compile an adequate body of fact, contrive a theoretical apparatus that will elucidate patterns that connect systems and networks, and the Golem stirs.

In his chapter on Leonardo in *The Renaissance,* Pater writes: "The way to perfection is through a series of disgusts." For moderns, the way matters more than the perfection, and the disgusts themselves are exemplary.

Why are the jets and emulsive tracks of paint in Pollock's *Lavender Mist: Number 1, 1950* so compelling? It's not only because he was creating a greater plasticity of space and laying out dozens of contested fields of formal activity where disintegrating patterns pitch against imminent, struggling stabilities. There's something one can't reduce satisfactorily to formal terms. In 1964 the Romanian-born Eliade, who was a great admirer of his countryman Brancusi, spoke of "nonfigurative painters who abolish representational forms and surfaces, penetrate to the inside of matter, and try to reveal *the ultimate structures of substance.*" In order to talk about Pollock, and Rothko for that matter, in other than purely formalist vocabu-

laries (and to avoid the useless argument that both were represen-
tationalists masquerading as abstractionists), we may have to pick
up where Pierre Schneider left off in his discussion of Matisse and
talk about the sacred and the mundane. Eliade also says that non-
representational art corresponds to the "demythologization" in
religion advocated by Rudolph Bultmann. As Christianity may
dissolve the images and symbols of its traditional narratives to con-
front once again the freshness of religious experience in our secu-
lar, materialist time, certain artists give up the making of represen-
tational images so that they can see *through* traditional iconography
to the world as it could have been seen only on the first day of
creation. Moreover, he says, today's artist "sees only the freshness
of the first day of the world—he does not yet see its 'face.' The
time of the epiphany has not yet arrived, or does the world *truly
have no face?*" I think Pollock and Rothko worked to paint that
facelessness. For Rothko it was toned with a magisterial, volumi-
nous solemnity. For Pollock the tone was one of self-devouring
conflict.

Why the erotic pinch of photographs? Eros, the divided egg, the
desire, the likeness separated forever from its matching, comple-
mentary half. Maybe because the whole shape of the ghost of the
flesh is already there—and yet is not there, I mean not *here,* not
actual (the image tells us that, too), its likeness so like what we
imagine our own likeness to be. We see ourselves remembered, al-
ready posthumous, sometimes smiling. I have an old studio portrait
of my grandmother as a young woman in Abruzzo. I see the digni-
fied stillness, the compassionate self-containment that men found
so attractive. In a snapshot of my father, taken in South Phila-
delphia when he was in his early twenties, I see the familiar shadow
structure and stress lines of my own face. A third image, of my
grandmother and grandfather, not long after she joined him in
South Philadelphia: my young grandfather, who would die a few
months later, has the alert, triangulated, almost wolfish features my
father bears in that other picture. My grandmother is wearing a

dark, simple dress and high-laced boots. Both are dressed in famil-
iar, too frequently brushed and washed and ironed grays and
whites. They have in their faces the strained look of what Henry
James called the launched populations. But now, in my life, my
memory, there are other presences that sharpen the pinch even
more. Lewis Hine, Walker Evans, Paul Strand, Russell Lee—they
are there, too.

Realism into Camp. The representation as sitting duck: see Jasper
Johns's *Decoy.* The title identifies the image as an easy target, but
also a deceptive one meant to draw our attention away from some-
thing else, away from the really real likeness. Deception depends
on coy verisimilitude. Johns is the realist as sign painter. Each
form, even abstract patterns like the famous hatchmarks of the
1970s and 1980s, is a sign meant to stand for something else. So
what does a decoy painting mock? The painted image is a stand-in
for the original, it's not the duck. So where's the duck? Nowhere
present but everywhere signified? Johns's enterprise since the late
1960s seems to be the making of images that are purposive stand-
ins for a reality too fragile, intimate, or vulnerable to expose. And
what might that reality be? Maybe it's the mind in which corre-
spondences and connections between signs and emblems—flags,
numbers, Savarin cans, bathtub fixtures, posters, letters—hold
their coherence, generate some system of meaning. Or does an im-
age refer to some originating prototype, the really real, that has fled?
Is Johns mourning the loss of some untold but felt Golden Age of
image representation? (Does the lament become soon numbed by
its ritual funereal repetitions?) Or is he devious or impish or callow
to have devised an art that is essentially a model of the monkey
mind? *Decoy* recapitulates familiar motifs in somber indigo and
pale blues: framed in the center is a Ballantine can, positioned as
an exhibit or lure. Color words (RED, ORANGE, etc.) form column
and buttress patterns. That field is mounted on a lower border il-
lustrating silkscreen images of Johns's earlier works: the Savarin
can, a light bulb, a flashlight. *Decoy* and many other pieces of the

1970s and 1980s are essentially design concepts so overdetermined in their impassivity that the felt life has been drained from them. The blandness of purity.

———

Baudelaire says in the *Salon of 1846* that the great criterion of art is memory. "Art is a kind of mnemotechny of beauty; and slavish imitation interferes with memory. There is a class of atrocious painters for whom the smallest wart is a great piece of luck; not only would they not dream of leaving it out, but they must needs make it four times life-size." But there is also reality's command to artists (they feel it as a command) who, though practiced in Baudelaire's mnemotechny, cannot ignore the high shine of the world's objects, the allure of the given. Such artists, however, would rarely think of enlarging a wart. The exaggeration and intensification of the given comes from their transformative way of seeing the world. Memory may turn what's before our eyes into a fever dream, and *that* becomes the object the artist copies.

———

Discussing Giovanni Morelli's argument for making correct attributions of works of art, Edgar Wind says in *Art and Anarchy:* "This is the core of Morelli's argument: an artist's personal instinct for form will appear at its purest in the least significant parts of his work, because they are the least labored." The same can be said of a poet's work. What can be felt in the simplest, least significant turn of phrase is the stirring of language in answer to the poet's instinct for the necessary (not the correct) form. A poet follows the pattern that language generates the way a painter follows or pursues the emergent image. It's the strange perfume of the work.

———

Fairfield Porter's double portrait of John Ashbery and James Schuyler depicts a certain kind of poetic distraction. The two seem to have nothing to say, each lost in a thought that holds little interest even for them, to judge by the look of bland restraint on their

faces. Their composure seems just as likely to verge on terminal boredom as on delirium or hysteria. That makes them truly Baudelaire's children.

For Lucian Freud the flesh is a garment worn by an exhausted spirit. His figures seem to bear too much weight of the past, and the burden bores them. They look like ideal sitters because it would be more difficult for them to move than to sit still for long periods. It's the skin, with its vestiges of conscience, that distinguishes the humans from the plants that Freud sometimes paints into their scenes.

The 1986 Biennial at the San Francisco Museum of Modern Art is devoted to what the curators call the presence of the past in recent art. The works on display are meant to demonstrate the complex ways young artists are taking over, making over, classical influences. Giulio Paolini, best known as an Arte Povera artist, is represented by *Nesso:* to compose an image of the centaur Nessus he mounts a scroll of paper with a human head and torso drawn on it atop a classically modeled horse's body. (He said he doesn't intend "a revisit, in the sense of a choice in the stores of the past, but rather an undifferentiated welcome, a memory that wants to reach the very making of the work.") The German Hermann Albert's paintings blend explicitly the influences of de Chirico, Balthus, and Picasso. Carlo Maria Mariani offers pictorial résumés of Ingres, Fuseli, and Blake. In these cases the relation of present activity to past achievement is essentially archival, recuperative, and parodistic; the presentations are theatrical and bluntly self-aware. The formal instigations of older artists quoted in these images are not recovered so that they may be pushed further, detonated, retested, or pounded into new possibilities. (Any of Giacometti's ballpoint sketches of masterworks in the Louvre would be a measure of how that's accomplished.) They're mummified, made pristinely historical. The exception is the Norwegian Odd Nerdrum, whose paint-

ing *The Water Protectors* shows a bombed-out terrain patrolled by half-naked warriors in leather headpieces carrying automatic weapons. The drawing and coloring are obviously derivative of baroque painting, but Nerdrum isn't simply manipulating historical values or pushing imagery around; he has a singular and disturbing vision that he's trying to model in paint, and his homage to masterful predecessors becomes unnervingly folded into his vision of civilization undone by its own overrefined sense of need. His work doesn't suffer from formal fatigue and isn't immunized, as so much recent figurative painting seems to be, against unexpected feeling.

The way Pollock skeined paint onto the canvas would seem the supreme manipulation of accident—decisive accident. He used the brush like a stick, pointing the paint into emergent arcs and spindles on the blank ground of the canvas. He used the action of gravity on a painter's material as a crucial form-making action. He was no more a shaman wielding a medicine stick, as one critic melodramatically described him, than was Courbet or Cézanne buttering the canvas with heavy loads of paint from the palette knife. Better say Pollock was no *less* the shaman than they. As for accident, in a 1951 interview he said that the drip paintings were products of a controlled application of paint, that he did not use the accident, he *denied* it. Those forms were, in other words, exclusionary. The snarled, implosive space created by the apparent galactic chaos of pigment came from a discipline of denial. The application of paint by the Wild Man from Cody was a stay against the derangements of form that accident creates.

The Cibachrome process so saturates the photographic image with color that the tones look hallucinated, engorged with dream dyes, but at the same time cool, shellacked, almost decorative. I saw somewhere a show of images of sports events. The colors were so ripe and swollen that the tension of physical action—a soccer player falling, a motorcyclist turning a curve (his knee about an

inch off the ground), a gang of racing cars at the starting line—was loosened, drained of energy, because the drawing, I mean the composition of stress lines and tension points, was slack. Intensification of color can't compensate for wobbly structure. Or if it does, it usually makes for visual bombast. But I also think of Richard Misrach's Ektacolor images in his 1983–84 "Desert Fires" series where the conflagrations of light seem a visionary part of the natural life cycle of the landscape. The paper itself looks as if it has caught fire, ignited by likeness. Used in this way, a color process can set the image in an adversarial or strained relation to its own support.

To write or make images in response to Nietzsche's challenge (from the notebook he kept while writing *Thus Spoke Zarathustra*): "He who no longer finds what is great in God will find it nowhere—he must either deny it or create it."

Rothko's art is the kind that cultivates the imminence of oblivion, cultivates it with such disciplined passion that possibility comes to seem desirability. How then does one make an art of defiant resolutions out of the knowledge of despair, the tantalus of complete forgetfulness? That's the poet's question, too. One sustaining answer (Rothko's): a feeling tone blending vexed joy and pained (never blissful) forgetfulness.

Artists who take their Americanness too literally as a subject are likely to become mere processors of American facts, though in the bargain they may also become well known, maybe rich, producers of such facts as commodities.

In much Pop Art the crucial aesthetic decisions seem to have been made before the image comes into existence, so that the materials

can't respond in a challenging way to the artist's exertions. In a way such an art liberates the artist: the image is "non-negotiable"—but often it also results in a numbed and numbing exclusivity and a new academicism waving the banner of cultural criticism. The pleasures it offers are those of good-humored, cautious, and fairly predictable artisanry. One pop trap was that some of its artists wanted everything, in moral terms. They wanted images having critical adversarial energy—all those votive objects of a market economy: movie stars, comic-strip heroes, cars, refrigerators, TVs, canned foods, and hot dogs—but they wanted them also to be celebratory. The critical energy was mostly co-opted immediately by the sheer political commodity value of the images. How can an image maker criticize what he or she also exalts? Does ironic presentation redeem one from that dilemma? What if pop irony itself carries a high market value? Is it necessary to do as Warhol did and confuse the public into market delirium by becoming a vendor of your own masterful affectlessness?

My friend L., a ceramics artist and furniture designer, took me to a furniture art exhibition on lower Broadway. She kids me for being a romantic nostalgist and hopes to liberate me from my loyalties to figuration. Deployed in the long high-ceilinged space were chairs, tables, play sets, wet bars, lawn furniture, models for landscape designs, etc. Each piece had its own idiom angled into some kind of dramatic relationship with the object's traditional use value. Nothing seemed exclusively decorative or primarily useful. Each had designs on the viewer-user, begging for some lively response. One fabulous piece: a wet bar made of (I think) black granite. The front played with the light, breaking it into hundreds of black glints. It had no fake or ironical sacrosanctity, though it kept some of the solemnity of its form—it looked like a cropped monolith. But its chief beauty was in the adjusted monumentality of the black stone, which also held some surprise: on its rear side, invisible to the imaginary guests, was a carved hive of gleaming cells and cubbyholes, the secret inflections of the monolithic front disclosed only to the initiate. The entire object seemed to talk back at us. De-

signed into it was the assumption that there is a living relation, a ritual conversation, between us and our things.

———————

Richard Diebenkorn may have proved by now to be the most masterly of the painters associated with Bay Area figurative art in the 1950s, but during that period David Park was the most exciting because his painting was so anxious. Diebenkorn's pursuit of colorist geometries in the figurative work, then later in the abstraction of the 1960s and 1970s (culminating, I suppose, in the processional varieties of the "Ocean Park" series) shows a tenacity of purpose and investigatory deliberation he learned from Matisse, though Diebenkorn has never really been driven by passion for the figure or by fauvist enthusiasm. By contrast with the serene buoyancies of Diebenkorn's work of the 1950s, Park's figure paintings from the same time are massive and not yet fully evolved cult objects. In Park the instrumentation of the brush is more a part of the drama of subject, and the color is madder, more incensed and driven, though (in the work of the early 1950s especially) there's an anxious devouring of space by color volumes that seems one moment a terrible violence, another moment a diffident impatience. The flesh in *Standing Male Nude in the Shower* from 1957 glows a bar-neon red, tacky-infernal, painted from the inside out. In the 1954 *Nudes by a River,* built up in broad banded color masses, the flesh, shown in a state of repose, still struggles to define itself against the erosions of space. The 1957 *Bather with Knee Up,* like Park's work generally after 1955, is solidly constructed, but the planks of ocher, brown, and gray look nailed into place. The colorist disruptions of the earlier work—and the instinctual surprise: in portraits like *Head of Lydia* (1953) and *Profile and Lamp* (1952) we're pitched into the intimacy of the subject as we are in genre pictures like *Sophomore Society* (1953) and *Cocktail Lounge* (1952)—are over-resolved in frontal, increasingly monumental poses. If there's anxiety in these later pieces, it may lie in the disparity between the often grimly isolated individuals in the figure groups and their representation in loaded, erotically charged masses of paint.

———————

Baudelaire's praise for the imagination comes from his hatred or dread of nature, of the fallen world of the visible. It's a Catholic's version: "How mysterious is imagination, that Queen of the Faculties! It touches all the others; it rouses them and sends them into combat. . . . Those men who are not quickened by it are easily recognizable by some strange curse which withers their productions like the fig-tree in the Gospel. It is both analysis and synthesis. . . . It is Imagination that first taught man the moral meaning of color, of contour, of sound and of scent." The Imagination thus dissolves and recreates the world, it redeems nature from itself, saves it from its chaotic beginnings. Baudelaire's Romanticism—the Imagination as moral adjudicator and meliorator of all in nature—cannot accommodate a Cézanne, a Giacometti, a Matisse; although they certainly exercise Imagination more or less as Baudelaire understood it, they did so in order to represent nature as they saw it. They practiced the same degree of moral attentiveness to nature as did Ingres, whom Baudelaire so disliked, and Manet, who he felt was gifted but misguided. It's not the fallenness of nature that determined how certain modern artists have gone about their work but the fallen condition of the Imagination itself, which knows it wants to make an image of nature but knows it has lost for good the innocence of realist representation. (In light of the impossibilities modern artists faced, splenetic Baudelaire sounds almost cheery.) Maybe one ambition of Abstract Expressionism was to vaporize the very terms of the question, to take the god out of technique, to replace Eros with erotics, to demythologize and dismantle all moral analogue left over from representationalism.

The question of transcendence in painting since 1945 is not God stuff, at least not exclusively. It has a social meaning, if we accept Erich Fromm's view that transcendence means overcoming the limits of selfhood, the prison of the self, of solipsism and alienation, and opening ourselves to others, to relatedness to the world. Jasper Johns may be the exemplary painter of the cell of selfhood—the game of form being both play activity and the ramparts of the garrisoned self—with no sense of relatedness to anything outside the

circuit of familiar forms, and with very narrow, repetitious relations among those forms. But he is not bound alone in that nutshell.

––––––––

William Bailey's still lifes are images of perfection. Some say he's heir to Morandi, but Morandi's paintings, especially the great ones from the mid-1930s and mid-1960s, are all articulated doubts, skepticisms, uncertainties. Their "spectrality" was a way of accommodating the spirit life Morandi felt in the thing life of paint. Exact rendering wasn't important. What mattered was formal curiosity, the investigation of feeling occasioned by *the thing that's there,* the use of painting to interrogate and disclose feeling. His greatest paintings are images of aggrieved, restive stillness. Bailey, by contrast, makes images of a contented imagination; they have no anxiety about their own existence. He's a superb designer, though. One goes to his work not for mysterious inquiries of color but for colorism's high schematic resolutions. It withholds eruptive disturbances—color is the code of predetermined harmonies. The pleasure it gives us is that of a perfect fit, and of certain serenity. It's not a happy art, not as Matisse's or Miró's or Klee's was often happy, celebrative, nervy, sometimes giddy, and teased out of mind by formal excitements. Bailey's is a contented art, unperturbed, wonderfully composed. One of his tables, with its warm textures and methodically distributed values, occupies its space in a way meant to attract our admiration. It offers itself a little too readily, and earnestly, to our appreciation.

––––––––

Is it worth the effort to perfect a rhetoric of coy but conquering persuasion that mocks its own intentions? Is it worth the effort to make oneself—painter or poet—a genius of affected affectlessness? *That* is the most disconcerting sentimentality of our time. We've come so far from Bergson, who less than a century ago could say that the universe is a machine for the making of gods! Our time needs an artist who, without the insulating mockeries of Camp, will be brilliantly and fearlessly antisacred.

––––––––

In the work of some moderns it's impossible to distinguish between the pursuit of transcendent reality, of the old sacred, and the de-sacralized commitment to formal realization. Modernism's necessary blasphemy was to keep alive the idea of the sacred by saying that it inheres in the pursuit of forms. This is what Matisse meant when he said he believed in God only when he was working. It's not historical vestiges or residues of the sacred that exist in their work, it is in fact spiritual essence, the assumption that the driven-ness of the form-making imagination is authored by and answer-able to some force or energy or historical contingency greater than itself, even if that greater power is a fiction of the eternal, the infinite. In the work of certain first-generation Abstract Expression-ists, of Pollock and Rothko and Clyfford Still, I always feel the presence of the sacred in the forms. The boundary has been crossed; nature and likeness disintegrate and recohere as an *otherness* of formal mystery. And their formalism is more infused with a natu-ralistic, fearful, primitive religiosity than is the work of Matisse and Giacometti. In a good deal of pop and neo-expressionist art, fig-ures of sacred power and the sense of the transcendent are taken mainly as materialist cultural residue, or as elements of camp nos-talgia. We've been living through another passage in the expanding and contracting relation between the mortal order and that which it conceives as transcending it. It's a story of estrangements.

Questions of Anselm Kiefer. In both versions of the 1982 *To the Unknown Painter* the palette is planted in the center of its scene; it doesn't have wings, as in other paintings. It's atop a rickety pole, like a flag or grave marker, and in both versions it's surrounded by the massive "heroic" architectural motifs of Albert Speer. Is it therefore an image of spindly weakling art holding its place in the bombastic vacancies of the officially heroic? Is Kiefer mocking the worshipful heroizing of art and artists? Is the palette-on-a-pole an image of hermetic isolation, of the artist as Simon Exemplar? Does it mark a gravesite in a cavernous mausoleum? Does the image, so simple in its elements, cohere? / / / Many of his paintings barely concede light. Light appears as an act of will, never casual or inci-

dental to subject or composition. It's so carefully rationed that its dispensations must be prepared for, ceremonialized, and when it does come it's usually zinc light, sand-grit light, as if in illustration of the lines from Paul Celan's *Deathfugue* (a poem illustrated explicitly in Kiefer's Shulamite and Margarete paintings):

> Black milk of dawn we drink it at sundown
> we drink it at noon and mornings we drink it at night
> we drink and we drink it

/ / / Why isn't the pictorial conceit of *Icarus–March Sand* (1981) ludicrous? A flying palette. Winged aspiration. The painter scorched by ambition and foolhardiness, trusting too much to technology. A hackneyed contrivance? But the presentation is utterly graceless, mineralized, the palette's grossly feathered wing a scorched gluey black. The textures are decayed, clotted, pounded. Icarus, with his kidney-shaped head and fat wings, is a turkey vulture, a carrion feeder out of nightmare, fallen, still falling. / / / Why is the second great influence on Kiefer after his mentor Joseph Beuys, by his own admission, Andy Warhol? Kiefer often begins with a photograph implanted on the canvas. Then, he says, "I cover up the pure reality of the photograph with my thoughts and feelings, since I paint in layers." (Warhol wanted that pure reality, too, but he wanted it stained, exposed, tinted, combed not covered, and his process was one of refining *out* thoughts and feelings.) Kiefer's layers are visible in the finished work: "I work according to a kind of 'inverted archeological' principle." He constructs a painting not as a digging or unearthing but as a seeding of the site. A painting thus becomes the evidence trove of its own history. Why Warhol? Does his image making represent to Kiefer a purity unavailable to him, a historical innocence or indifference so bland, uninflected, and impersonal that to a mythopoetic painter like Kiefer it must seem a perverse ideal? Is Warhol's influence some kind of vaccine? / / / *Nigredo* has a surface so congested with pigment, emulsion, shellac, and bits of paper stapled to the canvas that it creates an earthwork inertia, an apparently impenetrable voluminousness. The subject announced by the title is the stage in the alchemical process when a pure black liquid, the perfect blackest black, is achieved as prepa-

ration or ground for the emergence of light. Nigredo is a death, a resolution of all color to primal chaosblack. The emergent light is a sign of transformative genius and invention, of which we see other testimonials in Kiefer's homages to Germany's spiritual heroes. But it seems to me also a gnostic, messianic drama, the light brought forth by the alchemical artist from fallen chaotic matter. The painting's titanism (I wonder at the sheer expense of materials to produce this and many other of his paintings) and its concern with the heroic presagings of illumination in a dark, fallen world perpetuate the Parsifalism so many critics praise his work for denouncing. Pictorially, *Nigredo,* like the winged palettes (one of which has been installed at the foot of the main staircase in the Philadelphia Museum of Art so that it gestures up to the classical Diana in her niche), is a massive redemptionist cliché. But the rhetoric of his materials is so overwhelming—he uses canvas like an athenor, an alchemist's furnace—that we can be moved and rocked by it as we are by grand oratory. I'm moved and shaken by some of his works, but I'm also repelled by their suggestions of purity, election, rescue, and purifying fire. We do not need to be redeemed from ourselves, from history, from the earth. / / / To know the devil, swallow his spit. Kiefer, as visionary image maker, exposes, criticizes, grieves over the imperious myth-making self-exaltations of modern Germany. His scorched, blood-margined images (in his landscapes bloodstreaks often root trees and humans) sometimes seem the immediate register of tormented conscience. Yet he practices the gargantuan, emblematic, myth-encoding ceremonialism that is the major style of that Germany, that Wagnerism. Leon Golub, in his flayed, sagging canvases of paramilitary terrorists, torturers, and mercenaries, enters into a palpably dangerous sympathy with the tormentors he portrays. His monstrous images, however, release in a very disturbing way the moral devastation not only of the actions depicted but also the devastation of the temptation to sympathy and alliance and silent collaboration. Golub is a much older artist and has a more refined sense of moral complexity (and of politically motivated horror). In Kiefer's *Germany's Spiritual Heroes* a sketchy charcoal figure, barely visible from a distance, occupies the center of the composition. Is he a worshiper at the fire shrines that

line the walls? His figure is partly rubbed into the grain of the wooden floor and beams, rubbed into their substance like a troll, but he's drawn slightly across the grain so that he can be distinguished. Is he the not-yet-materialized challenger (and future co-tenant) of those enshrined heroes? Is the painting a self-portrait with figures?

———————

In 1983 the San Francisco Museum of Modern Art put on an exemplary small exhibition titled Rothko 1949, featuring nine paintings: one from 1947, another from 1955, and the rest from the decisive year. In the adjacent room were several large works by Clyfford Still. You could see, with the kind of clarity too few exhibitions allow, not only the influence on Rothko of Still, who by 1949 had already begun to intensify and explore the form language of ripped seams in the planar colorist unities of his paintings, but also the gradual resolution of Rothko's early modeling of forms into the brooding, morally volatile masses of his mature style. The 1945 *Tentacles of Memory* has some of Klee's menacing whimsy in its floating, weedy lines of ink drawn on thick bands of watercolor. *No. 17* from 1947 shows some of the biomorphic form of other early pieces, but we can see colors being amassed into adjoining mood fields. The 1949 *Multiform* is a saturated burnt-orange field on which, at the bottom, stand two differently sized columnar grays; a faint, broken blue-gray outline runs around the large solid upper portion, which in some places breaks down into archipelagoes of color. It looks very much as if those lower columns and the squared upper field will become engorged with their color, filled out into the familiar resolute hieratic forms soon to emerge in Rothko's painting. In his efforts that crucial year, however, there are streaks, nervous or anxious brushwork, runny frontiers of color seeping jaggedly into neighboring fields. Seeing them so close to the Still paintings makes me think that Rothko learned from Still most of all how the mediating intellectualism and Jungian conceptualizing of his earlier work could be diffused in expressive need. In 1949 Rothko began to find colorist presence without analytical or illustrational apparatus. But it's not just the color relationships

that mattered. Much later he would say: "I'm interested only in ex-
pressing basic human emotions—tragedy, ecstasy, doom. . . . The
people who weep before my pictures are having the same religious
experience I had when I painted them. And if you . . . are moved
only by their color relationships, then you miss the point!"

Greenberg says somewhere that watercolor is a more intimate me-
dium than oil and that American artists consequently feel more
comfortable using watercolor because they can be more direct and
immediate and private. This is certainly true of Charles Demuth.
He seems to feel less obligated to be emblematic, representative,
formally constructive, and self-conscious in watercolors, especially
the still lifes and the erotic scenes among men. The flowers in his
1923 *Gladiolus* are nature retold as infinitely veiled vacancies—the
petals are serial disclosures. An image like the sensuous *Green
Pears* is celebratory and analytical, yet these qualities exist as an in-
timacy rare in his oil paintings. And his images of men are humor-
ous, robust, unapologetic, immediate; they carry the gleeful bold-
ness of hidden pleasures treated as privileged loves. By contrast, an
artist like Robert Mapplethorpe, self-consciously postmodern and
consequently moodily affectless, makes images that propose inti-
macies as intellectual commodities. His flowers, with their cool,
overdetermined effects, have such a pristine aura of lasciviousness
that as erotic emblems they are finally quite harmless. Demuth's
1930 watercolor *Two Sailors Urinating,* with its frontal view of un-
buttoned sailors holding big penises, is an image of appetite, dan-
gerous fun, anonymity, and obsessiveness. One sailor looks drunk,
a cigarette hanging tough-guy fashion from twisted lips; the other,
standing behind him, is pretty and stares at him with obvious de-
sire. The black penis hanging from the open zipper in Mapple-
thorpe's *Man in Polyester Suit* is an aesthetically hermetic (not
emotionally intimate or private) event. The image is defined—that
is, its emotional effects are defined—entirely by self-consciousness
of effect, and that is abstract and intellectualized. There is another
image by Mapplethorpe, of a male back, curved, the skin texture
almost gritty, pipped, fretted by shadows created (I presume) by

studio lighting, that is a dazzling image of flesh as object of de-sire—purely object. In the watercolors Demuth is not as knowing and formally self-conscious as in his paintings—he's freed from having to seem notable. Mapplethorpe may never have freed him-self from that self-awareness. His images may unsettle us, but usu-ally they aren't intimate enough to be truly disturbing. He certainly made images, as if to order, that suit the pristine arguments of postmodernist intellectuals, because he purged chance and uncer-tainty from his work as if they were a contagion.

Every portrait is a kind of posthumous rendering or memorial. The camera intensifies the sensation of the evanescent solidity of the flesh. In an installation called Monuments at the University Art Museum at Berkeley, the French artist Christian Boltanski used a 1931 class portrait of students in a Viennese Jewish high school. He rephotographed, enlarged, and isolated each of the faces, setting them inside tin biscuit boxes. Above each he attached identical cheap gooseneck reading lamps, like portrait-frame illumination except that the cowls are bent down in front of the image, partially blocking it and blurring the already overenlarged, disintegrating features of each young face. The illumination interrogates the im-age, terrorizes its apparent stability and normalcy. But the identical machinery of presentation and illumination terrorizes each image in a like, machine-tooled way. The tin-box frames are spread over a large wall in the concrete bunker of its exhibition space at the mu-seum. The room is darkened. The space becomes a necropolis, and the somber, measured (though not lugubrious) presentation allows for no antic tones, no send-up of memorial conventions. The in-tense sorrowing activity enacted in the configuration of images is de-personalized; it's unattached to any authorship. Boltanski doesn't show the self-aware historical grandiosity of Anselm Kiefer. (The dangling lamp wires draped like bunting among the images remind me strongly of the circuitry in a few of Kiefer's paintings.) Paul Celan wrote poems as if in answer to Adorno's remark that there could be no poetry after Auschwitz. Boltanski's images in Monu-ments are one kind of adequate portraiture after Auschwitz.

Not a Beautiful Picture:
On Robert Frank

O<small>N HIS TRANSATLANTIC JOUR-</small>
ney in 1947—he was twenty-three when he emigrated from Switzer-
land to the United States—Robert Frank photographed an over-
head view of a male figure leaning over the ship's stern. The
marbled wake looks like Earth's swirling land and ocean masses
now familiar to us from satellite photos, but it also has a pounded
silvery murkiness, the sea foam resembling macerated ore. The
depth of the image is so compressed that the man seems to be
standing before a wildly painted backdrop. An artist's images may
remain mysterious even while they instruct us in how they ought to
be seen and felt. That image of the crossing is mysterious and in-
structive because it is a stilled configuration of the massive turmoil
of consciousness, of the mind confronting a natural metaphor of
the consciousness in which we all swim. We do not experience con-
sciousness as a sequence of thoughts or moments. No one instant
can be separated out or known apart from the whole forceful pitch
of mental activity, of what comes before and after, or of what we
imagine came before and might come after. But photography can
represent what we want (and need) to recognize as a moment expe-
rienced in time. Frank's work is singular because, by exercising dif-
ferent styles of attention, he not only separates out the moment
lived by his subject but also braids it into its penumbral streak of
time passed and passing. One of those styles is evident in his photo
of a Detroit drive-in movie, made ten years after his arrival in
America. The figures draped across the big screen, vague and granu-
lar in the twilight, compose a stilled moment picked from the nar-
rative that consciousness uses to represent to itself certain patterns
of human action. The screen image, as Frank envisions it for us, has
a decorative aloofness. The ranked pods of cars beneath it are re-
ceivers, little housings for motion-picture lore. Between the screen
and cars there exists an intimate confrontational relation. The
viewers—those, at least, who are bothering to watch the show—
are folding back into their story hoard the patterns acted out above
their heads. Frank's station, his angle of attention, is a witness's
half-step backward, at the margin of the relation, shaping its tonal

blend of melancholy and expectation. But the image is just as decisively shaped by an alertness that cants the artist toward his little world of fact. Slightly estranged from the scene, Frank is at the same time at the threshold of a crossing into the scene.

Frank has enacted that powerful mixed predisposition again and again as his work has progressed. If *progressed* is even the right word. For his work in still photography has not matured or developed along formal lines. He began as a finished artist who moved not through formalist stages of development, but from subject to subject, from one style of attention to another. The ambitious pursuit of formal discoveries that Edward Weston conducted has never been important to him. And yet no other photographer so casually combines quick instincts with formal awe, or possesses a preparedness for the revelatory pattern in a given scene so natural and primed that it is indistinguishable from mere reflex. His work represents, in individual pictures and as an adventure, the crossover state where material being is at once a spiritual consistency; it records and claims as its most frequent subject consciousness caught in the act of migrating from the inner to the outer.

In *Macy's Parade, New York* (1948) the bulbous, ethereal trapeze artist hangs from its balloon, and beneath it swells the darkly corrugated lower rim of the frame. The image is scrubbed of illusionist depth. The tilted, wedge-shaped buildings with their cheesecloth textures are fuzzy backdrops against which the circus figure seems printed. All that familiar solidity, the steel and granite stabilities, is dematerialized, brought over to the floating giant's state of helpless weightlessness. It is an image of world stuff as we sometimes feel it—as momentarily condensed vapors. Frank practices a rather different style of attention when he collapses depth not to deplete the image of materiality but to laminate and impact it. In *White Tower, 14th Street, New York* (1949), for instance, the image is pressured forward with the joyful urgency of self-offering or appeasement. In such a picture, the display of its contents is an act of moral intensification, physically enacted in the allover immediacy of the image. Six young women sit at a window counter facing out at us from the frame of the White Tower window. Five of them—they would be

"office girls"—are smoking. Around the head of the central figure, whose mouth blooms with smoke like the old Times Square Camel billboard, bursts an array of signs: "Pie 15¢," "Beans 10¢," "Hot Soup 20¢." The prices, the smoking, the costumes, recorded less than half a century ago, have the kind of archival shock that reminds us of the velocity of change in American society. Only twenty-five years after pie cost fifteen cents, Frank would film a documentary of a Rolling Stones tour, called *Cocksucker Blues.*

But the archival reach of Frank's career—that which is most available, most given, to any straight photographer—is its least interesting quality. Pressed behind the girls, backs turned, are men sitting at the counter, wearing felt hats. The wall clock reads 5:25. The girls are having their after-work coffee. Like most of Frank's images, this one preserves American facts, especially facts related to ritual celebrations. But what makes it formally compelling is the way all the bundles of fact congest the foreplane, the front wall, of the picture. Frank refuses to allow for a more discriminating, and therefore more accommodating, clarity of illusionist depth. All the materials occupy a heraldic foreground. Even the background food cases, which ought to suggest depth, are pasted over the front of the image like a transparency. More than just a documentary image of overlapping social and economic zones, *White Tower* is an image of momentary intimacies and the precious spaces that define those intimacies—among the girls, among the men, between the counterman and his customers—and that require social crossings. And the girls, who are having such a great time, look out into the imagined distance that separates their reality in the image life from us. It's the look, and the distance, that we see in *Canal Street— New Orleans,* from *The Americans,* where the front of the image, engorged with the different races and ages hurrying along the sidewalk, is broken up by the stare of a young man standing tallest in the composition yet almost concealed behind the others. Looking into that distance, out at us, he is the courier of consciousness from the image life to our own, and he triggers a nostalgia that inheres in a lot of straight photography, as it represents things or places or persons that at some time have been the mind's home and are lost

or far away. That look, from the girls, from the young New Orleans man, is a call to another existence which, even while it carries the full charge of consciousness, does not change.

Photography is an act of visitation. It does not engulf and master reality with a made form language, as painting does. The visitations conducted in Frank's images are invariably polite, wary, and unstoppably inquisitive. In the late 1940s and early 1950s, while earning a decent living as a fashion photographer for *Harper's Bazaar* and other magazines, Frank spent his off-hours taking photographs of street life in New York and in the European and Latin American countries he visited. The attention in many of those pictures—as in *White Tower* and *Macy's Parade*—is pressurized by the fugitive circumstances in which they were made. They already showed the manners of a migrant or transient who must depend on the disclosures and presentations of strangers; but the manners are also shaped by hunger, and that brings with it an almost rude pertinacity. When he received a Guggenheim Fellowship in 1955 (it was renewed the following year) Frank was able to cut loose from his commercial work for a while, and the product of those two years was *The Americans,* first published in France and later criticized by several American reviewers as a vicious, distorted, unjustifiably bleak portrait of American culture. Frank's ambition to move through the different levels of American life, to visit not only marginal social groups but also more stable and prosperous communities, with special concentration on politically charged scenes, brought him into natural affinity with beat writers. His images have the breakneck rush into the random offerings of circumstance that we hear in the poetry Allen Ginsberg and Gregory Corso were then writing. It can be heard in Jack Kerouac's prose, too, though the introduction Kerouac wrote for the 1959 American edition of *The Americans* strikes a tone of petulant righteousness: "Anybody doesnt like these pitchers dont like potry, see? Anybody dont like potry go home see Television shots of big hatted cowboys being tolerated by kind horses." That tone of sour rebuke, mocking the presumed expectations of a philistine, bourgeois audience, whined beneath even the more exuberant and audacious assertions of beat writers. Frank, however, was too curious about experience to be

self-righteous or sullen or theatrically manic, and he was too polite to whine. Unlike Ginsberg, Corso, and Ferlinghetti, he was not a megaphone artist, though one of his favorite subjects was the megaphone squeal that pierces so much American culture.

From that early image of the crossing in 1947 to a 1981 picture of Mabou, Nova Scotia, with snowdrifts and mist melting around coastal rock like two energy states, gaseous and solid, transferring one into the other, there is an all-availing readiness of vision, a formidable receptivity to the instant lost as soon as it is lived in the course of time. The spiritual configuration of the instant, as it is actualized in appearances, is one of Frank's subjects. In his 1965 film *Me and My Brother*—from 1959 to 1969 he worked almost exclusively as a filmmaker, usually on independent, low-budget productions, with occasional money-making assignments in still photography from magazines like *Fortune, Vogue, Esquire, Glamour*—the subject is Julius Orlovsky, brother of Allen Ginsberg's long-time companion Peter Orlovsky, who after many years in an institution was released into his brother's care. The film documents Julius's mind emerging from its long catatonia; he is, as Ginsberg says in the film, "coming into consciousness." Frank shapes the film into a narrative of innocence becoming available (and vulnerable) to the contingencies of the world of experience. When an off-screen voice asks, "Where does truth exist?" Julius answers: "Inside, outside. But outside, the world is . . . well, I don't know." That could be a statement of Frank's own curiosity and bemusement about his work, which he takes to be the expression of spiritual truth—of the moral force and structure of relations—as it is lived out in appearances, though Frank certainly knows that the changefulness of matter can give the lie to spiritual consistency. He talks about his ambition in a self-interview included in the 1983 video *Home Improvements:* "To tell something that is true; maybe what's 'out there' is the truth. The problem is, what's out there is always changing." He has never been interested in photography as a meditative activity. In contrast to the presentation of objects as holy existences in Minor White's photographs, Frank's images have an immediacy of lived physical fact that yet records migratory movements between what's "out there" and the moral consisten-

cies of "in here-ness." I use *spiritual* and *moral* interchangeably because while Frank is clearly involved in trying to make visible a spiritual condition, a meaningfulness that preexists and outlasts its material manifestation, that spirituality is also value laden, subject to deliberation though not to physical laws, and its expression is determined by the selective judgments of the artist. His pictures, which express so vibrantly the material presence of subjects in the stream of circumstance, are at the same time spiritual configurations; or, to put it differently, they articulate the stirrings and deliberations of consciousness in response to living in a world of contingency.

The young woman steering a bumper car in one of the pictures Frank took in Paris in 1950, her eyes shut, her mouth split into a delirious gummy grin, is twisted away from the young man beside her, who is himself lost in a giddy swoon. In the exhilaration of their shared moment, the turmoil of youthful sexuality is immediately made available to us in the gashed hilarity of the image. The moment's truth is *out there* in the swimming physicality of the scene, but in that configuration there exists also a contentious mix of moral feeling, the confusions and decisiveness that are part of erotic anticipation, of attraction and ecstasy. At the peak of their joy, the two figures are ever so shyly turned from each other. When we go back to the image, its mood can switch from buzzing fright to jubilation. But it's characteristic of Frank's artistry that we do not feel manipulated into a predetermined moral "fit" or attitude. The crossed zones, the spiritual pitching into the quick of physical fact, exist entirely there in the (apparently casual) formal qualities of the image. It is not a formal perfection he seeks but a quality of presence. In fact, the better part of his art grows out of his passion for imperfections and irresolutions.

The children playing on the slag heap in the 1953 image *Caerau, Wales* have the same look of crazy joy as those Parisians. But if the bumper-car lovers are a momentary resolution of the shimmering flares of light on metal shattering all around them, the kids on the slag heap look like concentrates of the crude industrial byproducts on which they play. They don't emerge from the glittering heap of scoria, they are *stamped* on it, tooled into that support. The dross

that possesses the children's flesh, their material being, is a value-
less castoff from the material that supports the town's economy.
A moral and economic relation is thus made available in the physi-
cal truth of the image. The simultaneity of matter and spirit be-
comes more complexly toned in the series to which the image
belongs. In one of the Caerau street scenes, for instance, three gen-
erations of males stand on a corner, idle, backs to a wall. A dog
crosses the street. (It looks like Giacometti's scavenger dog.) Grimy
row houses slant upward to the right like a stage flat in *The Cabi-
net of Doctor Caligari.* Down the street runs muck from the slag
heap we've seen in the other picture. The town, with its inert econ-
omy and distressed male population, is physically and spiritually
trapped in, and fouled by, the consequences of its own mean
prosperity.

When I try to understand why Frank's images have been so tena-
cious in my life, why their mystery and clarity have for nearly
twenty years called me back, asking for some answer, some recip-
rocal spiritual response, I come up with things not very helpful to
formal analysis. His purity of intent, for instance. He is more than
just preternaturally sensitive to surprise. His mind holds no deter-
minants, no categorical resolutions or sentences of experience, nor
does it imply any expectation of them. Among photographers he is
the one who most completely possesses the quality of imaginative
response Keats called Negative Capability, "when man is capable
of being in uncertainties, Mysteries, doubts, without any irritable
reaching after fact & reason." A too scrupulous creative mind, or
one too obsessed with thoroughness and completion, "would let go
by a fine isolated verisimilitude caught from the Penetralium of
mystery, from being incapable of remaining content with half
knowledge." It's certainly not innocence. It's rather a fearless avail-
ability which exercises itself as inquisitiveness. It's judgment by se-
lective inclusiveness, not by austere exclusiveness.

What are the purest expressions of this selective quality? There
is a picture in *The Americans* of a black funeral in St. Helena,
South Carolina: six men stand around cars, self-contained, each an
island of thoughtful, ritualized waiting, except for the figure deep-

est in the image who stares at us from his distance. In formal terms, though, the image has no "deepest" point or "distance"; the figures, the cars, the gray air, all the things in the picture float on the surface of the scene, a scene that they themselves make up. There is the black Pentecostal in *Mississippi River, Baton Rouge, Louisiana,* dressed in white, a white cross in one hand, a tambourine in the other; kneeling on the riverbank, he looks at once like a black parody of a Klansman and a minstrel-show performer, but subsuming both shadow presences is the sheer presence of power that worship generates, especially when it is enacted by that river, America's holy river, which we can actually see flowing. There is the black woman in *Beaufort, South Carolina,* sitting in a chair in a field at sundown: at her elbow, though positioned at the field's horizon line, rises a telephone pole that looks like a man-sized version of the cross held by the Pentecostal. The passing awe of Frank's encounter with the world is written into so many of his pictures that they suggest the purity of apprehension of early childhood, or of holy idiocy. But I never feel that the pictures issue from an Edenic blankness or dawning of consciousness. Frank's strange purity is history-freighted. He is not naming what has not yet been named. He is feeling in images the particularity and value-charged distinctiveness of what he knows to be old and used. If there is any Golden Age innocence in him, it is welded to Swiss orderliness and American good sense. His purity of intent, at any rate, accounts in part for his attraction to children as subjects. In the Parisian lovers we still see the hysterical child, and the Welsh children on the slag heap are already miniature adults.

Unlike the drifters and marginal characters slanted into their scene—such as the cowboy of *Rodeo, New York City* leaning against a sidewalk trash basket rolling a cigarette, or the black and Hispanic queens mugging the camera from a doorway, with their penciled eyebrows, hipshot poses, and "done" hair—the children in Robert Frank's photographs are positioned among the world's instructive objects, as if in preparation for the irreversible passage into adulthood's circumstantial improvisations. During his 1952 visit to Spain, Frank made another of his sea-journey images: a child in diapers sits atop a wooden horse, ramping on the shore.

The horse looks seaward, the child toward the clapping hands of his mother. The formless sea is the counterforce that would pull the child from those protective, instructive maternal hands. In a 1948 picture, Peruvian children sit on a curb watching a military review, absorbing that model of force, discipline, and order. The swaggering precision is one appeal from the adult order to children just beginning to sort through desirable images of behavior. Frank often photographed his own children. (The child on the horse is his son, Pablo.) They rode along for several months while he took pictures for *The Americans,* one of which, *U.S. 90, En Route to Del Rio, Texas,* shows them drowsing in the car with their mother, Mary Lockspeiser, whom Frank married in 1950. Road weary, co-cooned in the dark car in dusk light, they form an image of love sustained during a fugitive existence. A counterimage is the 1956 *Mary and Andrea, Third Avenue, New York City:* Frank's young daughter occupies the light at the lower right of the image, looking straight at us while her mother, on the left, stares out the window. Andrea is patched by a smothering light spread across her face. Her emergent consciousness is so needful and vulnerable that she seems adrift from the mother, who is distracted, secretive, ab-sorbed in an already formed selfhood.

For Frank, making pictures has always been a way of living into the moral moment. He once said that *The Americans* "showed that period in an unmistakable way, how I felt about it, where I stood— it's a way of life for me—How I live, that's my politics." This is, I think, his own version of Matisse's insistence on making an image not of the thing seen but of the feeling the thing calls into exis-tence. For Frank, however, the intimacies of photography are tied not only to the rhythms of his own life of feeling but also to his politics, his view of life in a governed society. Bristled about by a contingency it is only beginning to intuit, a child's mind is the purest, most immediate register of these two conditions. The two fused in the adult mind make for political feeling. Frank is by no means a naive or childlike artist, but he is (like Wordsworth and certain other poets) by sympathetic capability wonderfully close to the child's experience as it is *kept* by adult consciousness in its ex-periences of the world, and this makes him a photographer of un-

usually complex yet fresh political feeling. Throughout *The Americans* children are implicated into political mood. Centered in the famous image of the New Orleans streetcar, in that congested synoptic view of America's sullen racial and social varieties, are two children staring from a window. Like all the faces in the picture, theirs are in distress. Each of the adults looks out with a different greeting of the spirit, from the white woman's defiant frown to the black man's pained squint. The children are placed as both precursors and inheritors of those moods.

Like most of the pictures in *The Americans,* the New Orleans image is so bled of vivacity and good cheer—and therefore contrary to what the popular imagination conceives (or did at least in those days conceive) as essential characteristics of our national temperament—that the book inevitably drew outraged moralistic criticism from some reviewers. In *Popular Photography* Bruce Downes wrote: "There is no pity in his images. They are images of hate and hopelessness, of desolation and preoccupation with death. They are images of an America seen by a joyless man who hates the country of his adoption." Frank himself said of the book: "I knew the photographs were true. They were what I felt, they were completely intuitive. There was no thinking." The remark suggests his hatred of pedantry and justified suspicion of any moralistic intellectualism that would suck the intuitive force out of art images.

But I think he is also saying that in making that book (and, I would generalize, in nearly all his work until 1974) he did not design or belabor scenic elements in his pictures, did not concern himself with the "supreme instant" of formal realization, did not seek out social configurations that might serve as political slogans. If he is the purest (and least smug) straight photographer of our time, pure in his attention to the ceremonies of circumstance as value-laden relations, he cares little about the formal purity of his images. The few times he has tried to contrive the order of a scene or schematize the political content of an image, the results have been arch, self-satisfied, and literary. Perhaps because it is yet another portrait of childhood, the most glaring example for me of things gone wrong is *Cape Cod* (1962), where Andrea is running

across the beach unfurling an American flag that forms a canopy beneath which sits Pablo, reading the *Daily News*. The headline, shoved at us in the compressed space, announces: MARILYN DEAD. From a front-page photo the movie star's hand reaches out, a familiar gesture of appeal in Frank's pictures. The image is programmatic, the figures of children inserted into a scheme of cultural signs that carry a monotonal charge. It's the one photograph of his that might pass as beat art—a sour, overconceptualized image of moral relations that have had all the suppleness and mystery of actual existence, actual occasion, leached from them. Marilyn, the fallen goddess, the fallen fiction, vulgarly remembered beneath the vulgar, glamorous providentiality of the flag. The picture is not dishonest or lazy. Frank is incapable of the disingenuousness that in some contemporary artists is praised and rewarded for its delectable self-contempt. In *Cape Cod* he is testing another way of making a picture, a way I think was dangerously available to him if he wanted it, but the effort suppresses his remarkable intuitive capacity for selecting moments in which the moral or spiritual life is enacted most intensely in material circumstance.

In a 1975 lecture at Wellesley College, Frank had this to say about photographic form: "I'm not interested in taking a beautiful photograph. I don't mean that there's no room for it; I just don't want to do it. For example, I live in a very beautiful place [Mabou, Nova Scotia]. I could get a camera and make a very beautiful picture. It could be almost as good as Ansel Adams. But I don't want to take a beautiful picture, and I can't, really." Privileged visions, darkroom exaltations, definitive "finish," these have never mattered to him as much as making the photograph a materialization of subjective consciousness. I want to suggest that his work has its best apologist in William James. In the *Principles of Psychology* James set out his famous description of the stream of consciousness: "Consciousness does not appear to itself chopped up in bits. Such words as 'chain' or 'train' do not describe it fitly as it presents itself in the first instance. It is nothing jointed: it flows. . . . *Let us call it the stream of thought, or consciousness, or of subjective life.*" Because of its selectivity a photograph by Robert Frank presents a chopped-away im-

age of consciousness. But most of his pictures also bear signs or memorial traces of their own selection and contain fossil scorings of the stream from which they have been cut. In contrast to the work of photographers as diverse as Weston, Stieglitz, Minor White, and Harry Callahan, no one of Frank's pictures has the tone or aura of an eternal moment. His images in fact bear some mysterious quality I cannot account for but feel as a healing agent that, always serving continuity and fused consciousness, soothes the lesions its own chopping activity creates. This healing is intensified, and situated morally, by Frank's imaginative sympathy for his subjects. In *The Americans* there is a photo of a Detroit assembly line in which the workers look entangled in the hoses, tools, cables, parts, and storage racks all around them. It is an image not so much of industrial tyrannies—workers caught in a webwork their tools and support systems create—as of toiling absorption, where human attention to a task fuses to the instruments that execute it. There is no tone of exclusivity, no sense of privilege, in the selection of the moment. But like many of Frank's images, it has a shadow existence where other possible pictures, other imagined configurations, stream in his consciousness.

Later in the same chapter in *Principles,* James writes that the mind is a theater of simultaneous possibilities: "Consciousness consists in the comparison of these with each other, the selection of some, and the suppression of the rest by the reinforcing and inhibiting agency of attention." The selectivity of the subjective consciousness is one of the decisive dramas in Frank's work. His "Bus" series—pictures taken from Manhattan buses in 1958 and the last thematic series he finished before going into filmmaking—is interesting because the view of consciousness is determined by a given scheme, a bus route, a pattern for the inquiring eye. I've seen the contact sheet and two prints of a sequence of shots made while Frank's bus was pulling up beside another. Pinched in the narrow space ahead, between the two vehicles, a pedestrian crosses the street. The contact sheet is a record of the chopped moments making up the mental event. The two prints demonstrate the shocking changes consciousness absorbs and photographic selectivity isolates. In one, a blade of sunlight slashes the image vertically, and

the small pedestrian is nearly dissolved in its brilliance. The light, in those city spaces, is both heavenly visitation and ordering force. In the second image, taken just a moment before or afterward, the side of Frank's bus obstructs the light; its radiance is deflected, its disclosures interrupted, curtailed by the shift in view, by the turning of attention. In formal terms, neither is superior to the other. Each imprints the action of the selective mind, both are rich with the sense of a larger, more inclusive stream of awareness.

But artists who are guided too much by sympathetic attractions and inquisitiveness become hostages to occasion and risk a drifting arbitrariness. Decisions must be made, themes pursued, subjects owned. The most decisive figural pattern in Frank's photographs, one that drives and organizes what otherwise might become a desultory receptivity to the world's offered occasions, is the call. Sometimes it's political, sometimes religious. ("Politics," he once said, "it's close to religion. To believe in a voice—that is what I think much of it is about. But I think it is better to believe in religion than to believe in politicians.") When the call comes, it gives provisional shape to the community that amasses around it, which may be a crowd of strangers or a familiar group. The call, and the response to it, are not just a theme in Frank's work, they're also a technique. His alertness has a religious intensity, though he usually stations himself a little way from the heat of the source. In 1947 Louis Faurer took a picture of a New York crowd on a sidewalk rubbernecking something out of view: one step back from the crowd is the young Robert Frank, hands in his pockets, interested in the off-camera event but not gawking. The others are looking at what's happening; he is *seeing* it. The call in American life must have leaped at him when he came here, and he responded immediately to its presence. *New York City, 1951* shows in close-up a preacher's hand holding a tattered book of Scripture and a sign announcing God's will. In *San Gennaro, New York* (1949–51) the hand extended toward us, in a gesture that crosses commerce with supplication, is draped with holy medals. That festival offers such abundant local color that in Frank's image we feel the shaping force of what he elected to exclude, of how he is answering the call of his theme. The foreground in both images is sharp, emergent,

expansive, stabbing at us from the out-of-focus throngs, the canopies and parentheses of bleared light. Less aggressive is the appeal of the old Jehovah's Witness in Los Angeles (from *The Americans*) clutching a copy of *Awake!* as if to rebuke passersby, and us, for dullness and ignorance. The mind of the image maker, whose shaping selective powers are worked into the tone and texture of these pictures, is alive to the appeal exercised by anything that might answer to spiritual need. The hands holding out amulets or words also hold out some promise of hope, solace, knowledge, redemption. They all promise a way of being delivered out of time. But Frank is also alive to the dangerous constraints that a call can impose on the social order.

He has created an entire class of images that consider the place of the call in the social order. Many of the interiors in *The Americans* are structured around message sources, and often the most desolate scenes are those most dominated by instruments meant to attract and enthrall an audience. In *Restaurant, U.S. 1, Leaving Columbia, South Carolina,* the TV in the corner of a vacant lunchroom looks all the more solid and promising, more full of plenty, in a space where half the Formica top of one of the tables is vaporized in window light. The television set is the strongbox. The obsidian jukebox in *Cafe, Beaufort, South Carolina* looks like a cargo cult object. The scene is bare: a wooden floor, a table, and a pillow or fluffed pallet on which lies a black child, like an offering to the enchanted jukebox. There's another in *Westside Bar, New York City,* it too in a desolate space, glowing like radioactive material, a hazardous, attractive power source. The jukebox in Frank's images makes its own social appeal because its song shapes our consciousness of circumstance and consequence. It's the aural equivalent of the TV and the drive-in movie screen, returning to us ritualized patterns (or moral paradigms) of experience. All of these, as social instruments, rhyme pictorially with the tuba bell shining forth from one of the several images in *The Americans* taken in Chicago at the 1956 Democratic National Convention. In the political images, however, the specificities of melodrama played out in TV shows and jukebox music are overwhelmed by a more general, indiscriminate, and virulent appeal. The intent of a political rally is not to

inform or to enhance consciousness but to rouse emotion to the pitch of action. The communities improvised by the political call can become ideological mobs whose purpose is not celebration but forceful persuasion. The human figure that rhymes with the others I've mentioned is the convention delegate standing on a balcony above us, legs spread, a "Vote for Kefauver" placard pinned to his shirtfront. He thrusts his arms upward in a gesture which, as Frank tones it, may be exultation or demagogic rage. Both, in this very disquieting image, exercise their appeal. Frank is seeing into that current of American passion where optimistic glee flows insepara-bly with ideological mania, and when he made the image of the Kefauver supporter, he was also remembering balcony speeches that had been so decisive in reshaping his native Europe twenty years earlier.

Frank is an artist of such complexity of feeling, however, that even when his subject lends itself to satirical broadness or prescriptive stringency, he sees into the shadow zones of the relation. When in *New York City* (1961) he shows us a crowd looking literally to the heavens, with an elderly woman in the foreground clutching a book titled *Listen to God,* the easily mocked gullibility of that populace is tangled and snagged by other tones. That group is looking beyond itself for deliverance unto another's will, the weakness of the subjective life when it thinks it wants to be told what to think. That feeling is a true one. But the individuals in the picture are not represented as sheepish anonymities or whacky fanatics. Each figure dramatizes a different attitude of the wish to be saved—saved from uncertainty, from the random instabilities of existence, from the solitude that these enforce. One ritualized demonstration of the desire for redemption from solitude is holiday festivals. The black couples and solitary figures spread out on the dark beach in the 1958 "Fourth of July, Coney Island" series look like castaways, remnants of a society of exiles. Another image, but one of bounty and sanctuary, is the Fourth of July picture Frank had taken three years earlier for *The Americans:* over the entrance to a community fair or picnic, Old Glory hangs low, like a portal, and two young girls holding balloons pass underneath. The protective presence of the flag is benign reassurance, but its immense, assertive size—it

hangs from the heavens—makes it, as Frank selects the scenic in-
stant, a visual equivalent of the strained American happiness that is
sometimes indistinguishable from self-righteousness. The flag is
both a sheltering and smothering benefactor. Its flamboyant confi-
dence issues from some uncertainty, some unsettling sense of in-
sufficiency. But it also exists as a political stability, an almost Pla-
tonic image of the ideal, the good. The children would seem, in
Frank's presentation of them, free of all these deliberations. They
are part of the social and political configuration, wards of the flag,
but, as in Frank's other renderings of children, they remain bliss-
fully open to possibility and unconcerned with accident. They do
not yet know they should feel that they need to be saved.

The images in *The Americans* were created by an intelligence that,
while it focused on the pinch of contingency so visible in its sub-
jects, was not itself whipped or driven by the awareness of contin-
gency. Frank was a happy artist. Not frivolous or insouciant, but
happy as Wordsworth was happy. Even as he scrutinized his sub-
jects in what he knew to be a world of accident and suffering, the
actual expression of that knowledge was not strife-ridden or disso-
nant; it was becalmed, composed, accepting, and benevolent in its
regard. For the happy artist, the sheer involuntary momentum of
the ongoing stream of thought overcomes what is for the tragic art-
ist a jangled, headstrong, quarrelsome nurturing of the conscious-
ness of hazard. In *Principles,* James writes: "Experience is re-
moulding us at every moment, and our mental reaction to every
given thing is really a resultant of our experience of the whole
world up to that date." The nature of experience as Frank lived
it until 1974 was a rolling, processual, uninterrupted sequence.
Events and images flowed, and he flowed along with them, always
the passionate bystander, a little off to the side. He did not strike
back at the presentations of time, he did not spike himself into the
process. Rage was a tone as foreign to him as it was to Wordsworth.
 In 1974 he became a changed artist. Early that year he began
experimenting with Polaroid film, making collages using multiple
negatives and handwriting. He had separated from his wife in 1969
and, with June Leaf, moved to Mabou, where they built a house.

For about fifteen years he had spent most of his energy on film-making. In December 1974 his daughter, Andrea, died in an air-plane crash. Most of the images he has made since then register or recall the grief of that event in a ripped, pictorial idiom. His art, in James's terms, has been recast to meet a changed experience of the world. The familiar reserve and sweet-tempered receptivity to the world's offerings become a cry of alarm and outrage. The continuity of the subjective life so firmly sustained in *The Americans* is now fractured; the new images are obsessively mauled over, lacerated, intruded upon. For the first time in his career, the picture-making process becomes part of the pictorial finish. Act is transferred as artifice. The negative border, the invisible housing of his previous images, is now a garishly exposed, tentative restrainer. The front of the image, the inviolate, pristine transparency that had been Frank's chief device in organizing the intimacies he observed, becomes a violated zone slashed by messages, stray marks, autobiographical debris. Frank's response to the new devastating fact in his life—it's unseemly to trample on his grief with commentary, but I don't know how else to get at the important questions in the career of this artist—is to tear into his own image patterns, to borrow old pictures and set them in a different redefining context, to disrupt form until it responds adequately to his new feeling. The violence in the images after 1974 is an effort to find new patterns that can answer to a new mind. What once was instinctive and familiar in his art no longer sufficed.

In an essay on Baudelaire, Walter Benjamin describes the peculiar power of the camera to fix an event for an indefinite period of time: "The camera gave the moment a posthumous shock." It's that shock we feel, in its finely blended tones, in Frank's earlier pictures. After 1974 his images purge the posthumous shock from the moment and dramatize instead the jangled densities of the feeling of remembrance. The new images are excruciatingly self-conscious, above all in the way they expose Frank's interventions. Throughout his career he had made incursions into erotic relations, household intimacies, and public ceremonies, but the happy spirit that allowed him to treat the front wall of the photograph as a divisive transparency is shattered now. The image field becomes a work-

space memorializing contested feelings. As viewers, we no longer look on safely from the margin but are made co-witness and conspirator to turbulent assertions of the image as a contrivance, not a gift; a made thing, not a visionary mood. Our own attention is spiked into the image. The mechanical details of remembrance are hammered into many of the new images not as a retrieval or recovery but as an expression of the strain of remembrance as it elides, crosses, crowds, and chops up moments in time's passing.

In the 1977 *Words, Nova Scotia,* two of his own famous images, the tuba from the "Chicago" series and the 1953 *London to New York,* in which passengers on the *Mauretania* look out expectantly from the rail the evening before their arrival, hang from a line across a stretch of beach. Beside them hangs a flag bearing the letters W O R D S. Unlike those other autobiographical photographic bits of Frank's early practice, W O R D S recollects no images of the world, has no feeling tone in isolation, and is morally numb as the other images are not. It refers to (it does not *image*) the abstractions of consciousness that give us sometimes the power to express qualities of the visible world. That neutral blazon represents, if anything, ineffability and the annihilation of the material reality that had always been Frank's primary subject, as the companion pictures demonstrate. (The *Mauretania* image is another in Frank's album of crossings.) Those early pictures, made when the subjective mind creating them was different, are here exposed for their inadequacy to absorb the feeling of desolation. All three, however, are set in a larger context, the formless expanse of sea and sky in the background, against which the autobiographical moments and the bland W O R D S sign are feeble, tentative exertions of imagination, of image making. Words, however, become essential intrusions in his new style of attention. And style, for any artist, is completed feeling.

Andrea is elegiac shriek. Across snapshots of her and a plain clapboard house are smeared brown and white splashes; the house is blotched by black marks that look like grim, wildly thrown bunting. Written into the image is a dedication, the date of the crash, and the words: "She lived in this house and I think of Andrea every day." The words, a simple, exact, restrained statement of grief, are

excruciating in their inadequacy to the occasion, and the anguish of that inadequacy floods the image. Frank is attacking and dismantling what had sufficed in his earlier work as the consolation of form—form as a binder, a unifier, a healing agent. So many of his pictures in the 1950s and 1960s had a decisive clarity and immediacy of occasion. Even in the smoky fluorescent interior of *Bar— Gallup, New Mexico* in *The Americans,* with its furtive under-the-table view, the figures slouching at the bar are carved from the opacities that contain them. But singularity, immediacy, and marginal watchfulness are precisely the formal values that a work like *Sick of Goodbys* (1976; Plate 8) upsets in order to reach for a quality of feeling that, for all the richly mixed and evocative tones of the early work, was not available to him before. In the new work he pushes himself to be a master of extremity. In *Sick of Goodbys* mirrors are stacked and set at angles to other mirrors, in a vicious parody of the niceties of pictorialism and of the banal conceit of the reflective surface in straight photography. For the reflected images are muddy and unrecognizable. The top half of the image is a separate negative—a Polaroid, I think—that melts away into a ragged fringe at the margins. The devastated appearance of the support and Frank's exertions against its stability are active stylistic elements. It's impossible to sift out all the debris. An arm extends across the front of the mirrors, breaking into the space in a way reminiscent of the plaintive gestures of the call in his earlier work. But the hand in *Sick of Goodbys* has no intention to instruct or persuade; it is not reaching *out* toward anyone. Dangling from it, against a background of what looks to be the horizon of sea and sky (everything is turbid in the mirror), is a tubby little skeleton, a Day of Death toy. The title is swabbed across, as if to identify and cancel the image in one lurching gesture. If this picture has a subject, it is the toil of the mind to contrive a form that can contain the annihilating feeling of grief and the struggle of consciousness to find a way through its own raging contrariness, a contrariness inseparable from the bereavement it hopes, in vain, to assuage.

The French couple in the bumper car were at the stage before sexual anxiety and fatigue can determine a life, the Coney Island images of the 1950s expressed a muted erotic melancholy, and

other of Frank's pictures have revealed the relatively secure (because stable and stabilizing) normalcies of erotic bonding. Given this history of moods, one of his most startling recent images is *4 A.M., Make Love to Me, Brattleboro, Vermont, 1979.* The print is raw, its margins fluid and blurred, the title written across the surface like a defacement. The scene is a bedroom containing a TV (glowing dully like the TVs and jukeboxes in *The Americans*), an open suitcase, a dresser, a rumpled bed, and in the background a naked woman who looks fatigued, annoyed (or disgusted), physically and emotionally sagging. She incarnates eros as a long weary story. The appeal, the cry scrawled across the picture, comes from the bed, from the subjective mind that contains the image. The cry of appetite? habit? boredom? Whatever the source, the woman doesn't seem very interested. This is a picture of a call, to be sure, but the mind of the image is entirely implicated in its history and consequences. This is not a call to a passing crowd; it has no political or social force. It is the call of private need, and the image does not so much present it as enact it. And it enacts an appeal cast against, perhaps stifled by, the world's response. Other versions of this scene have attracted Frank from the beginning of his career: stopping places for transients, spaces where we see the human figure in transition from one place to another, or from one spiritual zone to another. In no other picture, though, has Frank established so forcefully the distance in the image between the seeing mind and its object, nor has he ever pressured the space so definitively around his own presence inside the event of the photograph. With this new scenic turbulence Frank's art is able to contain more because it now contains his own consciousness as subject participant. His old lyricism, played out in the sweet composures of the middle distance, has become in his recent work an intrusive, obsessive action. We should not want him to remind us of the early style, extraordinary as it was, because what he has come to, what he has contrived in answer to the call of his own spirit, is a jagged, divisive, complex lyricism, which, though it has little of the aching affability of *The Americans,* yet lives into the quickened densities of consciousness more exactly and completely than anything he has done before.

Other Americans

Julian Schnabel

At a small New York gallery exhibition of Giacometti's work several years ago, I entered a space whose tone was determined by the eroded figures placed here and there around the exhibition area. There must have been a dozen bronzes of various sizes and at least as many wiry, hollow-eyed oil portraits. The entire setting was the articulation of a mind whose rather narrow vocabulary of forms—narrow, that is, in contrast to the vocabulary of a Picasso, a Matisse, a Cézanne—was yet extraordinarily plastic in response to its subjects. And each work retained as formal elements the actual deliberations which led to its realization: the imagination's products recapitulated the process that produced them. I was reminded of William Carlos Williams's exclamation in "Pictures from Brueghel":

> The living quality of
> the man's mind
> stands out
>
> and its covert assertions
> for art, art, art!

Williams was responding to the wholeness and availability of the painter's consciousness in the forms of his work and to the way those forms assert a necessary belief in artifice, in artificiality. He was responding, in other words, to what he valued in his own poetic practice. The quality of Giacometti's mind was just as fully disclosed at that modest exhibition; there was nothing furtive or smug about the work, and it did not have calculated designs on the viewer. In their dignified, suffering separateness, those statues and paintings did not grope for viewer response. They were the products of an intensely self-corrective conversation about the human form between the artist and his materials, a conversation broken off only when Giacometti felt he could abandon the process and release the work to the public eye. (Or, as he once said, throw it into a trash can.) The disquieting charm of Giacometti's art lies in

its solitude and self-containment, which do not invite us to "own" it emotionally but which do not exclude us, either, or set us at some holy distance. Those pieces, which made their exhibition space into a destiny, seemed to me the imagination's purest expressions, indifferent to expectations beyond those generated by the work itself, even while they had a richness of feeling that met Mallarmé's prescription: "Paint not the thing but the effect the thing produces." They were artworks made to exist without a sustaining environment of response.

I cannot imagine that condition for Julian Schnabel's paintings. The quality of the mind on view in the recent traveling exhibition of his work from 1975 to 1987 is a strangely grandiloquent evasiveness that begs for a sustaining environment of response, and its primary tone is an exuberant flirtatiousness.* A familiar complaint against Schnabel's work, acknowledged by Thomas McEvilley in his essay for the exhibition catalogue, is its gesturalism, nonfigurative marks used as a private, improvised, haphazard code of feeling. I think, however, that it's the actual pictorial representation of gesture in his work that indicates its exemplary limitations and its coquettishness. In the 1981 painting *Prehistory: Glory, Honor, Privilege, Poverty,* a figure hanging by his heels on the far right has the face of a Cycladic statue (or of Ezra Pound drawn by Gaudier-Brzeska); out from his side emerges a reddish cord, part of his bindings, which forms a hoop that hovers over the painting's central figure, an oversized infant floating upright at the center of the canvas (not canvas, in fact, but pony skin). The baby points to our left, to a large masklike face that stares out at us like an accusation. As a manipulative image, the picture playfully bullies us. Schnabel draws us into the image with the upside-down figure (antlers mounted to the surface look like thorns wrapped around the figure's chest), loops our attention to the plump, elongated baby, who points us to the face, which returns our stare. It is a clever shuttling from one gesture to another and demonstrates how an artist can kick us out of a painting as readily as he draws us in. Each gesture, though, is a pictorial contrivance numb of feeling. One wishes

* At the San Francisco Museum of Modern Art, February 11–April 3, 1988.

the manipulations were enlivened (or made brutally contrary) by anger, or nuttiness of some kind, to relieve the pedantry of the forms. It is an artwork eager for, and dependent on, the smother of self-consciousness.

In many instances, the theatricality of gesture that makes some of Schnabel's paintings at first glance seem energetically defiant turns out to be bombast, because it must depend on a contractile, literalist vocabulary. The found forms of art history that rattle through his paintings are moody, ambiguous quotations. He takes over an old image not to re-engage or quarrel with its formal life but chiefly to demonstrate his powers of owning such an image, and he pretends to hold some secret to the fact of the appearance of an old image but is not about to disclose it to us. The appearance, for example, of Caravaggio's *Youth with Flower Basket* in *Exile* (1980) is an inert quotation. Caravaggio's picture is a portrait of self-offering; the flowers the beautiful youth bears are a token of mysterious carnal promise. What can it mean, then, when Schnabel paints Caravaggio's voluptuous figure in gummy, flaccid textures? Is he mickey-mockering the belief in figurative representations of desire? I think he wants us to see *Exile* as an art-history emblem, as an intentionally garbled *re*-representation of a famous painting event. McEvilley suggests that this sort of quotation is a miniaturized expression of Schnabel's larger ambition: "The sense of time or history as an ocean filled with the fragments of the past and randomly laying them on the beach of the present [which is the dominating "sense" in Schnabel's work] is duplicated at another level by the presence of quotational elements throughout the oeuvre." Painting as a register of time's tidal debris—the canvas as a sort of oceanic dump—has an absolutely legitimate part to play in the criticism an artwork embodies; Robert Rauschenberg's big culture-anthology canvases and Robert Motherwell's collages are brilliant enactments of this. But the Caravaggio youth and the other figure in Schnabel's painting—a featureless ball-and-stick figure taken from a child's comic book—exist not for the energy of the relation established inside the pictorial space but for the frontal, toneless display. To argue that it is *meant* to be a display piece enjambing two given representations of the human figure—

one carnal, the other mechanical—is to confirm its purely academic quality.

It is not always easy to identify and evaluate the tone of formal mimicry in Schnabel's work. Arthur Danto has said in his book *The State of the Art* that Schnabel sometimes uses velvet as a support because, since it is commonly associated with a vulgar idea of opulence, it is a mockery of the art world whose expectations his ambitions evidently gratify; it is, in Danto's words, "a nose thumb at his pushy clientele and an acknowledgement of the crass structure of the art world he has so ingeniously internalized." The "Maria Callas" series probably bears this out. The forms are an anthology of abstract-expressionist mannerisms, from Jackson Pollock's early archetypal herms to Franz Kline's frayed pigment swathes, laid on velvet; it's the same compound of the vulgar and the heroic suggested by the series' title. But the issue gets more complicated in a painting like *Ethnic Types No. 15 and No. 72* (1984) where Schnabel presents a black male and female (and snakes, chalices, and other decorations, a few of them made of animal hide) on a velvet ground. The material certainly gestures, as Danto says, to "the stuff of cheap ornamental pillows and sham tapestries found in bazaars and *puces* in bordertowns or in the luxury motel." But I think Schnabel is also reaching after a pop iconography that can accommodate heroic types, and his use of materials refers inevitably to a specific cultural situation that has little to do with the commercial art world. In the 1960s and early 1970s many self-declared black and Hispanic folk artists used cheap Day-Glo colors on velvet to declare the sources of their racial identity. Those productions were authentic, if crude and rigidly conventionalized, expressions of spiritual and cultural need. The visual operatics—Aztec princes, African queens, Zapata, Huey Newton, Malcolm X, Che Guevara, blooming in tropical yellows and violets—had an evangelical appeal because they were directly connected to political and religious streams in American subcultures. That extravagance blended social discontent, artistic ingenuousness, cultural piety, and commercial aggressiveness. (Anyone who ever dealt with such an artist hawking his or her wares in a subway or bus can testify to the volatile social-artistic compound I'm trying to describe.) When an artist like

Schnabel appropriates these mannerisms, he retools them as gestures to serve his own schematic purposes. Just as much as in the Caravaggio quote, he absorbs precedents into his image field only to neutralize, by aestheticizing, all residual moral quality. Another velvet painting, *Salinas Cruz* (1984) is a smallish piece showing punch-drunk putti faces mounted on what look like harpy wings. Wound around one is a Möbius sign. Another of the faces is obliterated, its features erased in a colorist mash. The alarming derangement of traditional religious iconography and the laid-on symbol of infinity are blatant theatrical conceits, and they may charm us with their cleverness. But they also push us out of the painting, since there is no charged relation sustained among the compositional elements. There are only the rather banal signs of mimicry. The painting, like a good deal of Schnabel's work, has its appeal, but like most of his work it's little more than brilliant schoolboy banter.

His paintings do help us, however, to understand some of the problems artists are struggling with. Figurative artists of Schnabel's generation—he was born in 1951—and expressionist painters in particular, feel more than ever the need to punch into and distend the painting space so as to absorb the facts of our moment (one of the most critical being the awareness of painting as a representational act). At the same time they feel the need to recapitulate past modes of representation, as the Impressionists, for instance, recapitulated genre painting while also forging representations that could absorb, as T. J. Clark has demonstrated in *The Painting of Modern Life,* the material facts of a capitalist economy. But the Expressionists of the 1980s have also had to modify or build on Pop Art's encyclopedic scrutinizing of culture facts. Schnabel is certainly aware of the task. His monsters and gargoyles in *The Wind* (1985) suggest the demons and incubi of Hieronymus Bosch and of romantic visionary painting, but they also absorb as sheer information the commercial renderings of the demonic that flooded popular culture in the 1960s and 1970s in the form of record jackets and bookcover designs. Executed with a willful deftlessness characteristic of his work, *The Wind* illustrates a formal crisis: What to do when essential images in consciousness, the pictorial expressions of evil and nightmare, become so self-consciously *owned* that any new

expression of them must be sheathed in irony or bristled about by our enervating powers of cultural mimicry? Schnabel does not make the picture zone a field of actual engagement with the problem. His talent and desire are so cautious, at least at this early stage of his career, that he can only illustrate it, showcase it for our examination. This limitation is due, I think, to his unwillingness to sustain an intimate conversation between himself and his materials—one that is not "framed" to be overheard. At the same time, it's precisely the snarling awareness that others are watching him perform that gives his images their belligerent waggishness. He is like the brash, self-satisfied poet whose poems illustrate or mock the trouble of self-consciousness but never realize the feeling of *living out* the trouble.

To judge by his commercial success, Schnabel's image rhetoric is fairly persuasive. But I cannot help feeling that the intention powering the rhetoric is often callow, that he means not to make art in answer to internal need but rather to create study pieces or object-occasions. I know it's difficult to separate such an intention from the theatricality of most young Expressionists, but the work of an artist like Anselm Kiefer, for all its extravagant rhetoric— several of Kiefer's gigantic canvases depict theatrical architectural spaces—possesses a moral consistency of representation that in Schnabel's work is either absent or fragmented. Some of the critical debate about Schnabel converges on his interest in religious and historical subject matter, what the media shyly refer to as Big Subjects. (Poets, too, must speak awkwardly of having major themes, as if in a crepuscular time we are all inevitably muted by the wretched modesties of self-consciousness.) He may claim religious subjects, but Schnabel is not an artist of religious imagination, whose activity enacts in images the processual encounter of the form-making will with a mode of being that it takes to be larger than itself. Schnabel's chief purpose, I think, is to announce the importance of a subject, not to express an encounter with a subject. His method is declamatory, not investigative or revelatory. A religious painting by him thus seems like a preliminary to some other, as yet nonexistent, work.

A work like the 1987 *Diaspora* declaims in a pictorial shorthand the attempt to master a subject. Done on heavy tarpaulin (an old truck cover) *Diaspora* is one of a series of panels titled "Stations of the Cross," and its title comes out of William Gaddis's novel *The Recognitions*. The work is shaped like a stump-winged cross, its base a pedestal upon which are painted the letters D I A S P O R A. Except for the emblematic force of the cross, nothing in the drab, lethargic diffuseness of color (the khaki green ground is streaked with fluffy white and yellowish ovoids) suggests any specific quality of impassioned response to the subject. The overall configuration is expressionist in its gestures—the emblematic tarp, the bold letters, the ovoid gashes, the entire field of paint conceived as a shout—but in execution the compositional elements are restrained to a bafflingly indifferent, affectless decorum. The imposing size and glamor of the piece cannot overcome what is essentially a pictorial cliché: Christianity triumphant over, and built upon, the Diaspora. Schnabel has said, however, that although he means the painting to be seen in its full historical dimension, it can also be detached from "meaning" and that he chose the word *diaspora* in part for the formal quality of its characters. (There is some foolery enfolded into all this: Gaddis's novel, from which the key words for all the panels in "Stations of the Cross" are taken, is about forgery and confidence games.) We are advised, therefore, to regard *Diaspora* as both a statement of historical relations and an artist's response to them, *and* as a neutral formalist image related more or less to Jasper Johns's alphabet paintings. I don't believe we can have it both ways. The consciousness of exile, suffering, deprivation, as it lives in our historical memory, cannot be so casually deposited and retracted (or made visible and erased) from its representation. *Diaspora* shows the strain of this double mood. It has the belabored clamorousness of a subject that has not really seized its interpreter, or that its interpreter has failed to penetrate. If we compare this to Kiefer's struggle to situate religious and historical material in paintings that possess a complex, extremely unsettling tonal variety and to make the image field a value-laden space, a work like *Diaspora* feels tinny and evasive. Kiefer accepts the sublime as a primary

tone and is chagrined only insofar as he knows better than most that Western culture needs to believe it has exhausted the sublime of its images and sentiments (and that the sublime is intrinsically dangerous politically because it entails uniqueness and hierarchy). Part of the ambition of the new Expressionism is to recover whatever expressions of the sublime may have survived Pop Art's invincible ironies. Schnabel's work, by contrast, tends to drift from one illustration to another.

His *St. Sebastian—Born in 1951* (1979) coolly displays the challenge of recovering a classical form (the archaic torso) and a familiar topos of Christian art. Long wounds, like weals, are channeled into pasty, clay red flesh, but from the normal icon of St. Sebastian the painter has excluded the standard pain registers: the face, the arms and legs straining at their bonds, the arrows. Part of the pictorial drama is to make us aware of these subtractions, and also of the addition of bloody wounds carved into the normally pristine torso of ancient sculpture. If the "1951" means that this is a self-portrait, it's self-portraiture as art history. The painting's chief interest, in any event, lies in its concepts; as painting, it's a dull, mechanical execution of a thesis. Schnabel conflates two pictorial facts and affixes to them an autobiographical fact; the result is a mock-up art-history problem. If we take the painting as expressionist, a work that bears the torture marks of its passage from the painter's fevered consciousness into its image existence, Schnabel's *St. Sebastian* is surprisingly tame and subdued.

Kneading unusual or found materials into the pigment field has become an identifying assertiveness for some of the new Expressionists. Kiefer not only accumulates massive loads of pigment and emulsions on his canvases but builds up textures and gouges depth into the image by affixing straw, sand, lead, and other things. To one recent painting, *Osiris and Isis,* he attached a circuit board at a crucial passage; on another he mounted a pair of iron skis; and in a recent series, ferns are both the subject and the material. Additions like these enlarge the thing life of a picture. Both Kiefer and Schnabel want to make the picture an open frontier available to things spiked into the painting from other orders of use. (The Surrealists and pop artists prepared the way for the more severe en-

ergy these young artists exercise.) Skis and straw, broken plates and antlers, all with autonomous identities, do not simply enter the formal configuration of a painting but enlarge and complicate what it represents. The world's work—fieldwork, factory work, and their products—extends its life into the representation made by the painter.

Schnabel seeks to build up the dimensions of an image by constructing secondary surfaces, scales on the skin of the canvas. The most famous are the craterous, eruptive canvas-scapes made of broken crockery. In *Vita* (1983), the central figure is a crucified woman; the pieces of shattered plates that frame her emerge from the painting's surface like star bursts, and some of the stellar debris tumbles into the configuration of the body itself. The fusion of oil pigment and jagged, rippling plate fragments makes the image look at once muscular and dismantled. The figure has a high, intense resolution even while it seems about to disintegrate. Formally, the painting is brilliant; conceptually, however, its presentation of the suffering female seems calculated to win sympathy (or approval) by virtue of its correct political tone. The predetermined content of the image constrains Schnabel's explorations. There is a different, more formal, kind of constraint in *Aborigine Painting* (1980), a two-panel work. On one side, an aboriginal crouches, his head turned toward us as if he were about to tell a story; his body is all streaming yellow flesh tones outlined in red. His face is indigo with red and yellow highlights. Across from him, filling the left-hand panel, is a blotched, swirling land mass in amber and mud brown, roughened by the scales of broken plates. The compositional elements exist in dramatic relation: the pictured setting might be an image from the aboriginal's own consciousness. And yet the coloring of the figure is very derivative of Nolde, and conceptually the picture owes perhaps too much to Edvard Munch's renderings of a turbulent mind in a turbulent universe.

Vita and *Aborigine Painting* are interesting because they are at least toiling somehow with feeling and form. More often, however, the rhetorical purpose of Schnabel's work is to charm. *The Sea* (1981) is a compendium of exciting materials: big chunks of broken terra-cotta angels, fish, animals; a fragmented crèche; clay pots fun-

neling out from the surface; and antlers. In front, freestanding, is a stout piece of charred wood that looks like an expressionist herm. The imagery is vaguely Mesoamerican. The title is the only defini- tion of subject. This is presumably an image of history and its sea wrack, its allusive fragmentary representations swept along at dif- ferent depths. Like much of Schnabel's work, it has designs on us. It comes at us not to manipulate us through a system of images, as *Prehistory* does, but to instruct us on expressionist ambitions. It announces the desire to disturb the picture surface into new defini- tions; the announcement is itself an inarticulate cry of turmoil; the canvas-scape is proposed as a register of the turmoil. And yet the picture is governed by a serenity, a certitude, that I feel even when I'm looking at pictures with the most violent flourishes. What's missing is the desire for form made sensible in the forms of the work. Schnabel's paintings, most of them, are finally so placid be- cause they are not committed to the disequilibrium artists need to feel—sometimes even to cultivate—if they want to find their way to new resolutions.

Jerome Witkin

In Diane Arbus's famous image of the scrawny boy in Central Park holding a toy hand grenade, the child's body is seized up in a con- vulsive but ludicrously posed anger. His left side contracts in a spasmic rage to a point just below his shoulder—his hand is a baby steam-shovel claw about to jackknife and tear off a piece of flesh. The male figure in the third panel of Jerome Witkin's polyptych *Subway: A Marriage* (1981–83) imitates the spastic, half-collapsed stance of the hand-grenade child, but whereas Arbus's subject poses for us—the contrived menace accounts for the travesty of innocence dramatized in the image—Witkin's figure is not posed or arranged; it does not "project" anything. The mysterious pain he suffers is a sensation thought through the body, the figure modeled by interiorized torsional forces. Photography, of course, cannot think through the body as painting can; it is constrained by the

given fact of the pose. For Witkin, painting the figure is often an essay in eruptive sensation; the expressiveness of his figures is florid, peaked, an articulation of tremendous pressures built up within or "before" the finished work. Witkin may have used Arbus's image as a source. He's a painter who takes in as much of the ancient and modern tradition as he can to extend and discipline his own energies, not so much to resolve formal painterly problems (his exertions to push color into new expressiveness are evident enough) as to master his theme, which is sensation lived out in crises of public and private conscience.

In *Subway: A Marriage,* a suffering conscience is modeled into the anatomy. We see its physical bite—remorse (*remorsus*) means to feel bitten again and again, gnawed at—the wound that erupts from within and threatens to rip the body apart. The narrative armature of the polyptych is almost drearily familiar: a wife, her presence disclosed only in the last panel, provides comforting witness to her husband's dream agony, the vision of which is hammered forth in the three preceding panels. The dreamer, in pajamas, stands in a subway car; the interior is wreathed with graffiti. Two vipers have eaten their way out of the pillowcase clenched in the sleeper's hand. On the seat next to him is a manikin's hand. The pillowcase, residue of his waking life, dissolves as the nightmare unfolds; in the second panel it's ghostly, and a hooded executioner now occupies the seat, holding what is either a baby or a frighteningly lifelike doll. The sleeper now cringes from some unseen hurt. In the third panel, the executioner, female, grins, eyes still hooded, her teeth like those of Francis Bacon's popes. The baby has become a green-faced doll, with a doll's perfectly spherical head, and its sweet, round mouth seems to be singing, though it and nearly everything else in the frame is spattered with blood gushing from the sleeper's shoulder. He looks like a torture victim, unable to return to life's normalcies. But the source of the torture is the dream life. The snakes and pillowcase are both gone, absorbed into the vision's transmutations. When the dreamer awakens in the final panel, he stands at the bedside as he stood in the subway, his body shaken loose from the torment, which now concentrates entirely in his worldless gaze. He stands amid spilled night-table de-

bris—an overturned telephone, a lamp, and a notepad where Witkin has signed the painting.

Because he is determined to recover the narrative energies of figurative painting without falling into the plaintive exercises of Neorealism, Witkin depends heavily on scenic anecdote. But I don't think he's interested in narrative for its own sake. Clarity of event, the outlines of dramatic situation, act as formal constraints upon the forces he wants to represent. The subdued, oblique narratives of a painter like Eric Fischl seem genteel in contrast to Witkin's extravagant Venetian manner and thematic openness. *Subway: A Marriage* dramatizes not so much a fear of women (though erotic anxiety is certainly one of Witkin's subjects) as the dread of the wounding containments of married life; and that disclosure is driven by the revenge that imagination takes while we sleep. The final panel presents a comfortably middle-class marriage, and the husband's shock is complicated by the figure of his wife, whose extended hand is a moving and unequivocal sign of solicitous affection. The previous panels expose the lacerations of a conscience terrorized by a woman, a child, and family relations. The later triptych *Division Street* (1984–85) presents a consequence of that dread: the father walks out the door, suitcase in hand, the worldless gaze of the sleeper in *Subway* now transformed into the anonymity of a turned back; the young son cringes in a chair as plates loaded with food explode melodramatically against the door frame, around the departing father's head. The mother's fury and the father's slouched withdrawal converge in the horrified loathing that contorts the young boy's face.

Anecdote is essential to Witkin's work, but he pushes against its compactness, its tendency toward oversimplification and the formulaic. Because he possesses a moral imagination—that is, he is concerned with evaluative representations of the qualities of human action—he must remain available to tumultuous surprise. And so he pushes against the constraints of anecdote with aggressive operatic color. He paints clothing as shimmering foils that melt in the glare of floodlighting. In *Division Street,* the dinner plates shatter into gouts of blood and flesh, like shrapnel in a fever dream; in *Subway: A Marriage* the sleeper's pajamas glow a silvery

TV green. (Witkin says he got the aluminum green of the mother in *Division Street* from Peter Pain, the Ben-Gay trademark.) In painting after painting, light seems flayed off the substance of the clothing, in which the flesh is provisionally housed. In his 1980 portrait *Jeff Davies* (Plate 9) the green of the parka the huge man wears is a bulbous exfoliation of the greeny tints of his eyebrows, cheekbones, beard, and hair. The swollen, tubular sleeves, collar, and pockets pick up the rhythm of his big belly and tight little breasts. All that voluminous robustness looks tenuous and frail. For all his bulk, Jeff Davies looks about to disappear.

Witkin's most disturbing works are those where the suffering or passion of conscience is enacted in a public, historical context. In the triptych *Death as an Usher—Germany 1933* (1979–82) the subject is Nazi terrorism fouling the stream of ordinary life's ordinary amusements. More recently, in *Mortal Sin: In the Confession of J. Robert Oppenheimer* (1985) an explicitly sacramental intimacy enfolds public consequences, but in a manic pandenominational way: the unorthodox Jew Oppenheimer, purveyor of Eastern religions, participates in a Catholic sacrament. In counterposing scientist and priest, Witkin is restoring and readjusting the tradition of crier and listener in religious art. In the left panel of the diptych— Witkin paints his way *through* the picture space the way a storyteller moves through time—Oppenheimer kneels at a cutaway confessional. Behind him a blackboard is jazzed with equations, the word *sin* tangled and almost lost among them. One hand grips the jaw of his open mouth as if to rip it off, while the other points to his heart. The figure is one of inexpiable fault, of a knowledge that brings gnawing pain. The body, as in so much of Witkin's work, is conscience's torture room. In the right panel, somber and unmoved, a priest hears the confession. His space is all disorder, and it's hard to tell if it's a bombed-out residence or an artist's messy studio. The priest's work is to absorb the narration of humanity's worst crimes. He tilts his head down in the usual way, so that Oppenheimer's raised mouth cries out through the Judas hole above the confessor's head. Witkin has so cunningly deployed his materials that he allows our eye to assemble most of the crucial constructive details—the armature of the anecdote—before we re-

alize that the peach tones of the priest's forearms are not the colors of flesh, but prosthetic devices with hooks. Then we see he has only the stub or stump of an ear.

It may seem that Witkin sets a man of the church, maimed presumably by the devastations of war, against the man of science who helped to develop a more "efficient" way of slaughtering populations, in order to illustrate a thesis. That's the anecdotal harness, and in some of his work it leads Witkin into sentimental simplifications. But illustration is not, I think, what really matters to him, though his skills as a draftsman are such that the paintings have almost too much "attack." What matters is the quality of moral feeling. The priest is sullen, unresponsive; the pasty red outlines around his eyes make them seem bleary and attentionless. In the knifelike figure of Oppenheimer we see one kind of religious feeling, ecstasy, turned into self-accusation. Even his most intimate confidences are cries to the heavens. Both figures inhabit spaces in disarray, both express powerlessness to control a reality authored by them both. If the painting can be said to have a subject, it is the devastation of conscience when acts produce consequences that render the author of those acts inconsequential.

What makes this and Witkin's other political-historical paintings compelling for their formal values is that he is working, consciously I think, in the tradition of the lives of the saints. His impulse, and the tableaux format he favors, sets his work in the tradition of Renaissance cycles about St. Francis, St. Mark, and the Gospels. His presentations, however, are never devotional. His subjects are secular and historical, but the turbulent religious feelings expressed in them—the awakening, emergence, and testing of transfigured realities—are sometimes nearly as intense as those in Tintoretto. Witkin's "texts" are not Scriptures but newspapers, chronicles, and broadcasts, and he has absorbed into his form language some of the effects of those other technologies. He says that for some paintings he works up his palette the way "you can play with a television set and 'fry' the picture." He loves to draw and makes numerous elaborate preliminary drawings for his paintings, but he cannot stay away from painting too long. "I need to paint," he says, "be-

cause it will take me to a visceral experience of making light, of making all sorts of impulses with color and line." For him paint is often the florid handwriting of suffering and dispossession. If Witkin is working in the tradition of the lives of saints, his work is representation as investigation or interrogation of moral value. What's given is historical fact, not pious disposition. At any rate, the sulfurous surfaces and glassy radiance in his larger canvases make it obvious that Witkin's "sourcebook" is usually not a hagiography but a demonology.

An art so driven by the theatrical momentum of subject matter risks hysteria and the complacency of its own conceits. In our grindingly self-conscious age we know that even horror can be made into "good material." Witkin avoids the trivializing hysteria of poster art by blending into his chosen events complex, ambiguous nuances. He needs extravagance and operatic gesture to both release and master feeling. But a few of the paintings are narrowed by conceit. In an earlier work like *The Devil as a Tailor* (1978–79), for example, Witkin's devil is a Teutonic scholarly craftsman in shimmering, embroidered robes—a studious dandy. His face is "fried" by a floodlamp; the light sizzles red and yellow around his skull bone. Hanging from a rafter behind him are finished products, army uniforms of different countries and a jacket with a yellow Star of David. The fiery flakes and motes of the devil's face seem reflections of his mandarin finery; the reds and golds of his own costume rhyme with the colors of his Singer. He's an avuncular presence who enjoys the becalmed dignity conferred on him by his occupation. But the entire composition is locked into a thesis: that nationalism, which encourages self-righteousness, divisiveness, and exclusivity, is evil. The platitude is only slightly upset by the devil's serene, benign, self-assured countenance. Part of Witkin's enterprise, however, is to challenge formulas of historical wisdom and journalistic platitudes that numb us to moral ambiguity. The risk is that adequate formal response will tip over into illustration and sentimentalist opportunism.

Witkin perhaps fits Ruskin's description, in *Modern Painters,* of men who "live entirely in their own age, and the greatest fruits of

their work are gathered out of their own age . . . all of them utterly regardless of anachronism and minor error of every kind, but getting always vital truth out of the vital present." Much of Witkin's work reminds me of Ruskin's comment, not because of the facts of the case—the topicality of the work—but because of the felt quality of relations among the human figures and the events they devise or are caught up in. One of his latest pieces, a five-panel work called *A Jesus for Our Time* (1986–87), serializes the aspirations of a charismatic evangelist named Jimmy. He intends to preach in Beirut, which he will enter as Christ entered Jerusalem, except that he enters like a rock star, his pulpit the rear of a truck. His aspirations are defeated when a car bomb goes off nearby. The mix of tones is dazzling: the visionary call, the vocation, is almost tenderly presented in the first panel, but later we feel Jimmy's manic righteousness when he preaches, as well as the devastation not only of his faith but also of his carefully arranged public self— the ingenuous religioso in a white Jerry Lee Lewis suit—in the face of sectarian terrorist violence. Panel by panel we are made to witness the falsehoods and ideological viciousness that slash across the life of religious belief in our time.

When Jimmy is brought to his knees by the explosion, twisting away from the storm of glass and debris, he strikes the kind of *contrapposto* that Tintoretto loved to paint. But Witkin, for all his powers of recapitulating the figurative tradition, has his own vision of the body as an architectural structure in jeopardy, about to spring apart from the stress of circumstance and obsessive feeling. For the preparatory drawings for *Unseen and Unheard (In Memory of All Victims of Torture)* (1986), he had his models pose "dead," stretched horizontally on a hard surface, pelvis lifted in a position of maximum tension, breakability, and exposure. In the painting, a naked male strapped down to a bedspring thrusts his pelvis upward at the moment when the electric shock from a torture device turns his body into a pain conductor. The shape of that pain—the flesh is painted in long light bands as if it possessed an excruciating elasticity—arcs across the middle foreground. In the background, where Witkin has taught us to look for messages,

traces, *signs* of some sort, a flak jacket, ammunition belt, and field jacket hang from a scarred wall—another ravaged interior expressive of moral disorder.

The picture enacts the oblivion of physical torture when all time converges on the instant of pain or release, when consciousness, owned by the torture masters, resolves into a shriek. The daring complication in what might otherwise remain mere earnest grandiloquence is a second figure, the anonymous collaborator, sitting in the corner of the room. American by his look and dress, gone to fat, he's shouting into a telephone, his face contorted by grief and disbelief, covering one ear as if to shut out the screams of the torture victim. But the collaborator clearly occupies a different narrative space; detached from the field of the painting, from the enforced relation to the victim, he would be an unequivocal expression of shocked sorrow. Witkin blends the two zones, and here there's no architectural artifice like Oppenheimer's cutaway confessional to separate the crier and the listener. The two moments of suffering are engaged in a horrific conversation, the hermetic domestic existence of the collaborator (his corner is lit with the same interrogating glare as the sleeper's corner in *Subway: A Marriage*) fused to the public world of ideology, State Security, and terrorist force. Blended into one frame, one congestive narrative space, the collaborator can no more easily escape the victim's cries than the victim can evade the pain inflicted by his torturers (who are absent, represented only by their technology, by the coils and generator of a device that looks like a field telephone). The devastation of the body and of consciousness in the name of ideology or political rectitude becomes, in Witkin's visionary theatricalism, an inescapable fact in our awareness of ordinary life, and one we labor not to forget.

The immediate force of Witkin's paintings comes from their act of witness. I don't mean to trivialize his art by suggesting it contains homiletic content or is moralistic. (Unlikely in any event, since the serial paintings are all blistered with mysterious, irrational, utterly unprogrammatic elements.) But his work has a weird restorative power, restoring to us facts of consciousness and of feeling that we hazard to ignore.

The Starns

The art marketplace has changed so much in the last thirty years that the kind of patience exercised by some early modern artists must now seem a liability to young artists, who come of age in circumstances that pressure them to develop a signature manner or subject matter as early in their careers as possible. Matisse spent nearly fifteen years picking his way through the influences of Cézanne, Pissarro, Impressionism, and Divisionism before he emerged with his singular fauve style in 1904 with *Woman in a Hat*. Cézanne himself had retreated into an aloof, obsessive practice that brought him only a long delayed (and contested) fame. Giacometti was in his late thirties and had been making art for many years before he began to discover what became the most identifiable sculptural idiom of the century. But the pressures and expectations artists are alert to have changed dramatically. The number of exhibition spaces in New York has multiplied several times over in the past quarter century. Jed Perl, describing the situation in *The New Criterion* (June 1988), says that in just a couple of weeks he saw about a hundred shows in SoHo alone, few with anything worth writing about: "The scene is now so crowded with frauds, clones, and mediocrities that it's become a test of patience and willpower to find the genuine article." It is not simply the artists who must compete for dealers to represent them, but the dealers themselves who must compete for attention from collectors, the media, curators, and corporate interests. In such an environment an artist's early emergence, or breakaway, is crucial. Artists who developed the famous breakaway styles of the late 1970s and early 1980s—Schnabel's histrionic canvasscapes; David Salle's laminar grisailles and his juxtaposition of old master quotes with teasing nudes; Eric Fischl's deflected sexual narratives—have met with an intensity of early fame that only a few of the major artists, under very different market conditions, experienced in the first half of the century.

Mike and Doug Starn are identical twins born in 1961. They are represented by a prestigious gallery (Stux) and have had their work on exhibition at Boston's Institute of Fine Arts, the Whitney Bi-

ennial, Documenta 8, the Saatchi Collection, the San Francisco Museum of Modern Art, and the University Art Museum in Berkeley. The art they make—rough-cut, pieced together, toned enlargements of single or multiple images—is a plastic treatment of photographic material. In *Boots with Metal and Film* (1983–87) the image of two standing laced boots is a reconstructed 5- x 6-foot enlargement patched together so that the work seams—where the print has been cut, folded, torn, taped—are visible as traces of the dismantling and reassembly process. The treatment, the edited restoration of the master image, is really the chief subject of the work. The Starns do not break down or dissolve the initiating image. Even in their most heavily webbed pictures, the ghost of the original whole remains visible—everything they produce, in fact, seems a cracked memorial to some lost seamless form. The boots picture (which is owned by Julian Schnabel) is an industrial-strength image, with seedy boiled tints and surfaces mottled by chemical bubblings. The texture is spread so fine by enlargement that the boots look vaporous. Clamped to the surface are several small square metal sheets and a piece of maroon film; all the paper patches are wrinkled. Everything in and about the picture looks worked, used. The compositional field, however, has no elasticity. The elements are not deployed in any dramatic or formally compelling relation to one another, though the image does seem to project a less disintegrated spectral duplicate of itself that floats before it. Like many of the Starns' pictures, and strangely for artists so young, *Boots* has a stately, unaggrieved equipoise.

The same equipoise is apparent in the other dismantlings that go on in their work. Absorbing the influences of pop, conceptual, and performance art, the Starns not only unmake, then reconstruct, the photographic image but also hack away at the conventions of exhibition. The boots picture, for example, has no frame: its irregular shape (or "patch print") is stuck to the wall with push pins, as it might be found in the artists' working space. The crisscrossing of work space and exhibition space has a shaggy informality which, executed in the solemnly welcoming air of a modern museum, can seem mildly disingenuous, like an academic poet who reads to a

classroom filled with students a poem endearingly contemptuous of the academy. When a picture by the Starns does have a frame, it usually just hangs there like a harness on a hook, glassless, around a push-pinned image. Sometimes they attach or hang mere fragments of a frame, or lean a glass sheet against the image. These disruptions, however, seem to express a rather mild-mannered formalist curiosity more than compulsiveness or anarchy. By executing these playful determinations so frequently, they run the risk of making the rhetorical setting of their work—work meant to reform our notions of finish and completeness—so monotonal and self-conscious that it becomes mere conventionalized rigor. It may be the Starns' intention to contrive and then to live by such conventions, and there is a genuine hangdog affability in their manner, but their charm cannot woo us out of our complacencies. The formal problem of making busted framings a part of the image life of a work (the most recent and glamorous solution being Frank Stella's swirling, long-horned aluminum constructions that both support paint and frame or define its action) is now so familiar that the real question for artists of the Starns' generation is how to escape from or detonate the academicism of the "problem."

When Matisse was twenty-six years old, he painted a copy of Philippe de Champaigne's *Le Christ mort,* pulling the image into his own youthful idiom. The planes of Christ's face were prototypes for the sheeted colors he would be using in portraits twenty years later. The de Champaigne, however, not only offered Matisse an object occasion to develop his own style but also inaugurated him as a religious painter. Painting was his way of expressing what he later called his religious awe of existence. The Starn Twins recently took over the same model, though they treat it not as a subject but as an object, as material. Their "Christ" series consists of twenty-one works developed from a single negative made when they visited the Louvre a few years ago. Their energetic manipulation of the image—the folding, scissoring, blistering, Scotch taping—is a festive violence that suggests the eager intensity of students *getting* classical art. Theirs is a new way of copying a classic. They don't really copy or imitate it, they appropriate it, so that the master image itself becomes a medium to be worked. The elabora-

tion of the given form—that is, pulling it through the mutations available to the photographic process and then adjusting that product—thus becomes the primary task. Their range is impressive. They drag the image through all sorts of visual registers, from the plaintive, open-grained garishness of newsprint photos to the sullen, crepuscular shadowings of pictorialist photography. But the Starns also draw heavily on Andy Warhol's example. They seem to share his sense of art as the banal pushed toward exaltation by replicating or stuttering the image. The Starns' multiple images though, like the *Triple Christ* made of three differently toned slabs of the de Champaigne picture stacked like bunks, have an inquisitive disintegrating heat that is far from Warhol's calculated affectlessness.

That heat is generated, however, by a purely secular curiosity; their concern for the symmetry of multiple images and for the mechanics of dismantling dissipates the hush of ancient sacrifice surrounding the image of the dead Christ and replaces it with a familiar reverence for the painting as a culture object. One of the most compelling images in the series, *Rose with Christ,* crops all but the torso from the picture. The body's frailty is beautifully articulated in the swollen, thinned-out consistencies of flesh and musculature. But on a square patch at the figure's armpit is pasted a purplish rose. To what purpose? To signal a meaning? To assert or fix a feeling tone? To posit an allegorical equivalent to the Redeemer? Or is it there for its morally neutral formal character? The Starns are trying to find their way, I think, through what David Salle calls the condition of simultaneity, by which "everything in this world is simultaneously itself and a representation of the idea of itself." This extends naturally, and in its most defiant form, to any art thing as "a representation of an idea of itself." This skein of self-consciousness is what I think leads the Starns to graft the rose image: its presence represents the will of the artists to put it there.

The Ascension, from the same series, is a big smoky blue-toned print that incorporates a literal illustration of its title. Implanted in the major Christ image is a snapshot (covered with a messily creased strip of transparent tape) showing an overhead view of some oceanic expanse. The artists clearly want to recover and maintain

the religious icon, but only as a culture fact, a material to be worked. The representational gestures are so busy—the old image preserved in intentionally banged-up shape, the new little image spiked into the other, its little vastness grafted onto the singular mythic human form—that the picture is more interesting as a formalist conundrum than as an expression of religious feeling. The Starns do not address the image of Christ as a representation of mythic fact loaded with feeling, they address it as an institutional artifact. (The issue gets even more complicated: the Starns insist that these images be arranged in exhibitions in imitation of the deployment of pictures in the Louvre.) The "Christ" series is intentionally denaturalized and culture-obsessed. For all the imposing, large-scale presentation of the Christ in *Ascension,* and the instructiveness of its aerial-view snapshot, like most of the works in the series it expresses at best a very feeble nostalgia for the idea of transcendence.

The Starns have in any event struck young and fast with a singular idiom. The range of formal possibilities available to them seems rather narrow. The doublings and replications are already signature patterns. *Double Chair* shows mirror images of a chair cocked both sides of a diagonal axis. *Lake Michigan Steps* is a doubled image. *Horses* is a series of one hundred differently toned and patterned prints, all developed from a single negative of a pair of horses. There is a *Triple Landscape* and a *Multiple Rembrandt* and a *Triple Seascape,* all of which suggest the formulaic, the prescriptive. But there is also the fabulous *Double Stark Portrait in Swirl* (1985–86), where the scorched, bandaged textures of the composition are indistinguishable from the felt drama of the figure. The subject, a young man, is doubled; the horizontal axis that divides the image is like a reflector, but cutting across the neutral doubling are discordant, melancholy tones—russet, charcoal, purple gray, silver. These, along with the twisting meditative posture of the figure, fill the space emotionally. It is a portrait of sullen youthful withdrawal. But the most challenging of their works I've seen is *Homo Faber,* which measures 6 x 10 feet in a bulky aluminum frame. It shows what looks to be a burnt-out warehouse interior or underside of a bridge. Though it does not have the high

definition of much of their work, it is more detailed in its feeling. The vague ravaged or decayed structures, some wrecked product of civilization, are intensified by the macerated discolorations of the Starns' methods. Inserted into the major image is a snapshot of that same image, the specific locale no more discernible in minia- ture than in its enlargement but with the feeling of devastation more impacted. In this case the Starns are not simply doubling an image, they are doubling the process by which an image or repre- sentation is realized. And each picture enacts a different intensity of the shape of a piece of our world coming undone. Here and in the *Double Stark Portrait in Swirl* they are pushing beyond the moody limitations of their manner. To say that they are still young and may yet break through to new forms no one can foresee is to patronize them and pretend that they are unmoved by the expecta- tions of the art world. It does not matter that they don't have real subjects yet. When Wallace Stevens told Robert Frost that Frost's problem was that his poems had subjects, he meant that a modern artist does not need anecdote, narrative, or sensational occasion. The artist *does* need curiosity and passion for the life of forms in consciousness. That curiosity, at least, flashes in some of what the Starn Twins have already accomplished.

Gregory Gillespie

Now in his early fifties, Gregory Gillespie has followed the advice Delacroix gave himself in his *Journals:* "Choose stubborn material and conquer it by patience." Gillespie lived in Italy from 1962 to 1970, during which time he developed his major pursuits: land- scapes, often squirming with strange vegetative details; still lifes, where organic textures become nightmarishly clarified in studio light; portraits, which have challenged his technical skills at representing temperament; and "shrine" paintings, modeled on the votive images of dead people sometimes seen on walls in Italian towns and often used to mark grave sites. He has also done numer- ous street scenes and figure groups, most of them derived from

Balthus. Whatever the material, most of his work has clustered around the technical task imposed by the shrine paintings, where he has addressed a crucial formal question of our time; Frank Stella has plotted his career by the same question, and younger artists like Julian Schnabel and David Salle noisily contend with it. The shrine paintings were occasions for Gillespie to punch into or distend a pictorial scheme and create new opportunities for deploying dynamic space. He seemed especially interested in creating a space that could bear the full awareness of surface flatness and also allow for illusionist depth, without turning the pictorial event into paradist trompe l'oeil. Once he returned to the States, Gillespie continued these investigations in his studio paintings by turning his actual working space into a shrine site.

Because he has been so obviously influenced by old masters, the temptation of parody, of infusing technical or thematic facts from the past into a new pictorial event, is a constant shadow presence in Gillespie's work. He went to Italy to study Masaccio, and the shrine paintings were at first not simply an American way of appropriating foreign subjects but also formal tributes to the architectural housings of Masaccio's figures in the Brancacci Chapel and in Santa Maria Novella. But the Italian who meant the most to him was the fifteenth-century Venetian Carlo Crivelli. Gillespie admits to the technical breakthrough he owes to his study of Crivelli. Frustrated by his inability to render the form of things accurately by blending paint in the usual way—"If I put a squash or rubber ball in front of me," he said in an interview in the early 1980s, "I couldn't make it look round with the usual blending"—he took over Crivelli's method of crosshatching. This corrected and sharpened the clarity of objects; it made the coloring thicker, busier, yet still fluid and resilient. By crosshatching he could, like Crivelli, condense the volume of objects and give them an unsettling vitreous solidity. Although there are few conventional religious icons in his paintings, especially when compared with the tabernacle rattlings of younger neo-expressionist contemporaries like Schnabel and Anselm Kiefer, there's a consistent devotional tone borne by the formal values Gillespie confers on brick, mortar, stone, color, and wash. This gives evidence, I think, of the other major influence on

his work. The Italian trace is mixed with, and secularized by, Dutch genre painting. One painting, the 1981 *Untitled Landscape (After de Hooch),* is testimony to that influence. In several of his figure groups we see the smudged physiognomies and sheeted lighting of Vermeer and de Hooch; his still lifes and interiors often borrow and revise the brickwork arches and tiled surfaces so commonplace in baroque painting. At the same time, though, Gillespie contests the restraints of influence by folding and buckling the picture surface into telescoped boxes, with no intention of dramatizing depth or discovery. And the walls and floors in his studio paintings, like his landscapes, become fever dreams of volume and massive color. To pursue his own visionary contrariness, he learned painterly disciplines of a conventional kind.

Gillespie is very much of his moment in the way he infuses debris into painting both as a pictorial subject and as material that complicates and disrupts the conventional surface. Ever since his years in Italy he has worked magazine and newspaper photographs into many of his pictures, taking them as a used, found armature on which to construct a scene. In several paintings of the 1970s he introduced all sorts of studio wrack: wooden models, old photographs, discarded studies for paintings, palette scrapings, still life items, and his children's toys—conforming to the atelier convention of including whatever happens to be on hand. But Gillespie arranges and distorts the material to suit his own purposes. *Studio Wall* (1976), which at 96 x 120 inches was the largest piece he had ever done, is constructed like a double shrine divided by a strip of wall with a light switch and notepad. The shrine on the left is a punched-in recess of four telescoped boxes; the fastidious (but in dramatic terms inconsequential) perspective and crisp edges of the nook are mocked by other objects painted into that devotional space: a houseplant, a leering mask, a crosshatched sketch tacked to the wall, a photo cropped like a classical bust. The right-hand shrine holds a doll, a toy airplane, more photos (one of them of a 1968 self-portrait), cinder blocks, and a teddy bear. Deployed as objects of painterly attention, the studio clutter has the look of holy objects. The devotional rigor of an inquiring imagination confers on these ordinary things an almost sacramental value. Maybe this is

what Gillespie had in mind when he said in the mid-1970s that his recent paintings were "moving toward religiousness in a positive sense."

If Gillespie's technique in the shrine paintings perforates the flatness of the pictorial surface, in his landscapes it amasses weeviled textures. In the 1974 *Visionary Landscape,* for instance, mineral and organic matter is built up so thickly that the picture plane melts into the encrustations and engorgements of the scene. The vegetative forms seethe so densely that Gillespie's realist gesture here is one of bringing back alive not the appearance of reality, not a persuasive or affecting likeness, but rather the feeling for a vital force that infuses all matter. Looking at this and other of his landscapes is like looking into a shattered pomegranate, or at a mad elaboration of an anatomical illustration by Vesalius. His visionary natural forms are cellular, viscous, cankerous. He paints nature's appearances as if they were viscera, a concealed hyperarticulated mass. Vines, shoots, flowers, weeds, soil, and rock all seem to bloom and rot in the paint itself. (A realist's favorite worst dream must be that the paint becomes the thing it represents.) The homunculi and vegetable excrescences that spill from the labial hives in *Visionary Landscape* remind us inevitably of Hieronymus Bosch.

Gillespie's forms, though, do not have the episodic deployment of figure groups that we find in Bosch and Bruegel; moreover, in these artists we always feel the restraining hand of the draftsman governing the turbulence. Gillespie renders the eruptions in nature's ordinary appearances as a fused detailing of the resolution and decay of matter. He catches natural process at the stage when ripeness rots. The images can be overpowering because they seem beyond the artist's control—or beyond his will to control. The tendriled and bulbous forms of the 1973 *Night Garden* seem to possess a consciousness borrowed from the human and are yet utterly strange to us. Gillespie is, as we might expect, aware not only of these effects but also of their pedigree: "Lots of people say Bosch or Bruegel when they speak of my work. I've liked them from time to time. . . . I don't know who these kinds of paintings [like *Night Garden*] really relate to. Maybe that Victorian Irish painter, Richard Dadd. He was actually insane and he painted little

creatures. . . . He's interesting, this Dadd—he painted the anthropomorphic qualities of nature—goblins, leprechauns." Dadd was a literary, illustrational painter, and most of his work is quite conventional. What attracts Gillespie, I think, is Dadd's queasy ability to make images in which we see the world of fairy—little people, animated vegetation, sprites—menacing normal waking perceptions and reason with a vaguely horrifying mischievousness, horrifying because it may at any moment invade and derange consciousness.

Gillespie's drawing becomes all the more rigorous when his subject threatens to burst the norms of composure and right design. His *Landscape with Perspective* (1975), for instance, has an elegant, almost somber, formal structure that is studiously observed because of the turbulent matter stirring within it. The title suggests an academic exercise, but the picture has a subversive sexual force. The "perspective" is in fact a vulval funneling from a pale misty sky filling the upper hemisphere of the picture (which is smallish, even by Gillespie's standards, roughly 16 x 12 inches) down to conical terrestrial forms that tumble and spill down the picture plane. Nearly buried in the scene are signs of culture, a farmhouse, a small church, a row of houses, provisional structures embedded in the heavily combed surface. Gillespie is trying not only to present culture's orders as they occupy pieces of the earth's surface but also to make visible the plasmic throb inside the actual physical ground of existence. Although technically the peer of any of the Superrealists of his generation who emerged in the 1970s, he is not interested in the vaporizing dilations of photorealist portraiture. ("Realism," Delacroix wrote, "is the grand expedient that innovators use to revive the interest of an indifferent public, at periods when schools that are listless and inclined to mannerism do nothing but repeat the round of the same inventions. Suddenly a return to nature is proclaimed by a man who claims to be inspired.") He aspires not to porous exactitude but to mass and volume, and to a kind of molecular movement. In a painting like the 1975 *Self-Portrait (Torso),* he wants us to see the tiny blood vessels under the skin not so we can experience the skin's transparency and frailty but so we can feel the movement and mass of blood channelings. Of his portraits

in particular he has said that he wants "a suggestion of veils, that things are happening underneath." That ambition applies equally to the landscapes. (Over the years he has also done several "curb-scapes" or "gutterscapes," crawl-space views of houses and land-scapes in which he offers literally an underneath view of things.) It accounts for the atomization process visible in the color in many of his works: the pigment seems consubstantial with the subject mat-ter. Gillespie is willing to forgo the tedious perfections of Super-realism to achieve what he calls a sense of colossal mass. However small the format—most of his things are modest in size and exe-cuted on wood—his pieces *look* heavy, not because he loads the surface with pigment but because the image itself expresses the feeling of the density and heft of matter.

Gillespie prepared for the paintings of the 1970s by some of his experiments with collage in the street scenes and shrine paintings of the 1960s, when he frequently worked magazine pictures into the pictorial scheme. His 1968 *Soccer Star* shows a photograph of a famous Italian athlete collaged into a street scene, but his seated figure is eviscerated, split from neck to groin. It's a shocking but rather impassive image, as clinical photographs sometimes are; it is also one of Gillespie's very few schematic and academic pictures. Its juxtaposition of the body's familiar exterior form with its hid-den interior is judicious and contrived, though it obviously pre-pared the way for Gillespie's more subtle interrogations of the rela-tion between the seen and the unseen. And out of earlier works like *Exterior Wall with Landscape* (1967) and the 1969 *Naples Shrine* and *Viva Frances,* where square crannies showcased all sorts of cul-tural debris, religious imagery, wormy human figures, and distant landscapes, came the mysterious landscapes, portraits, and still lifes of the 1970s and 1980s. *Landscape of the Realm* (1973) takes the visual format of the shrine and melts it into a stream of dark terrestrial recesses in which Gillespie sets his familiar homunculi, bladders, and intestinal coils. If a picture like *Soccer Star* offered too much of the mere shock of disclosure, *Landscape of the Realm* is executed by a mature artist who has found and is pursuing his theme. Gillespie admits that many of his paintings are about change. The organic matter he so often takes as a subject is painted as a

changeful, intermediary substance. The massive color resolution of his technique, though, allows these larval stages to look like adult identities, final and completed. The most representative Gillespie image is at once larva and imago. (He would be the ideal American illustrator of Ovid's *Metamorphoses*.) His methods sometimes participate in the process they express. He likes to use the dried paint from his palette in much the same way he has used photographs: "If the paint on the palette gets interesting, I'll pick it up and paste it down on a panel and start painting into the shapes— 'Rorschaching' into it." The mixed, unwilled, haphazard formations become a larval presence infused into the painting to bring it to some higher, more richly molecular, resolution.

Gillespie's many self-portraits display the formal disciplines he learned from the study of Italian and Northern European art. They also play out another dimension of the transformations evident in the landscape paintings. From one to another, his image in the self-portraits is revised, redecorated, re-emergent as a different tone of self-regard. In a 1978 painting his hair is long, he has a beard and wears a T-shirt, and the frontal pose of the head has not only a Venetian depth and complexity of color but also an intensity of mind registered in the gaze that recalls the Venetians Gillespie admits to admiring most—Bellini, Carpaccio, and Crivelli. The brushwork shows the fastidious attention to detail practiced by Gillespie's friend William Beckman, but in this and other self-portraits Gillespie continues a tradition, not usually evident in figure painting in the 1970s and 1980s, whereby likeness, as John Berger has written, "defines character, and character in man is inseparable from mind." In a 1976 self-portrait, the artist is stripped to the waist; his physiognomy and coloring have a historical shadow life that recalls Masaccio's and Mantegna's treatment of the figure. The painter looks at us, or at the imaginary mirror that returns him to himself, with a wariness and suspicion that releases the mind's anger at its own nagging candor. In *Self-Portrait in Studio* (1976–77) he is clean shaven, with a cropped skullcap of hair, and he sits behind his palette and worktable as if behind a barricade, his materials cunningly positioned as protective, explanatory intermediaries between his imaged self and painting self.

In the most complex of these pieces, *Myself Painting a Self-Portrait* (1980–81), Gillespie rips through the complacencies apparent in so much American figure painting since the 1950s in which the parody of old master images and styles has conveniently served as a gesture of extravagant self-heroizing exhaustion. His patient, methodical work over a fifteen-year period led Gillespie to what we see in this image, a transformation of the entire space of the painting into a shrine, a canvas lair. He shows himself enclosed and bound by the materials of his work. A woodsy green backdrop forms the wall behind him. To one side is a grid-covered wall—it looks like a comb of cells—on which drafting instruments hang. Before him, to our right, the easel is braced by another grid wall. On the table barricading him from us are pieces of fruit familiar from earlier still lifes, his palette, and two tiny manikins, shrunken versions of the forms that appeared in the 1980 *Manikin Piece.* The work space is just a pinched interval between those surfaces, a shrine pressurized by the planes that define the limits of the picture-making activity. The painter, the ostensible votive object, is bare chested, skinny, his torso wiry and torqued like a Cimabue *corpus;* his facial expression blends matter-of-fact concentration with a surly, self-absorbed impatience. It's the look of a person whose intelligence can never be satisfied by its own best products. The activity we catch him at is that of reimagining the appearance of the self, or rather of an emergent image of the self. And that portrait-in-progress on his easel is hilariously unsettling: a horsey face, with a toothy slice of a grin, looking into the middle distance between us and the painter, like a prankster mediator between what the painter might discover while painting and what we—checked and deflected by convention, historically determined expectations, moods, and fashions—think we see. That larval image, its goofy openness so unlike the severe look on the face of its maker, is in the scheme of the painting a completed, mature image, even though its flaccid textures lack the colossal mass of the fully painted objects, the completed natures of all the other objects in the picture.

Gillespie's ideal of colossal mass is palpable in a painting like *Still Life with Eggplants* (1983; Plate 10), where a leathery red pepper, an overripe banana, pears and squash and eggplants mys-

teriously bear forth, in their solemn stillness, the febrile densities and molecular movement of the earlier landscapes. Still life painting is a ritual of offering; in presenting his subjects, offering them to the viewer, the painter is offering also a formal interrogation by which technique and historical memory transfigure thing life into image life. Still life perhaps registers change more tremulously than any other kind of painting. A painter like Morandi, whose work Gillespie admires, can occupy an entire career investigating the spiritual qualities suggested by the forms of bottles, cans, and beakers; instrumental in such investigations is the veil of line and color that deflects or inhibits exact rendering. In Gillespie's still lifes generally, but particularly in *Still Life with Eggplants,* the objects are veiled by their own voluminous textures. The close-knit colors are weighted with a mineralized, night-garden light that exposes on the surfaces of the objects the physical energies of fruition and decay. In the orange-russet flesh of the squash sitting on its shelf, in the webworked purple sheen of the eggplants, we see released the changes that go on in the boggy undersides of the natural order. The actual making of the images sometimes partakes of the same changeful process. Gillespie has said that his paintings "go through a lot of turmoil and change." He said of a still life that he was working on in 1983: "It was going to end right under the edge of the table. That's where the painting ended in my mind, and I was just going to saw the wood at that point. Then, during the last month or so, I decided I wanted to make it bigger. It was a feeling that it's alive, you know, that the concept didn't prevent some spontaneous change from happening."

Gillespie possesses remarkable painterly skills, he exercises an unusual visionary imagination, and he works steadily (if very slowly) through his themes. His work seems all of a piece. I've passed over the trattoria interiors that he did in the late 1960s, which formally coincide with the shrine paintings, and the nudes and erotic paintings of the same period, a few of which were very controversial. (*Two Women* [1965], showing one woman in a robe, another nude in a frontal pose, was mutilated when it was exhibited. *Seated Man and Girl* [1965–67] shows a bare-chested man leaning toward a seminude woman standing in a doorway: the male

figure began as a photograph of de Chirico sitting at his easel, wearing a shirt that Gillespie then painted out. *Two Women* also began as a photograph.) As for the public presence of his work, Gillespie is at some disadvantage. The small panel format he pre- fers does not recommend itself at a time dominated by physically large and flamboyant canvases. He may also have momentarily slipped the armature of critical formulas. He is a painter of bril- liantly executed physical detail, but he is not a superrealist or a trompe l'oeil artist; his visionary landscapes and still lifes have little in common with the visionary mood of the Neo-expressionists, and he's not interested in narrative painting; he recapitulates old master facts but is neither a parodist nor a historical sentimentalist; and his classical rigor enacts high romantic themes. His career shows a coherence and sustained intensity that certainly rival the careers of younger artists who, for social, ideological, or commercial reasons, have drawn the attention that might be spread about to include a marginal, independent artist like Gillespie.

Francis Bacon and
the Fortunes of Poetry

I N ONE OF HIS ESSAYS MON-
taigne tells the story of the painter Protogenes who, frustrated be-
cause he could not accurately paint the foam on a panting dog's
mouth, threw a paint-soaked sponge at his picture. But, Montaigne
tells us, "Fortune guided the throw with perfect aptness right to
the dog's mouth, and accomplished what art had been unable to
attain." Dame Fortune may have surpassed the painter in the
knowledge of his art. Accident finished that picture, haphazard
gesture fixed the form. Francis Bacon considers himself a realist
painter, and he invites Fortune to play a decisive role in the realiza-
tion of an image, but he doesn't act out of Protogenes' enraged de-
spair. Since he began painting in the 1940s, it has been Bacon's
practice at some point in the evolution of an image to throw paint
at the canvas or to take a sponge or rag and swipe it across the
paint. He spikes Fortune into the process when the image becomes
so stabilized or resolved that the realization is no longer a chal-
lenge. He has said in his interviews with David Sylvester that half
his painting activity is disrupting what he can do with ease. If Pro-
togenes is a prototype of representational art before the modern
change, before the revised realism of the Macchiaioli painters and
the early Impressionists, before the self-consciousness of represen-
tation began to determine how painters and sculptors made im-
ages, it's because for the ancient painter technique was a way of
rendering as accurately as possible the image found in nature, a na-
ture interpenetrated or sponsored by the divine. Fortune or acci-
dent in art, under these conditions, is an intrusive element. Bacon
speaks for the general shift in modern representation, and for the
extreme self-awareness of artists since the 1940s, when he says that
by throwing paint at a stabilized form he is trying to "break the
willed articulation of the image, so that the image will grow, as it
were, spontaneously and within its own structure, and not my
structure."

The willed accident thus takes an image out of its perfected
form so that it can be made truer; it is not so much a form giver as a
form discloser. Although he has most often used models or photo-

graphs as initiating structures, Bacon pursues an image in paint in a way that frees him from the model; accident becomes its own idiom, ripping the normalized into an aberrant but more intensely felt form. In his 1946 *Painting* a male figure stands under an umbrella in what looks like a butcher shop, with sides of beef hanging high above him, like wings. It's an image of urbanity and civility among shambles, and those meaty wings are a frightful, melancholy travesty of transcendence. The painting, Bacon says, began as an attempt to show a bird alighting in a field, but the initial lines suggested another way, another pattern, out of which grew new pictorial suggestions, until the final image was one that Bacon had had no intention of executing. It was, he says, "like one continuous accident mounting on top of another." Those serial accidents were generated internally. Whether accident emerges from within a form or strikes from outside, Bacon *participates* by remaining vulnerable to transfigurations suggested by the action of the paint. He likes to use large brushes because they release more possibilities; their action is expansive, not contractile, and they broaden the range of unpredictability. Bacon is not interested in installing disorder or pictorial chaos on the canvas. His openness to accident is a way of intensifying the image, which is to say, a way of getting it right, of fixing and clarifying the order within it. What he desires is an unforeseeable order worked into place by the aggressions of chance.

Poets listen to the action of language in their heads and call it a music, the plastic rhythm of sound and sensation fused of learning, deliberation, feeling, desire, and memory, all modeling themselves in obedience to the instinct for form. The more practiced, assured, and disciplined the music becomes, the more important it is to let the cranky shriek of accident alter and shape desire's song. The rude enjambments of consciousness that disrupt familiar patterns of disclosure and destabilize what one has achieved with perhaps too much ease; the felt surrender of absorbing as right music a previously censored idiom or diction or cadence; the unprocessed, unworked matter of the unconscious hacking into the poem-in-progress, threatening one's assumptions about a poem's proper finish or texture—these keep the poet from being lulled by a too congenial music that expresses a glazed-over vision of reality. It

may be that some poems, like paintings, are best viewed close up, others from a distance, that some persuade by the power of their details and others by the force of a general conception or structure, but the peculiar relevance of *ut pictura poesis* for us now lies in the similarities between painting and poetry not as objects but as image-making activities, ways of working materials. A painter's material of course really *is* material. Poets do thought work and make thought things. And yet, more completely and painfully than we know these facts, we know that we feel language in our nerves, as if it were sense or impulse, the same way we feel the immediacy and tactile presence of dream images. The sensation of bringing a poem into existence is so much like the imaginative exertion of making a physical image that poetry, in its becoming, aspires finally not to the evanescent perfecting of music but to the manifest contrivances, *pentimenti,* and sumptuous imperfectibilities of painting and sculpture.

For me the movement from one line or stanza to the next, as a form-finding task, carries the kind of exasperating difficulty Giacometti described when he said how impossible it seemed, when modeling a head, to move from one side of a nose to the other. The imagination wants necessary forms, and a feeling of permanence, even when it knows that nothing is permanent except perhaps the divine mind; it lives in the world of what's possible with the constant persuasion of impossibility. The imagination is infused with its memory of achieved forms, of things rightly said, and of how insufficient achievement seemed in light of what was sought. As the imagination makes over its vision of reality into words, it takes with it into the next line or stanza, to the other side of the poem's nose, all the formal familiarity of past experiences. Often, though, that hoard of experience exists only as impoverishment in the presence of the new desire. Most poets write *toward* the form or structure of a poem, not out of it. As for me, I feel most helpless and inadequate when the configuration of material or subject finally begins to emerge, when the sense of the thing begins to feel whole and continuous. That's when I want consciousness to wield the accidental force of its scannings and fabulations, so that I can take a sound rippling from a word (the shocking sense of George

Herbert's flower "growing and *groaning* thither"), the bite of involuntary memory (what voice tells us to read Augustine?), the shadowy fragments of the unconscious rolling loose—or an already stabilized form, a way of saying something—into an intenser realization, or at least try to, since too fond a friendship with accident just as often results in messy obtuseness and obscurity. All experience, when I'm working, becomes phantasmagoria, and I believe the work of the imagination is to realize phantasmagoria in the whole image or metaphor of a poem. I mean image as the poem's entirety, not instances within it. The imagination, as I feel it, must resist or suspect what is pleasurably stable. That drive is one of its selective powers. If it masters, it does so by virtue of its unwillingness ever to be masterful. When I read *Antony and Cleopatra* or *The Tempest,* I feel I'm reading not a poet in secure mastery of his resources but a poet pushing language so far that it is a breath away from chaos—a poet, in other words, at the limits of his control.

Because of the way he vexes paint into unintended figurations, when Bacon paints a figure in repose he makes flesh look like a whipped-up action. When he displays or installs a figure on a bed or chair, or on one of those clinical slabs that turn up frequently in his work, even rest can seem a perturbation. In his portraits, likeness itself enacts the painting activity; it's dislodged from its stilled, presentational norms. And yet his images, for all their obvious unrest, also possess a strangely detached, fish-eyed mood. Bacon likes his paintings to be covered by glass, and the images themselves are pictorially sealed off, unavailable, even as the energy of those vehement swirls and crests of color pushes out at us. Somehow the act of derangement by which they are made creates an intimacy that excludes us. A blood-beaded hunk of meat, a knob of flesh perched on a rail, a screaming mouth colored with the florid extravagance of medical illustrations—even Bacon's most shocking images are both tortuous expressive acts and acts of cool, remorseless, staring witness. He has for many years relied on photographs, as models or as technical prototypes, to help him bring over into paint the style of insolent witness that photography enacts. This insolence is absent from the work of Bacon's friend and

sometime subject, Lucian Freud, who in his own paintings models flesh from the outside in, shaping the paint to study his way toward the desired likeness. In Bacon's figures, although the paint is more alarmingly acted on, carnal likeness is determined from the inside out, mustered into a flagrant truthfulness.

When Bacon says that he values Picasso for his "brutality of fact" and prefers him to Matisse, who "turns fact into lyricism," he is making his argument for a modernist realism. He considers himself a realist after the manner of Picasso not only because he brings over into paint as boldly and unsentimentally as possible images of appetite, abandonment, want, and dread, but also because realism for him means, as he put it in a letter to Michel Leiris, attempting "to capture the appearance together with the cluster of sensation that the appearance arouses in me." But in Bacon's representations of the figure—unlike Matisse's, whose remark about painting not the object but the emotion the object stirs in him is close to Bacon's sentiment, but who also insisted that the greatest art is sacred art— we do not see mind, or even feeling specific to the subject, but rather a condition of nerves. We see, in other words, no kindling of the sacred or the numinous so constant in Matisse. This distinguishes him even from Picasso, who practiced painting as a pagan ritual and whose formalist adventures were inseparable from his quest, as he put it in conversation with André Malraux, to find the mask of God. Picasso's heroic predecessor, in Bacon's view, is Van Gogh:

> I believe that realism has to be reinvented. In one of his
> letters Van Gogh speaks of the need to make changes in
> reality, which become lies that are truer than the literal
> truth. This is the only possible way the painter can bring
> back the intensity of the reality which he is trying to capture.

He dismisses anything less than this as illustration, "illustrating the image before you, not inventing it," and as something "very second hand." This kind of expressive realism demands likeness but not exact, or even close, rendering; reinvention but not fanciful elaboration; pronounced artificiality, so that the maker's hand is dramatically evident, but not mannerist nicety; deflection or frag-

mentation of narrative; the painted image as a fact added to our knowledge of reality. The shift in realism since Van Gogh has been, for painters like Bacon, away from the verisimilitude desired by Courbet, for whom painting was an expressive transferral of the material actuality of things ("[Painting is] an essentially *concrete* art and can only consist of the presentation of *real and existing* things," he wrote in 1861), toward the painted image as a reality obviously changed by the intensification of fact that occurs when the artist brings a subject over into paint. The energy of bringing over likeness becomes indeed more important than the quality of likeness.

But Bacon remains numb to, or uninterested in, the devotional fervor of Van Gogh's realism and the sacral ferocity of many of Picasso's images. We see in his work the entire force of the history of realist striving, but with no religious feeling or content, no sense of awe. Not only is the reality he paints not god-infused, but he cannot even be likened to those poets in a destitute time who, as Heidegger describes them, have no choice but to attend, singing, to the trace of the fugitive gods. Bacon's reality is governed by instinct, by accidental action and consequence, by unattributable horrors. The sheeted monochromatic interiors in so many of his paintings, with human shapes coiled or splayed or pooled onto the scene, are settings of blood and viscera. The occasional looming presences, the watchers who appear in mirrors or behind doors, are other remorseless appetites. Bacon paints not a state of consciousness but a condition of nerves, and that makes his images both sullen and nightmarish. There is no sense in his pictures that the human form has always been steward of a passion for transcendence. He accepts, in his urgency to make images that bear the brutality of fact, a historical obliviousness. His various renderings of Furies—he is a great reader of Aeschylus—are the vision of a man who believes in fatality, not fatefulness, and in the demons of hysteria more than in those of conscience. For all the technical influence of Giotto, from whom he seems to have taken his way of boxing or caging his figures to "site" them and isolate them from any suggested narrative, and of Cimabue, from whose Crucifixions he learned something about the softened, squirming muscularity of

the body in pain, and although he traces his line of descent from Van Gogh through Picasso, Bacon is the purest and most compelling example in postwar figurative painting of an artist with no sense of the sacred.

Our time has produced, by default perhaps, poetry equivalent to (or illustrative of) Bacon's nervous, desacralized imagery. I believe that in our own historically destitute time, when we live in a culture that functions as if the death of God announced by Nietzsche's Zarathustra were a practical reality, it is left to poets not only to trace the etiology of the death of the gods but also to feel that story as our central myth. Poets are traditionally the most unsentimental and inventive archeologists of sacred consciousness, and they can still perform an act that Eliade says he performs as a historian of religions: "*to identify the presence of the transcendent in human experience . . .* to unmask the presence of the transcendent and the suprahistoric in everyday life." I should say they *seek* to unmask that presence; their poetry may also be a testament of defeat, failure. The poet does his work in a nondiscursive, subjective way, and his work is not only, maybe not even primarily, to state knowledge but also to make images that express what it feels like to know. The poem is an image or metaphor the same way a painting is an image: it offers us an interpretive likeness of reality. The transfiguration of reality in poetry is all the more intense if it gives an accurate, true report of the real, I mean a report of the bonded suffering and exaltation of existence. Metaphor is the centaur. The word *author,* Ortega y Gasset tells us, comes from *auctor,* "one who augments." Imagination is essentially an act of desire—to desire reality in order to meet it, add to it, answer to it, remake and restore it to consciousness, and thereby intensify it. To do this is to relate legends of the sacred, to seek the mask of transcendence, even if the mask returns us, as it perhaps now must, to our own devices, to techniques of consciousness. In the task itself the formal perfection of the image counts less than living out, in the form of the poem, the traces of the struggle, one sign of which is the broken grain of accident. For me, it means reminding myself that precision or singularity of anecdote (the poetic equivalent of genteel, exact rendering in figure painting) has little value unless

volatilized by visionary feeling and that I do not want judicious il-
lustrational likeness.

To make paint over into a reinvented image rather than an illus-
trated one, Bacon often looks away from his subject to some inter-
mediary figure. One sitter has said that while working on a portrait,
Bacon spent most of his time looking not at the sitter but at a
photograph of a hippopotamus on the floor at his feet. He relies on
the photographic image for its factual immediacy, and because he
can push through the photographic likeness to arrive at a trans-
figured image in paint. It helps him, in other words, to falsify the
real, to *mis*represent it, in order to make a realistic image true to
the artist's sensation. Separating himself from those he calls the
mixed-media jackdaws, who put photographs and other found ma-
terials into their pictures (it makes for a literalness and third-hand
illustration that I presume Bacon detests), he describes photo-
graphs as "a sort of compost out of which images emerge from time
to time." His numerous pictures of male bodies wrestling or copu-
lating come out of configurations in Eadweard Muybridge's motion
studies of nude wrestlers. But Bacon's images are not laid on the
given structures in Muybridge's photographs (the way emotion in
certain poems is laid on, or appliqued to, anecdote); the photo-
graphic studies are mediating visual facts, even recollected struc-
tures, volatilized in the making of the new, "falsified," image.
Bacon uses photographs the way a poet, attracted by a news item
about unidentifiable pottery fragments unearthed in a pueblo ruin,
might realize a poem about how consciousness sorts through its
memory of the sacred—a poem, however, in which no mention of
shards or ruins appears. Or how a poet might realize an image
of shared, inescapable, divisive woe in marriage only after seeing
Tintoretto's *Adam and Eve,* though that mediating image be burned
off in the telling. There is a factual, emotion-laden webwork a poet
can take over from pictorial images, especially when the poetry we
seek is not *about* such images. To write a poem about a hippo-
potamus, it may be best to spend a long time looking at a photo-
graph of a fat man. Poems like Auden's "Musée des Beaux-Arts"
and Williams's "Pictures from Brueghel" are lesser poems because

they illustrate, in a philosophical mood, the given images; Rilke's "Archaic Torso of Apollo" is a great poem because the subject, the pictorial anecdote, disintegrates in the self-regarding, urgent, mind-altering mask of transcendence that the poem itself seeks to be.

I said earlier that Bacon has been reading Aeschylus for years. Many of his images bear the jagged shriek of events one hears in Aeschylean tragedy. The affinity is announced in *Triptych Inspired by the Oresteia of Aeschylus* (1981), where the central panel shows a throne-dais, the space of rulership, engorged with red; onto the dais is climbing a biomorphic shape, fleshy rotund lumbar parts in which a curving spinal column is embedded. Though modeled on nothing in Aeschylus, the left-hand panel shows a Fury, a bat-eared, crescent-shaped, horned creature hanging from a door frame—a skein of blood floats from the ear. Bacon is not making over any of the religious sense of the Oresteia; he is not interested in moral pollution, blood guilt, ritual, or social order. He is interested in carnal effects and the sensations aroused in him by events in Aeschylus's plays. Because of the kind of painter he is, the metaphysical dimension of Aeschylus is crushed to a materialist, sensationalist concentrate.

Bacon has been even more provoked and inspired by T. S. Eliot, but it is not the ventriloquism of "The Waste Land" or of "Prufrock" that has attracted him but the shocking suggestiveness of the Sweeney poems of 1920 and the uncompleted "Sweeney Agonistes." Those skittish, clicking quatrains with their mongrel idioms flash out dreadful scenic details that remind me of the medical illustrations of diseases of the mouth that Bacon used as intermediary images for several of his major paintings in the 1950s and 1960s: "This withered root of knots of hair / Slitted below and gashed with eyes, / This oval O cropped out with teeth." I also feel in those poems an oblique, slashing urgency of language that I do not hear in Eliot's other poetry, a forceful (even violent) modeling of language mass so that it can make a completed image of the felt experience of memory, mortal dread, and desire. Sweeney is the desirous ape, all appetitive mind. In him animal sweats burn with

the instinct for transcendence. Though he feels the weight of the mass of flesh in all his exertions, his mind wanders at will among the fiery stars. What has inspired many of Bacon's images of the male form is the brute, sensualist Sweeney—Apeneck Sweeney, whose existence is pure suffering massive flesh. Bacon's fascination with such forms was evident as early as his *Study of a Baboon* in 1953 and the 1955 *Chimpanzee*. The 1970 *Three Studies of the Male Back* brings over, in the figure of a male nude shaving before a mirror, a transfigured image of Sweeney "Broadbottomed, pink from nape to base" who "wipes the suds around his face." Bacon's image has been warped by fortune, by what he calls "the transforming effect of cultivated accidents of paint"; and by isolating elements within the image by setting a frame or drawing a radiographer's circle around them, he wrenches the figure from its normalized, "realist" contexts. Eliot, too, in "Sweeney Erect," smears the anecdotal consistency of the dramatic scene—Sweeney's woman, on waking, has an epileptic seizure while he shaves—with mixed orders of diction ("Paint me the bold anfractious rocks"; "Mrs. Turner intimates / It does the house no sort of good"), recapitulations of evolutionary moments ("Gesture of orang-outang / Rises from the sheets in steam"), recovery of mythic or sacred time ("Morning stirs the feet and hands / [Nausicaa and Polypheme]"), and intellectual mockery ("[The lengthened shadow of a man / Is history, said Emerson / Who had not seen the silhouette / Of Sweeney straddled in the sun]"). In Sweeney, Eliot has evolutionary time, materialist time, exist simultaneously in consciousness with sacred time. In Bacon's images we see the human figure in its secular, evolutionary materiality. Both artists, though, are preoccupied with violated orders, with the disturbance of one order so that a new order may arise.

One of Bacon's most mysterious images is *Triptych Inspired by T. S. Eliot's Poem "Sweeney Agonistes"* (1967). The central panel is a scene in a sleeping compartment: a dark suit and white shirt are thrown across a stool and a valise; the bed is a pulped, blood-drenched mess. The side panels depict a pair of lovers. In each the pair is placed, or exhibited, on a circular platform very much like

the erotic stage sets in many of Bacon's paintings. A cage rises like a canopy frame around each bed, and at the foot of each is a tall concave mirror. On the left, the lovers sprawl on their backs, hair hanging loose off the platform edge; in the mirror we see a pair of feet and, in the room's far corner (there is no room, of course, only the imaged space swept into existence by the object's position in the mirror), a nightstand. On the right, one figure mounts the other. In *that* mirror we see a man talking into a telephone while watching the figures. The watcher, however, is nowhere in the room; he is a reverse vampire, visible only as a mirror image. Eliot's unfinished poem, subtitled "Fragments from an Aristophanic Melodrama" (as deflective a subtitle as one could imagine), commences with a fragmentary prologue in which characters are introduced and in which Sweeney is mentioned, though he does not materialize until the second section, "Fragment of an Agon." Sweeney's agon is a contest against the inadequacy of language, the irremediability of fact, and the metaphysical yearning instinct in consciousness. Sweeney wants to speak truths about matter and spirit, and about the relation between the living and the dead. "I gotta use words when I talk to you," he tells his listeners in the idiom of vaudeville patter, though his assertion is born of helplessness and the knowledge that words are always inadequate to the telling of our suffering, an inadequacy that also has made for classic vaudeville gags. If life were reduced to its essential facts, he says, it would be simple:

> Birth, and copulation, and death,
> That's all the facts when you come to brass tacks:
> Birth, and copulation, and death.
> I've been born, and once is enough.
> You don't remember, but I remember,
> Once is enough.

What Sweeney remembers, and what gives the lie to his own claim about the three essential facts, is some unidentified source of guilt that eats away at him. He has knowledge of murder, though it's not clear—and not necessary for Eliot to make clear—whether it is Sweeney or someone else who committed the act. (The actual fact,

the brass tack, was the case of a Britisher who had drowned a suc-
cession of wives for their insurance money.) Sweeney admits not to
an act but to a compulsion:

> I knew a man once did a girl in
> Any man might do a girl in
> Any man has to, needs to, wants to
> Once in a lifetime, do a girl in.

The knowledge of his own murderousness, which he seems to feel
as a natural part of male sexual drives, is Sweeney's Furies.

Because he is the only one who can see them, he feels all the
more desperate at the inadequacy of language to express the reality
of those Furies. The poem has two epigraphs: Orestes' words from
the *Choephoroi,* "You don't see them, you don't—but I see them:
they are hunting me down, I must move on"; and from St. John of
the Cross, "Hence the soul cannot be possessed of the divine
union, until it has divested itself of love of all created beings."
Sweeney wants to know how he can be united with divinity (he has
not so much a belief in transcendence as a twisted suspicion of it)
without at the same time detaching himself from what he hungers
after, the material creation of his own apish nature. For Eliot the
believer, and his image Sweeney, worldly love and remorse are in-
separable because they are too much a part of the apish nature that
sustains murderousness. Sweeney suffers the agony of material eros
lived under the aspect of sacred eros. Transhuman time, divine
time, lives in our consciousness, which itself lives in the human,
secular, simian time we experience in most of our waking hours.

John Berger has denounced Bacon's art because its world, inhab-
ited by those sullen, impassive figures, is one in which the worst has
already happened; and the worst "is that man has come to be seen
as mindless"—mindless because the human image in Bacon's paint-
ing is vacant of consciousness, of self-reflection, of the awareness of
time and change, of the will to act on circumstance. Berger's Marx-
ist biases are evident; he must denounce an art that not only seems
to accept unquestioned what he calls alienated social behaviors but
also represents them so vividly that they seem to viewers almost

exemplary. I don't feel that Bacon is enough of a social painter to be condemned for reproducing "alienated behaviors." His endless interiors are image places, not domestic "natures" or social settings. His work obviously has none of the social dimension of Lucian Freud's or, to choose a less glamorous but more interesting painter, Fairfield Porter's. But in isolating the mindlessness of the human image in Bacon's work—those hundreds of pummeled, affectless, staring faces—Berger is describing the particular place Bacon occupies in the history of modern figuration.

Bacon is a great painter whose art has a peculiar, timely, and inhibiting limitation. The painting accidents that make his images so vivid and quickened and that have given a unique energy to his own realist enterprise either surrender or displace too much the provocative formal interrogations that Picasso, Matisse, and Giacometti practiced. In the most fractured portrait by Picasso, in the most mild-mannered odalisque by Matisse or expressionless frontal portrait of Diego by Giacometti, not only does an energy of mindfulness emanate from the figure, but the image itself expresses an imagination internalizing and making over something that exists outside it, an imagination in which at least legends of transcendence still live. Picasso wanted to find the mask of God; Matisse in his last years made sacred decorations; Giacometti's work from the late 1940s on was an imaging of nature taking shape *in illo tempore,* in the Great Time. In Bacon's entirely desacralized reality the human image can be little more than a turbulence or stasis of matter. In his many interviews Bacon never speaks of spirit or soul, but of nerves. He wants his paintings to "come across directly on to the nervous system." The gnarled shapes, the glistening beaded brushwork of a dour face, the streaked turn of a head, the little glacial teeth mounted like a tiara (or animal trap) atop the spinal column, all set out on lush, monochromatic backgrounds that look like expensively lined display cases—these extraordinary effects are expressions of nervous self-consciousness *as a form-making principle;* if they come across immediately on to our nerves, it's because they bypass deliberation, inquisitiveness, reflectiveness, and contemplative speculativeness, even while we see in the paint the impressive learning of a master painter and the skills of a master colorist.

Bacon is the most famous painter of our time because he is the premier painter of nervous reflex. Most of his figures, even recumbent ones, cringe or recoil or contract; they cross their arms and legs in knots; they look away or down; their flesh is made of thick ganglia of shadows and bright pastel meat. In the portraits especially we see consciousness abnegating, clenching, closing down on itself. When the face is pulled or stretched from the head or spinal stem, it's an image of neurosis turned into hell on earth, an irredeemable condition, and our image consciousness as viewers—our awareness of how we view our own evolved form *as an image,* and how we read its nervous states—is intensified almost unbearably. This is certainly one consequence, one end, of the line of realist painting Bacon feels he has pursued. It marks the failure of the curiosity and will toward transcendence, even the new all-too-human transcendence of self-overcoming proposed by Zarathustra; nor does it exist even as a merely magnificent or desirable or necessary fiction. When a condition of nerves or titillated self-awareness, whether in painting or poetry, becomes a supreme subject, the torment it dramatizes is of a special, narrow kind. It's godless torment, a suffering not in the soul but only in the nerves. Bacon's major predecessors were major nonbelievers—Matisse's most teasing remark was that he believed in God only when he was working—but their images are infused with the spectral sense of other possibilities, each picture or piece of sculpture available to intenser deliberations. What we feel as the drivenness in their art was the conviction of a world elsewhere, in another piece of art, another interrogation. That kind of disbeliever's religiosity, rooted in the belief in the *other* reality of the undiscovered country of forms and feeling, is absent from Bacon's art. Without some suspicion of the sacred, the intrusive contributions of accident will return poet or painter more or less to the same place. The image will change, but the feeling will not be deepened or complicated. Accident is part of the skein of forces that make up a power we feel to be larger than our own, though it is yet a power vulnerable to, and finally circumscribed by, the hungers of consciousness that sustain us in time, in this world.

Selected Bibliography

Ades, Dawn, and Andrew Forge. *Francis Bacon*. London: Thames and Hudson, 1985.

Barilli, Renato. *Morandi e il suo tempo*. Exh. cat. Milan: Nuove edizioni Gabriele Mazzotta, 1985.

Baudelaire, Charles. *Selected Writings on Art and Artists*. Translated by P. E. Charvet. Cambridge: Cambridge University Press, 1981.

Beal, Graham W. J. *Second Sight: Biennial IV*. Exh. cat. San Francisco: San Francisco Museum of Modern Art, 1986.

Belz, Carl. *The Art of William Beckman and Gregory Gillespie*. Exh. cat. Boston: Rose Art Museum, Brandeis University, 1984.

Benjamin, Walter. *Charles Baudelaire: A Lyric Poet in the Era of High Capitalism*. Translated by Harry Zohn. London: Verso Editions, 1983.

Berger, John. *About Looking*. New York: Pantheon, 1980.

———. *The Success and Failure of Picasso*. New York: Pantheon, 1980.

———. *The Sense of Sight*. New York: Pantheon, 1985.

Bergson, Henri. *The Two Sources of Morality and Religion*. New York: Henry Holt, 1935.

Broude, Norma. *The Macchiaioli*. New Haven: Yale University Press, 1987.

Canetti, Elias. *Crowds and Power*. Translated by Carol Stewart. New York: Seabury Press, 1978.

Carluccio, Luigi. *Giacometti: A Sketchbook of Interpretive Drawings*. New York: Harry Abrams, 1967.

Clark, T. J. *The Absolute Bourgeois: Artists and Politics in France, 1848–1851*. Greenwich, Conn.: New York Graphic Society, 1973.

———. *Image of the People*. Greenwich, Conn.: New York Graphic Society, 1973.

———. *The Painting of Modern Life*. New York: Knopf, 1985.

Cooper, David B. *Robert Frank and American Politics*. Exh. cat. Akron, Ohio: Akron Art Museum, 1985.

Danto, Arthur C. *The State of the Art*. New York: Prentice-Hall, 1987.

Delacroix, Eugène. *The Journal of Eugène Delacroix*. Edited by Hubert Wellington. Oxford: Phaidon Press, 1951.

Eliade, Mircea. *Myths, Dreams, and Mysteries*. New York: Harper, 1960.

———. *The Sacred and the Profane*. New York: Harper & Row, 1961.

———. *Ordeal by Labyrinth.* Chicago: University of Chicago Press, 1982.

———. *Symbolism, the Sacred, and the Arts.* New York: Crossroad, 1985.

Frank, Robert. *The Americans.* Introduction by Jack Kerouac. Millerton, N.Y.: Aperture, 1959.

Gablik, Suzi. *Has Modernism Failed?* New York: Thames and Hudson, 1984.

Green, Eleanor. *John Graham: Artist and Avatar.* Exh. cat. Washington, D.C.: Phillips Collection, 1987.

Greenberg, Clement. *The Collected Essays and Criticism.* Edited by John O'Brian. 2 vols. Chicago: University of Chicago Press, 1986.

Hulton, Pontus. *Futurismo & Futurismi.* Exh. cat. Milan: Bompiani Editore, 1986.

James, William. *The Principles of Psychology.* 2 vols. 1890. Reprint. Cambridge, Mass.: Harvard University Press, 1981.

Kuenzi, André. *Alberto Giacometti.* Exh. cat. Martigny: Fondation Pierre Gianadda, 1986.

Lerner, Abram. *Gregory Gillespie.* Exh. cat. Washington, D.C.: Hirschhorn Museum and Sculpture Garden, 1977.

Lord, James. *A Giacometti Portrait.* 1965. Reprint. New York: Farrar, Straus and Giroux, 1980.

———. *Giacometti: A Biography.* New York: Farrar, Straus and Giroux, 1985.

Malraux, André. *Picasso's Mask.* New York: Holt, Rinehart and Winston, 1976.

Matisse, Henry. *Matisse on Art.* Edited by Jack D. Flam. New York: Phaidon, 1973.

Newhall, Beaumont. *Supreme Instants: The Photography of Edward Weston.* Exh. cat. New York: New York Graphic Society, 1986.

Nochlin, Linda. *Realism.* New York: Penguin, 1971.

Pater, Walter. *The Renaissance.* New York: Modern Library.

Rewald, John. *Cézanne: A Biography.* New York: H. N. Abrams, 1986.

Rilke, Rainer Maria. *Letters on Cézanne.* Translated by Joel Agee. New York: Fromm International, 1985.

Rosand, David. *Painting in Cinquecento Venice.* New Haven: Yale University Press, 1982.

Ruskin, John. *The Lamp of Beauty: Writings on Art.* Edited by Joan Evans. Ithaca: Cornell University Press, 1980.

Russell, John. *Francis Bacon.* New York: Oxford University Press, 1979.

Schjeldahl, Peter. *Salle.* New York: Random House, 1987.

Schneider, Pierre. *Matisse.* Translated by Michael Taylor and Bridget Strevens Romer. New York: Rizzoli, 1984.

———. *Matisse et l'Italie.* Exh. cat. Milan: Arnoldo Mondadori Editore, 1987.

Stella, Frank. *Working Space*. Cambridge, Mass.: Harvard University Press, 1986.

Stich, Sidra. *Made in U.S.A.* Exh. cat. Berkeley and Los Angeles: University of California Press, 1987.

Sylvester, David. *The Brutality of Fact: Interviews with Francis Bacon*. London: Thames and Hudson, 1988.

Tompkins, Calvin. *Off the Wall*. Garden City, N.J.: Doubleday, 1980.

Tonelli, Edith, and Katherine Hart. *The Macchiaioli: Painters of Italian Life, 1850–1900*. Exh. cat. Los Angeles: Frederick S. Wight Art Gallery, University of California, Los Angeles, 1986.

Van Gogh, Vincent. *The Letters of Vincent Van Gogh*. Edited by Mark Roskill. New York: Atheneum, 1985.

Vasari, Giorgio. *Lives of the Artists*. Edited by Betty Burroughs. New York: Simon and Schuster, 1946.

Weinman, Melissa. *Moral Visions: Jerome Witkin*. Exh. cat. University of Richmond, Va.: Marsh Gallery, 1986.

Weston, Edward. *The Daybooks of Edward Weston*. Millerton, N.Y.: Aperture, 1973.

Wind, Edgar. *Art and Anarchy*. New York: Knopf, 1964. 3rd ed. Evanston, Ill.: Northwestern University Press, 1985.

Index

Compositor: G & S Typesetters, Inc.
 Text: 10½ × 13 Simoncini Garamond
 Display: Meridien
 Printer: Braun-Brumfield, Inc.
 Binder: Braun-Brumfield, Inc.